Challenging History

THE CAROLINA LOWCOUNTRY AND THE ATLANTIC WORLD

Sponsored by the Program in the Carolina Lowcountry
and the Atlantic World of the College of Charleston

*Crossings and Encounters: Race, Gender, and
Sexuality in the Atlantic World*
Laura R. Prieto and Stephen R. Berry, eds.

*Black Freedom in the Age of Slavery:
Race, Status, and Identity in the Urban Americas*
John Garrison Marks

*Material Culture in Anglo-America: Regional Identity and
Urbanity in the Tidewater, Lowcountry, and Caribbean*
David S. Shields, ed.

Paths to Freedom: Manumission in the Atlantic World
Rosemary Brana-Shute and Randy J. Sparks, eds.

Challenging HISTORY

Race, Equity, and the Practice of Public History

Edited by

LEAH WORTHINGTON,
RACHEL CLARE DONALDSON, and JOHN W. WHITE

THE UNIVERSITY OF
SOUTH CAROLINA PRESS

Published by the University of South Carolina Press
Columbia, South Carolina 29208

www.uscpress.com

Manufactured in the United States of America

30 29 28 27 26 25 24 23 22 21
10 9 8 7 6 5 4 3 2 1

Library of Congress Cataloging-in-Publication Data
can be found at http://catalog.loc.gov/.

ISBN: 978-1-64336-200-7 (hardcover)
ISBN: 978-1-64336-201-4 (ebook)

Publication of this volume was made possible in part by the generous
support of The Avery Research Center for African American History and
Culture and the College of Charleston Libraries.

Contents

PART III: THINKING BACK, LOOKING FORWARD

Illustrations

Introduction

LEAH WORTHINGTON, JOHN W. WHITE,
and RACHEL CLARE DONALDSON

In the spring of 2020, with tension related to the COVID-19 pandemic already at a low-voltage hum across the United States, cities and towns quickly became electrified when protests broke out responding to the mistreatment and murder of Black Americans. A July 3, 2020, *New York Times* article, "Black Lives Matter May Be the Largest Movement in U.S. History," calculated that more than 4,700 demonstrations took place between the day of the first protest in Minneapolis, Minnesota, on May 26, and the date of the article, on July 3, averaging 140 demonstrations per day. The article cited national polls on the number of Americans who participated in these protests, with the lowest of these figures coming in at fifteen million people: 6 percent of the US population.[1] Tensions and outrage increased not only in the streets of US cities but also in the news and on social media as Americans expressed their views on the uprisings. Media and individual views ranged from complete support of social justice for Black Americans and of the Black Lives Matter movement at the one end of the spectrum to historically false and blatantly racist comments at the other end. As conversations about race and the legacy of slavery sprang up, it was evident that many Americans' knowledge of the country's history is underinformed, uninformed, and simply incorrect.

This moment in American history is connected to our profession as scholars of public history, serving as a reminder of how much work there is left to accomplish in helping Americans learn their national and local histories, particularly the difficult histories about slavery and race. With the rising national interest in learning about African American and other marginalized people's histories, the moment also created an opportunity that public historians can build upon. According to a June 2020 Pew Research Center poll, nearly 70 percent of Americans reported that they had a conversation about race or

racial inequality in the last month. In addition to conversations among family and friends, this moment also led many institutions and businesses to publicly announce their commitment to racial and social justice. Although public calls for antiracism increased and dominated some news outlets and social media accounts over the spring and summer of 2020, the United States has also seen a 55 percent increase in white-nationalist hate groups since 2017, according to Southern Poverty Law Center's 2019 "Year in Hate and Extremism" report.[2] One of the ways that white-nationalist groups spread racism, antisemitism, and Islamophobia is through historical falsehoods. Furthermore, when difficult or painful histories are hidden from the public by the tourism industry or public history professionals, the public not only receives incorrect or fractured history but also internalizes misconceptions, myths, and falsehoods used to prop up American racism.

Although the 2020 moment of racial reckoning has caught the nation's attention, many public history professionals have long contended with the necessity of creating racially inclusive and accurate history for the public. Therefore, whereas the 2020 national events have drawn fresh attention to Black and other marginalized histories, this volume provides examples of how this work is already taking place, along with the successes and challenges of those projects, and it identifies where further work needs to be conducted. For readers who are engaged in similar projects, this volume provides an opportunity to put your work and ideas in conversation with those of other public history professionals who are engaged in Black-centered public history. It also offers ideas on spaces where Black-centered narratives need to be implemented, pointing the way to new directions in the field.

The work conducted by the authors herein has several origins. Some authors write about historical topics presently underused at public history sites, calling for new interpretation and projects; several authors fit their projects into existing public history projects or museum spaces, either adding new Black voices to African American narratives or inserting Black voices into narratives that had been ignoring them; still others' work resulted, in part, as a response to current events. This volume's origin, in fact, began with a conference in Charleston, South Carolina, organized as a direct response to the racist massacre of Black people in a Black Charleston church.

In 2017 scholars from Europe, the Caribbean, and across the United States came to Charleston for the public history conference Transforming Public History: From Charleston to the Atlantic World.[3] Through presentations, workshops, and conversations at the conference, it became apparent that the challenges and successes that public history professionals see in Charleston and the Atlantic world are also experienced throughout the US South. The conference included a wide geographic scope, and this volume began to evolve,

focusing on practitioners and academics collaborating on research and projects within the United States, with a concentration in Charleston. As an outgrowth of the conference, the volume reflects the themes of the conference by focusing on public history and the representations and absences of underrepresented, ignored, or nearly erased African American histories. Inclusive of research and public history projects at all stages of progress, these essays explore untapped spaces of interpretation, newer voices and narratives presently being explored, collaborative projects that challenge entrenched mythologies and heritages built on falsehoods, and established projects that can serve as models for practitioners.

A reflection of the breadth of the field of public history, the volume's contributors have been serving in many different public history roles. Our hope is that the variable methods of involvement in public history will translate to being useful to a broad audience of practitioners and students who are also thinking about inclusive public history that centers on underrepresented narratives. This volume tackles topics and cases crossing into related fields such as museum studies, historic preservation, archaeology, African American studies, collective memory studies, and digital history. Therefore, it also represents an assortment of public history sites, including museums, federal and state parks, public squares, neighborhoods, the internet, sites of slavery, and historic homes. The volume's editors and authors include academic public historians working on public history projects, scholars with academic appointments who have taken an active role in public history projects, librarians working on digital public history, museum workers, and interpreters working at historic sites. Regardless of the type of public history space, each essay speaks to the changes and continuities in creating history for the public in the US South over the past decades.

In gathering the voices of public history practitioners working on southern history into one volume, it becomes clear that twenty-first-century practitioners are contending with entrenched ideas created by the dominant culture about identity and heritage that were developed in previous centuries and are evolving in the twenty-first century. True of United States history regardless of region, the effects of racism in the South did not stop with schools, housing, job opportunities, or voting. The work of public history practitioners in this volume underscores the increasingly acknowledged reality among both the public and historic sites that racism has also influenced, and at times outright controlled, the history told in many of the South's public spaces and private tourism spaces. Designed for tourists and locals alike, the spaces where collective memory and remembrance are formed that have historically excluded Black history include museums, historic sites, historic homes, monuments, and plaques.

White heritage and identity—regularly overlaid with ideological white supremacy—have dominated many southern landscapes and prevented profoundly important African American experiences from being told in the spaces where the history took place.[4] The southern plantation is ground zero for this occurrence: spaces where US dominant collective memory has been mythologized and romanticized, despite the reality that plantation history is the history of white people's violent, racist enslavement of Black people for their labor.

The decades of work on the part of public history workers and educators to share accurate American plantation history have recently begun changing public perceptions regarding historic plantations. Redesigned in the twentieth and twenty-first centuries as elite spaces with natural beauty and elegant architecture and stripped of their terrifying and painful histories, plantations have been—and often remain—popular sites for weddings. However, as more sites of slavery tell the actual history of plantations, Americans' popular opinion is shifting about how the sites should be used. As the public comes to understand the seriousness of the history that took place on plantations, some couples are deciding to celebrate their marriage elsewhere, with a few publicly expressing regret for having chosen a plantation for their wedding. For example, actors Ryan Reynolds and Blake Lively issued a statement of regret about holding their wedding on a South Carolina plantation, noting that the difference between the romantic website version of the wedding venue and the actual history of the site is "impossible to reconcile."[5] A 2019 *New York Times* article reported that major wedding-planning websites were cutting back on promoting historic plantation sites from their sites. Although the changes made on wedding-planning websites included "removing all references to plantations on their sites and prohibiting adjectives like 'charming' to describe venues where Americans' ancestors were once enslaved, tortured, and raped," some of the websites still have sites of slavery listed as wedding venues, and weddings continue to take place regularly on historic plantations.[6] These changes in public opinion, though incomplete, indicate that public historians can play a part in shifting Americans' perceptions of not only plantation history but also their collective memory about African American history and other underrepresented narratives.

Historic plantations are one of the most severe examples of a dominant white culture blotting out painful historical realities and then replacing them with self-serving myths. However, in nearly all public history spaces the enduring effects of the dominance of white-controlled history, heritage, and identity have affected the interpretation of historic sites, museums, and public squares. Therefore, this volume explores the changes that public history practitioners are making in southern spaces as they reinsert or center the histories that have previously been purposefully hidden or simply ignored by dominant

American culture. These changes in interpretation and focus act as a corrective in public history spaces historically dominated by falsehoods cloaked as fact, which have been subsequently—and dangerously—absorbed as fact by the dominant collective memory of the United States.

Because there is no one-size-fits-all solution applicable to public history spaces that have excluded or continue to exclude African American voices, this volume does create a space to discuss the state of public history challenges and successes in the South. Each essay reveals how public history professionals' method of including Black voices varies depending on a list of local circumstances, including the history of the institution, the permanency of the project, funding, and established research. In examining case studies of different projects and histories, we hope to spark new conversations and add to established ones not only in the US South but also throughout the nation about accurate and inclusive history for the public. In any place with underrepresented or silenced voices, or any historic site where the narrative represents only a homogenous voice, the themes found in this volume offer models of investigating and implementing inclusive and engaging history for the public.

The work of public history practitioners and scholars in this volume is underpinned by several themes: the interplay between and imbalanced representations of hegemonic versus marginalized identities; the challenge and necessity of replacing romanticized myths with difficult historical realities; and the role of race, class, and imagined heritages in creating collective remembrances. In a few instances, nearly erasing people and overlooking material culture in the historical record and landscape has resulted in potential projects and exhibitions that are early in the process of rewriting interpretation or establishing collaborative partnerships. Other essays offer reflections on changes in public history or collective memory over time, revealing lessons learned and insights for future work. Implicit in these essays is the knowledge that the ideological perspectives of all individuals working at historic sites or archaeology sites, in museums or historic homes, create bias and affect the content that the public learns in that space and, in turn, affect how the public then creates its collective remembrance of a place, people, or history. This volume calls for readers to think about the biases within their collaborative teams as much as within their audience and acknowledge how bias, institutional racism, and systemic racism restrain, distort, or refuse to create public history that is inclusive of African American or other marginalized voices. The essays in this volume present the ways in which changes to the dominant narrative have the potential to reshape collective memory and ideas about American history and heritage.

The approaches to resolve falsehoods or tensions regarding African American representation vary across the essays based on specific factors related to

their site or project, including the cast of collaborators, how long the historic site has been open to the public, and the public's relationship to the history being presented. Collaborators range from museum professionals and scholars to community members and private owners of historic homes. Other contributors are ultimately identifying new historical actors for the public or seeking collaborative ways to change interpretation at sites currently overlooking nondominant histories and people. The contributors' projects also include collaborators whose interest and/or connection to underrepresented histories varies. The collaborators include docents, volunteers, graduate and undergraduate students, scholarly collaborators, and institutional leadership. As works by public history professionals or students, these essays remind us of the reality that project collaborators vary in their knowledge of or enthusiasm for the goal of elevating Black voices in public history. Therefore, the education of docents, student workers, and other project members is part of the discussion of some projects in this volume.

The Difficult Past and Imagined Heritages

Whether reading exhibit text, listening to a guided tour, or walking around a nature preserve with wayside signs, visitors bring their identities with them, which include seeing the world and absorbing new information through complex lenses of imagined communities and imagined heritages they chose for themselves. Therefore, in addition to working through our own biases, including the presence of previously unacknowledged prejudice and racist ideas, public history professionals who share the history of underrepresented peoples also have to navigate the biases of the local public, institutional board members, local officials, and tourists. Because American exceptionalism has historically allowed the United States to claim itself as a nation born inherently good and as the protector of the free world, many white Americans enter public history spaces with the idea that the American history presented to them will reflect the values they have internalized as "American." The idea that one's nation is inherently different and superior is, of course, a dangerous way to self-recognize, for it allows and encourages blindness toward painful and difficult past historical realities and their connections to the present. Furthermore, US history is full of examples of suppression, oppression, and enslavement, particularly when this history involves Black people or other marginalized groups. By ensuring that we understand the complex ways Americans accept and deny present and past race relations, we can better prepare for bringing Black stories to the US public.

One effect that a dominant imagined community, such as "southerners," has on dominant collective memory is the lack of space they have historically allowed for telling difficult histories in public places. In *Interpreting Difficult*

History at Museums and Historic Sites, Julie Rose describes difficult history as historical narratives that disrupt people's sense of identity and can therefore act as a psychological obstruction to accepting information that threatens or conflicts with their sense of self.[7] In the United States, histories of human suffering, then, particularly the suffering that one group inflicts on another—slavery, for example—have historically been removed or barely mentioned in public history spaces where they took place because those histories are tied to present-day local, regional, and national identities of dominant white groups. White-controlled collective memory continues to demand that we discuss only the positive aspects of American history. Hegemonic forces do not limit their attempt to control historical narratives to public history spaces, though, making the work of public historians even more challenging. As the US protests demanding race and social justice carried on through the 2020 summer, President Donald Trump threatened to withhold federal funding from public schools using the Pulitzer Prize–winning 1619 Project curriculum, considering the curriculum un-American.[8] The 1619 Project centers slavery and its legacy in American history.

It is not only in the South, then, but rather in all of the United States that slavery and its legacy are contested issues, particularly among whites. An October 2019 AP-NORC poll showed that although 54 percent of white Americans believe that the history of slavery affects Black people today, 64 percent of white Americans also oppose a public apology for slavery from the US government.[9] Whereas more than half were willing to admit that slavery has had a lasting legacy, most whites do not want a public apology that would result in admitting that slavery was wrong. With whites being the racial majority in the United States, they account for the largest number of public history practitioners and workers. This volume adds to literature illuminating the historical effect of this situation in the present, and it asks public history workers and the public to interrogate how dominant collective memory and imagined heritages are operating internally in their institution or project and externally in their public audience.[10]

The AP-NORC poll data support the anecdotal experiences of interpretive aids at sites of slavery (former plantations) in and around Charleston, where interpreters encounter the thoughts of white locals and tourists firsthand. As interpreters share with one another statements heard from all visitors, it is white audiences who reveal to the interpretive guide their unwillingness to face historical realities about slavery. Interpreters are regularly challenged by whites with statements insisting that slavery was not that bad, claiming that some plantation owners were nice to their slaves, and other statements that function as restraints or filters that white Americans use to form their collective memory about slavery. These restraints imposed by white visitors falsely

limit the suffering that whites have historically inflicted on Blacks in the United States.[11] Part of the work, then, is correcting these comments and ideas in the moment to demand that historical facts, not self-serving falsehoods, are the foundation of the narrative.

This familiar conversation among interpreters was galvanized in the dark humor of Azie Mira Dungey's comedy web series *Ask a Slave,* where Dungey reveals the way in which white tourists' questions "betray a basic ignorance about the history of slavery in the United States."[12] While working as a first-person interpreter at George Washington's Mount Vernon, she regularly en-countered questions that proved many Americans' ignorance about the facts of American slavery. In the series Dungey created the character Lizzie May, a woman enslaved by the Washington family who is used by Dungey to recreate uninformed and absurd visitor interactions, explaining to Lizzy May, for ex-ample, that slavery was a good life with room and board or asking why Lizzy May did not simply take the Underground Railroad out of slavery.[13] The visi-tors to Mount Vernon, like the tourists visiting Charleston and other southern cities, are from all over the country, and Black and marginalized people have histories that span the United States from coast to coast. Therefore, although this volume focuses on public history practiced in the South, the implications of presenting Black and other marginalized histories to the public should be considered by all pubic history practitioners in the United States. In different ways all Americans struggle with and would benefit from an increase in public history addressing slavery, its legacy, African American history, and their local histories of marginalized people.

In *Difficult Heritage: Negotiating the Nazi Past in Nuremberg and Beyond,* Sharon Macdonald notes that a history "once seen as a sign of a country's achievement may later come to be understood as a reason for regret."[14] This leaves public history spaces as a venue to change an accepted dominant col-lective memory about a contested past and change the public's response to confronting a past inclusive of difficult heritage, particularly when the public is in a phase of transition, ranges from appreciation to outrage. Online reviews of angry or perturbed visitors to historic sites of slavery implementing Black-centered narratives have recently shed light on this tension. Historically, the dominant collective memory of historic plantations nearly mirrored *Gone with the Wind's* fiction, and although the dominant collective memory is shifting, many still envision historic plantations this way—thus a collective memory in transition. For this reason, the twenty-first-century shifts in plantation his-tory narratives centering interpretation around enslaved people and slavery still result in shock for many visitors. In this state of shock and sometimes disappointment, there are two outcomes: some choose to absorb what they are learning, and others choose to deny it.

At sites such as McLeod Plantation Historic Site (MPHS), where the experiences of Black people are the central focus of interpretation, the negative reviews on a site like TripAdvisor have an identifiable theme. These visitors write that the live oaks and old house were beautiful but ruined by the lack of furniture in the house and/or the guide's insistence on talking about slavery.[15] At sites such as Magnolia Plantation and Garden, which focuses on, as the name suggests, gardens, the negative reviews called out the lack of attention that slavery received in the overall interpretation, with one reviewer angry that a docent made the claim that enslaved people were never whipped.[16] Thus, the public's reason for a negative review of a historic site of slavery varies, with some wanting more historically factual narratives and others wanting myths, gardens, and antiques. The evidence is clear, though, that many in the public do want to learn the history of a place, even when they express that the learning experience was difficult or even gut-wrenching. As of February 2020, with more than one thousand reviews on TripAdvisor, MPHS has overwhelmingly positive reviews, with 92 percent of people rating their experience as "excellent" or "very good." If you are part of a historic site or public history project considering more inclusive and accurate history, these positive reactions are quantitative evidence proving the public's interest in histories with complex and painful narratives, and this volume shares numerous ways in which these narratives can be centered in new projects or incorporated in existing public history spaces.

These positive reactions do not come only from people who arrived to the site believing the history of slavery should be told, but they also include those who had previously internalized the myth of the romantic southern plantation as historical fact. For the latter, sites interpreting the experiences and history of enslaved people help humanize the people of the past in a profound way. At the close of a tour at a Charleston-area plantation, one woman explained to her interpreter that she had just learned on the tour that enslaved people had children. The visitor went on to explain her confounding statement: "Well, I knew that, but I never thought of them as being mothers and fathers."[17] For this visitor, as she recognized the humanity of enslaved people, she was able to immediately begin reshaping her collective memory about slavery. There is also evidence that visitors do not always shift their thinking or find new humanity in a group of historical people while they are on a tour or in a space where they are engaging with terrifying or painful histories. Shifts in visitors' thinking and collective memory can take place long after leaving the learning experience. Some visitors who were initially angry at what they heard went on to acknowledge their shift in feelings and collective memory years later. One such person felt trapped in being subjected to the horrible, painful stories of the enslaved when they were expecting a pleasant stroll down an oak allée.

However, two years later, they wrote a letter of thanks to the historic site's head interpreter, thanking them for the experience and specifically expressing that the tour ultimately changed their view of the history of slavery and its legacy.[18]

Whether immediate epiphany or years in the making, these anecdotes and data from visitors' reviews support the idea that many in the public are interested in engaging with the difficult histories and heritages that address slavery, its legacy, and race relations. On the other hand, individual and institutional racism, racial violence, and the murder of Black Americans, along with data from surveys such as the AP-NORC poll and racist statements made at every level of political leadership in the nation, stand as strong evidence that there is an enormous need in the United States for public history professionals to correct the fallacies found in the dominant collective memory of slavery and its legacy.

Collective memories and imagined heritages—whether those of dominant or nondominant groups—are reinforced, countered, or corrected at cultural heritage sites, national and state parks, museums, and in all other public history spaces. Imagined heritages, as with Benedict Anderson's imagined communities, are in part imagined because those who identify with a heritage do not all meet one another and do not emphasize the same aspects of their heritage as the most important. People who identify with an imagined heritage are also not always as committed to the truth as they are to forming an emotional connection with the others who also identify with the same imagined heritage.

The formation of that heritage and collective memory has the ability to be shaped or reshaped at public history sites through imagination and remembering. In "Cultural Heritage and Public Folklore: Tales of Tradition," Gregory Hansen explains that irrespective of facts or falsehoods, "The process of imagining these connections can both distort and enhance our understand of historical sites."[19] This places weighty responsibility on public history practitioners to responsibly use the tool of imagination because the stories invoked can become fact in the mind of the visitor. Hansen specifically addresses historical sites and buildings, but the process of creating an imagined heritage and building upon collective memory has the capacity to takes place in all public spaces. Because public history and cultural heritage workers can use human imagination as a tool to assist the public in creating connections to the past to either reinforce or correct damaging and false collective memories, the decision of what to include or leave out of interpretation is an ethical one.

This volume views the inclusion of underrepresented history in public history as a moral imperative because these are sites where the public is crafting

collective memory that shapes its ideas about communities of people. In *The Ethics of Memory*, Avishai Margalit poses a question: why we should remember "moral nightmares," such as American slavery? He points to the ethical activity of remembering history: "The source of obligation to remember . . . comes from the effort of radical evil forces to undermine morality itself by, among other means, rewriting the past and controlling collective memory."[20] The essays in this volume explore the experiences of practitioners working with and for groups that have traditionally controlled the collective memory of various geographies. In some cases the practitioners are complicating spaces where people of the dominant group largely subscribe to the historically accepted collective memory of slavery and African American history and then through interpretation reveal historical facts and exclude the falsehoods that come with imagined heritages. Others essays are also calling for certain types of spaces, such as federal and state parks, to stop excluding Black history by focusing solely on natural (e.g., environmental and ecological) interpretation.

Uncomplicated interpretation and historical narratives are signs of histories that demand further inquiry. "Good historical thinking," the National Council on Public History says, "seldom provides easy answers or lessons. But it can help clarify what's at stake. . . ."[21] History workers help the public better understand the world they live in. They assist in shaping ideas about heritage and historical remembrances, and they can reform, even transform, worldviews through more inclusive and ethically narrated histories. Though living in the time of open acceptance and perpetuation of the concept of "alternative facts," we hope that this volume sparks public history workers' investigations into historical narratives to find their own nontruths and that practitioners, historians, and other scholars see one another as collaborators in their work. Essays in this volume seek future collaborators, share new voices, and reveal effective methods and models, all with the ongoing goal of centering African American history for the public. We are hopeful that this volume will spark further collaboration not only among these groups but with K–12 teachers, community leaders and institutions, and students.

The editors of this volume, all of whom have been engaged in public history work in Charleston, have observed and participated in this shift in the Lowcountry's public history representation of African American history. John White started the Lowcountry Digital History Initiative (LDHI) with Mary Battle, a digital history project that was, in part, a reaction to events such as the Secessionist Gala, which celebrated the 150th anniversary of South Carolina's secession. An absurdist nightmare that rendered historical realities meaningless, the Secessionist Gala was run by organizers who denied that

their celebration of secession had anything to do with slavery. Instead of historical documents, they leaned on the fiction of the Lost Cause, propping up their mythologized heritage and denying the gala's explicit connection to the enslavement of Black people. This type of blatant disregard of historical fact is being corrected by public history projects. For example, in response to the mass murders of the nine church attendees at Charleston's Emanuel AME Church, Patricia Williams-Lessane and Conseula Francis worked with John White on the College of Charleston's campus to start the Race and Social Justice Initiative (RSJI). The mission of the five-year-old initiative is to promote awareness and dialogue about race and social justice issues in Charleston, the Lowcountry, and beyond. Leah Worthington was a graduate assistant at two sites on the College of Charleston's campus—LDHI and the Avery Research Center for African American History and Culture—before working as an interpreter at McLeod Plantation Historic Site. Her interaction with thousands of visitors along with her research focused on underrepresented history has assisted in guiding her current work as codirector of LDHI. Two of Rachel Donaldson's research areas, historic preservation and labor history, converged in her work as a public history practitioner in Charleston. Donaldson has been working with local majority-Black labor organizations to raise awareness about sites of labor in Charleston.[22]

Although changes in the response to encountering Black history in Charleston have been slow, seeming to go in fits and starts, public history practitioners, cultural heritage workers, and members of the tourism industry have laid the groundwork and are committed to including and centering African American and other underrepresented voices. These highlights are not comprehensive, but they serve to illustrate the broader context that a southern city such as Charleston has experienced up to this point. The Old Slave Mart Museum has been a bastion of unmythologized educational information about the Middle Passage, enslaved people, and Charleston slave sellers since the 1930s, and its doors remain open today. Drayton Hall, a historic plantation, is notable for its early 2000s debut of "Connections: From Africa to America," a tour that specifically interpreted slavery and the experiences of enslaved people. In 2015 McLeod Plantation Historic Site opened as the first Charleston-area historic plantation site that centers interpretation on enslaved and free African Americans.[23] A final example of public history sites and workers who have been centering Black voices is Joseph McGill's public history and preservation work through the Slave Dwelling Project. His mission is the preservation and increased awareness of slave dwellings and seeing changes in the narrative of American history and the legacy of slavery. Starting in 2016, his commitment to preserving and interpreting enslaved people's experiences has been accomplished through overnight stays in dwellings identified as homes

of enslaved people.[24] These public history projects and historic sites serve as examples of the ongoing efforts to center African American history in Charleston, the stepping-stones to where we are now that have inspired conversations among both the public and academics.

As Charleston-area residents and members of the College of Charleston's campus community, we have also observed academics with traditional department appointments cross into public history work in an effort to shift the collective memory of the Lowcountry. Charleston is a small city that now receives more than seven million tourists a year who come to see this quaint, beautifully historic place. However, tourists have traditionally received fiction rather than history, so public history practitioners have joined with scholars to provide clear historical analysis to correct the myth of the romantic South and contribute to the increase in African American representations throughout the city. For example, in teaching the Foundations of Education course at the College of Charleston in 2016, Jon Hale, a professor of education who specializes in teaching the history of education in the civil rights era, began a conversation with students about working toward a historical marker for the famous African American educator and activist Septima Clark. With many collaborators across campus, Hale was able to leverage his scholarship into a public history project, and the historical marker was unveiled in May 2018.[25] Hale also collaborated with the LDHI as author of an exhibit about the history of a local Black high school and its student activists, *A History of Burke High School in Charleston, South Carolina since 1894*.[26]

Far away from the Lowcountry, Stephanie Yuhl, of the College of the Holy Cross and Harvard Graduate School of Design, wrote *Golden Haze of Memory: The Making of Historic Charleston*. For interpreters and tour guides, Yuhl's scholarship put weight behind the discussions between public history workers and their audiences—tourists or locals—about the historical realities of Charleston versus the moonlight and magnolias myths.[27] In addition to providing scholarship useful to those working at cultural heritage sites, Yuhl also sought out collaboration on public history projects by partnering with LDHI on a digital exhibit where she worked with artists, scholars, and the Gibbes Museum of Art. In addition to the exhibit, she organized a panel discussion at the Gibbes to discuss race and art in museums. Scholars with traditional academic appointments, such as Hale and Yuhl, are a few examples of those who started or joined public history projects in Charleston.

The volume is organized into three parts: "Finding New Stories," "Seeking Collaborations," and "Thinking Back/Looking Forward." The contributors discuss their research and work in the Lowcountry and throughout the South. From early career to (theoretical) retirement, these practitioners shed light on the subject of public history today.

Finding New Stories

In "They Wore White and Prayed to the East: The Material Legacy of Enslaved Muslims in Early America," Ayla Amon brings forward a group of enslaved people who have been obscured in the historical record and often erased from public history. In discussing enslaved African Muslim's history and cultures, her essay reveals not only a topic but also methods for investigating their underrepresented history. To illuminate the range of religions and cultures that enslaved people carried with them, this essay shares how the Smithsonian's National Museum of African American History and Culture updated early African American identity to include Muslim identities that were previously unexplored. The identities of enslaved Muslims were often obscured by a combination of ignorance and uninterest on the part of white slave traders and enslavers, yet can still be found in historical documents. With the near-erasure in the collective memory of Americans regarding enslaved African Muslims, finding material culture and sources can be difficult. However, this chapter explores how interpretation can still occur, even when the subjects of interpretation are largely silenced in the historical record.

For archaeologists, interpreters of waterfront sites, and practitioners interpreting slavery that occurred near waterways, Edward Salo's "More Than Just a Way across the Water: The Identification, Preservation, and Commemoration of Ferry Sites in South Carolina," discusses ferry-landing sites and ferryboats as an unexplored cultural resource. Plats and remnants at ferry-landing sites from the colonial and antebellum eras open up possibilities to mark their history for the public. Because antebellum ferries were often operated by enslaved people, Salo discusses how the ferries became spaces for enslaved people to potentially increase their independence. He is one of the volume's contributors whose work examines nontraditional spaces to interpret Black history before the Civil War. In removing enslaved people from an agricultural field—where they are so often fixed in America's collective memory—and onto the water, this chapter raises questions: How are interpretations of enslaved people's lives limited by restricting their historical landscape to the fields? Also, how might cross-disciplinary scholarship and projects put more people in conversation with one another to yield higher results when interpreting underrepresented histories?

In examining the landscape for largely ignored history, scholars have also begun to identify new spaces in which to interpret the lives of marginalized historical actors. Natural landscapes such as swamps do not make many Americans immediately think of the history of slavery—or perhaps of any history at all. In "Power, Representation, and Memory in the Great Dismal

Swamp," Kathryn Benjamin Golden discusses a swamp that was once a safe haven and home for Africans who escaped slavery. However, signage regarding this incredibly important narrative of resistance is largely absent in federal and state parks, whose interpretive focus is ecology and environmental education. Benjamin Golden discusses how the ownership of land and of the interpretive focus is used to sidestep interpreting history that challenges collective memory. In discussing how parks approach interpreting Black resistance, Benjamin Golden makes the case for those working in local, state, and federal parks and conservancies to collaborate with scholars and public historians so that interpretation does not erase Black history at their site.

Seeking Collaborations

Moving indoors to historic homes, Jodi Skipper's "Hidden in Plain Sight: Contested Histories and Urban Slavery in Mississippi" discusses the success and challenges of correcting public history narratives that are directly negatively affected by dominant white collective memory based on mythologies like the Lost Cause. In Skipper's project, Behind the Big House, she worked collaboratively to put an entirely new tour into action alongside, and as a counter to, an already existing annual house tour in a Mississippi town. Notably, this project takes place in a landscape that does not frequently interpret slavery: a town rather than a rural space or a city. Skipper's project also presents an example of leveraging the popularity of an existing, separate history and garden tour for locals and tourists to draw people into a new tour that demands they reconsider the spaces they are learning about. She also reflects on the questions answered as much as the questions that she hopes to answer through the continuation of the project.

Leah Worthington discusses the permanent and ongoing collaborations of a digital public history project, the Lowcountry Digital History Initiative, housed in the College of Charleston Libraries. In "Creating and Maintaining Digital Public History: The Lowcountry Digital History Initiative," Worthington explores methods and collaborative efforts to create digital content with scholarly experts from around the world, campus partnerships, community partners, and graduate students. In addition to providing insight into how the five-year-old digital project continues to operate, she discusses the utility of a digital platform designed to focus on local and regional histories, how social media is used as an arm of the project's efforts to reach the local public, and how graduate students can successfully learn from and assist with digital public history projects. It also serves as an example of public history successfully centering underrepresented history.

Thinking Back, Looking Forward

Long-standing institutions often come with histories that fall short of meeting the standards we set today for public history practice or are sometimes directly at odds with modern public history and historic preservation standards. In "The Ansonborough Project: Lessons in Historic Preservation," Ashley Hollinshead explores the history of past preservation practices of the Historic Charleston Foundation, the effects of those practices, and the changes the institution has made over time. City planners, preservationists, and practitioners who work with histories of gentrification and the erasure of Black neighborhoods will find the lessons learned in this essay to be a useful guide. Continuing into the present, Hollinshead also discusses some of the changes that the Historic Charleston Foundation has made by looking at its current preservation practices and philosophies. These efforts act as a first step in undoing the erasure of Black people and their history in Charleston. It also signals a model for change and explores changes taking place in southern institutions that seek to examine and redefine their mission.

Peter Wood's reflections on Black and white Charlestonians' memories from the 1970s to the present is unique in its examination of collective memories over fifty years. In "'A Thin Neck in the Hourglass': Looking Back at Charleston Harbor from Colorado . . . and Looking Forward," Wood discusses the state of public history in 1974, the bicentennial of the Stono Rebellion, when few Carolinians had heard of the event, and present-day actions by the local government toward Confederate statues. In the process he delves into how historians and K–12 educators living in Colorado, more than a thousand miles from the land of the thirteen colonies, "could effectively teach about enslavement and its consequences." The essay provides an example of collaboration between an academic historian and K–12 teachers living in Colorado, and in so doing, Wood helps readers consider the importance of collaborating with educators of children. He also provides insight into the types of difficult histories that young people are being taught and how those histories might shape their worldview. In examining the past and present, Wood provides space to consider where we have come from as well as how things might look in the future as we plan our next public history collaborations.

What is next, then, for public history? As protestors have filled the streets of American cities demanding monuments of racism be torn down while counterprotestors have demanded that the monuments remain, the United States appears at war with itself over its collective memory, struggling to settle on an agreed-upon past. How will we direct our local historic sites to tell the messy,

difficult, and inclusive histories that challenge the public to contend with American history? As public history professionals, we know that the sites, museums, parks, and public squares are filled with historic symbols and stories. The experiences not only of Black Americans but also of Latinx and Asian Americans, of immigrant communities, of women, of LGBTQ+ communities, and of working-class communities are always embedded in our local histories and identities because the United States is a country rooted in diversity. This volume discusses several examples of where and how some of these histories are being revealed, providing models, presenting challenges and successes, and inviting collaboration. We also know from our own experiences that the work requires active introspection to first contend with our own biases before we can best navigate the biases of our audiences. In sharing the work taking place in our own local spaces, we also ask you to examine the work accomplished in your space. Is your site full of kinetic or potential history? Have you identified the lesser-known historical actors and events at your site? And how can your history be told more accurately and inclusively so that collective memory is shaped by all of America's experiences and people? The work cannot be left to those pedaling myths as history for entertainment, personal comfort, or political gain; rather, it must be carried out by people whose primary work centers on bringing history to the public.

In the midst of the 2020 protests, the John C. Calhoun monument in Charleston's central square came down. The man who infamously called slavery "a positive good" has been celebrated by white Charlestonians since before the Civil War. The event drew a crowd, and as Calhoun was removed from his one hundred-foot-high pedestal, many were brought to tears while others sang and laughed with joy. Black Charlestonians described him as a looming presence finally removed.[28] For more than a century, whites shaped the dominant collective memory of Calhoun, as with too many other aspects of American history, by unethical mythologizing and violent forgetting. We hope this volume contributes to your local conversations about underrepresented histories and supports your engagement in ethical public history work, illuminating the painful as well as the triumphant histories of Black Americans and reshaping the nation's collective memory to reflect actual historical realities.

PART I
Finding New Stories

They Wore White and Prayed to the East

The Material Legacy of Enslaved Muslims in Early America

AYLA AMON

On the night of August 29, 1810, under a new moon, a man looked up at a "house" and let out a sigh of relief. After traveling more than two hundred miles on foot from Charleston, South Carolina, to Fayetteville, North Carolina, he had found a place where he could safely stop to pray. A young man riding by the church saw a lone Black man enter the building. He immediately rode into town to tell his father, who returned with another man and their dogs to take the Black man to the Cumberland County Jail as a runaway slave.[1] Although the man barely spoke English, he was able to write "from right to left" in an unknown language, and he used pieces of charcoal from the fireplace to scrawl messages on his cell walls and floor.[2] None of the curious local citizens could read the words he wrote, yet they flocked to see this mysterious "conjurer" in his jail cell.[3] The language he wrote was Arabic, and the man was Omar ibn Sayyid.[4] Sayyid was one of thousands of enslaved Muslims forcibly migrated to the United States during the transatlantic slave trade, although their early presence in North America has been largely unexplored. Even less frequently discussed are the objects used and created by these enslaved people, objects that turned the confines of slavery into a space of resistance to capture, enslavement, and regulation.

Enslaved African Muslims occupied two distinct, yet related, modes of being in early American history: they existed in both utter obscurity and were prominently known in certain social circles. Travelers' notebooks, plantation and court records, newspaper articles, and runaway notices, among other documents, are filled with confused and unknowing references to the enslaved who were practicing Islam in early America. Observers called the faith practices they witnessed "animist," "pagan," and "African" but almost never

connected them to Islam; they noted "strange" methods of dress and "peculiar" dietary choices but usually failed to mention Allah or Muhammad. Perhaps their most striking oversight was seeing an enslaved person write in Arabic and dismissing it as "strange characters" or "nonsense." This lack of religious and cultural recognition of Islam was not solely a phenomenon among white society, however. Charles Ball, a self-liberated man, noted in 1837 that "I knew several [people] who must have been, from what I have since learned, Mohamedans; though at that time, I had never heard of the religion of Mohamed. There was one man on this plantation, who prayed five times every day, always turning his face to the east, when in the performance of his devotion."[5]

Conversely, numerous Muslim men and women became local or even national celebrities who were subsumed into American folklore as known Muslims, including S'Quash, Osman of the Dismal Swamp, and "Old Hamedy."[6] Others became the focus of spectacle and were made to perform their religion or write for the amusement of the public. As Joseph LeConte remembered of a man named Philip, "He used to tell us all about the customs and religion of the country from which he came. He was not a pagan, but a Mohammedan. He greatly interested us by going through all the prayers and prostrations of his native country."[7] And William Caruthers recounted meeting a "tall, bald-headed old fellow" named Charno who wrote a specimen beginning "on the right side of the page . . . in Arabic."[8] Even those outside of the legends saw their true lived histories augmented, made increasingly error ridden, or romanticized for a variety of propagandistic purposes, including the purported beneficent largesse of the American Colonization Society.[9] In the retelling, these men and women were endowed with agency, power, privilege, and even royal family histories they did not have; most importantly, they became the property of indulgent enslavers who acted as a foil to the stereotypic brutal southern master for white apologists of slavery.

Neither in their celebrity nor relative obscurity, however, were the enslaved Muslims connected distinctly or definitively to the traditions of Islam in a way that provided Islam a space within the religious history of early America. Additionally, these two ways of (not) considering Islam in America contribute to a striking historical deficit: they render the associated material culture mute, severely limiting perceptions of the faith practices of the enslaved among researchers today. This dearth of knowledge gave rise to two interrelated narratives. First, that enslaved persons were brought to American shores as blank slates, without religious or cultural practice of their own, and were converted to and practiced Christianity exclusively.[10] Second, that Islam and Muslims are recent arrivals in America who in no way helped shape or develop the country. This functionally negates a cultural and religious connection to western Africa for enslaved persons (whether Muslim or non-Muslim): they are not

represented with their full legacies in public discourse and at historical sites, and their lives are explored only after they survived the Middle Passage. In turn, it also fosters an attitude about Islam that constructs it as a religion of the "other," outside consideration as part of the religious fabric of America and, in the wake of September 11, 2001, a religion that has no part in American life. By including Islam at the very foundations of religious experience among the enslaved, we are both returning lived histories to those enslaved and returning an integral place in the formation of the United States to Muslims.

Given that no comprehensive data concerning the Muslim population were ever recorded, how can we attempt to reconstruct not only the size of the community but also the lived experience of these enslaved Muslims? Scholars must mine historical documentation for hints of their presence, examine extant pieces of material culture (including documents, textiles, and beads) for insights into their daily lives and practices, and look to living traditions today that shine a light on these communities. This essay aims to reconnect the material remnants of early Muslims with the practice of Islam and to propose a new method of public interpretation of the objects, primarily in museums. First, it briefly notes the historical context in which enslaved Muslims lived and worshipped, exploring the sources that should be reexamined for evidence of Islam. It then reassociates extant objects with Islam by using eyewitness accounts, oral histories, and, most importantly, the words of the enslaved themselves. Third, it conjectures as to why these objects have not been historically recognized. Finally, it proposes a model for integrating enslaved Muslims into museum exhibitions, using the National Museum of African American History and Culture's *Slavery and Freedom* exhibition as a case study.

Historical Context

By the beginning of the transatlantic slave trade, Islam had spread throughout sub-Saharan and western Africa, including forming majorities or large minorities in six regions that accounted for the majority of the enslaved transported to North America: Senegambia, Sierra Leone, the Windward Coast, the Gold Coast, the Bight of Benin, and the Bight of Biafra.[11] It is estimated that potentially 15–20 percent or more of the enslaved brought to North America were Muslim and that a much greater number were familiar with Islam.[12] However, our estimates are complicated by the fact that "no attention whatever [was] paid to the religion of the slaves."[13] Neither slave dealers nor trade companies kept records of the religion of their captives, paralleling a similar disregard by purchasers in North America for the religion of their new "merchandise."

However, the historical record reveals that, at least occasionally, some of those involved in the transatlantic trade did recognize Islam among enslaved

captives. For example, British abolitionist C. B. Wadstrom, recounting the slave trade in Sierra Leone, stated, "[On the ship] I saw a man about 35 years old in irons. He was a Mahometan, and could read and write Arabick. He was occasionally noisy; sometimes he would sing a melancholy song, then he would utter an earnest prayer, and then would observe a dead silence."[14] This striking account preserves for posterity a snapshot of an enslaved Muslim who, despite the overwhelming nature of the circumstances around him, maintained his religious devotion. It is likely that the "melancholy song" the witness describes is the *adhan,* or call to prayer, followed by *salat,* ritual prostrations. Despite this ardent practice and even acknowledgment of Islam on the coast of Africa, this man's religion was never written down before he was shipped to the New World, his actions were never concretely connected to his faith, and his religion was lost to the sea.[15]

Similarly, ideas regarding Islam and Muslims on American shores were both common and incorrect. Inflammatory ideas about Muslims and Islam were propagated throughout America by various European and colonial writers who set up the barbarism of Islam against their own religious and political freedoms. Largely fueled by beliefs surrounding the Ottoman Empire and the Barbary pirates, misinformation about Islam infiltrated popular American entertainment, including a popular 1742 play by Voltaire that quipped, "The sword and the Alcoran in my bloody hands, / Impose silence on the rest of humanity."[16] The play, first performed for and by soldiers on both sides of the American Revolutionary conflict, was filled with prejudice against a faith that most Americans hardly knew. Staged until the early nineteenth century for popular audiences, the play presents as an "artifact of European Orientalism" that contrasted with the truthful representations of Islam occurring unacknowledged among enslaved Muslims.[17] Made for mass consumerism, this incorrect presentation of Islam also found its way onto the American political stage, where entire constitutional debates in 1788 centered on the necessity of religious testing to hold public office and even the fear that a Muslim might someday be president.[18]

Other statesmen, however, at least nominally attempted to fight religious intolerance against Islam. Thomas Jefferson's purchase of a Qur'an as a law student influenced his writing of foundational American documents, and Jefferson acknowledged the importance of the text as a source of Islamic law as well as a symbol of early religious pluralism. He noted of the 1779 Bill for Establishing Religious Freedom that it was "meant to comprehend, within the mantle of it's [sic] protection, the Jew and the Gentile, the Christian and Mahometan, the Hindoo and infidel of every denomination."[19] Unfortunately, the final language removed explicit reference to non-Christian groups: "Our civil rights have no dependence on our religious opinions."[20] Another statesman,

Richard Henry Lee, pushed even further for equality in a letter to James Madison: "True freedom embraces the Mahomitan and the Gentoo [Hindu] as well as the Christian religion."[21]

The great irony in these statements is that the Muslims who American intellectuals and politicians were discussing were largely imagined Muslims from elsewhere. They recalled a diplomatic agreement with the Sultan of Morocco (the Treaty of Marrakesh) in 1786, the Barbary pirates with whom Jefferson negotiated a truce from 1805 to 1806, the Ottoman "barbarians" who resisted the civilizing influence of Christianity, and the enslaved Muslims who were revolting throughout Central and South America beginning in the sixteenth century.[22] But there was little to no recognition of the enslaved Muslims spread throughout North America, even those who were owned by such champions of religious tolerance as Jefferson and Washington. Their knowledge of and theoretical openness to Islam did not stop them from enslaving African Muslims.

Sources

One of the ways we can attempt to trace the Muslim presence in early America is through the names recorded in enslavers' records and inventories, on bills of sale, or in runaway notices. Although Islamic names do not concretely prove that a person was a practicing Muslim, certain names from the Qur'an strongly suggest Muslim faith or heritage.[23] George Washington, for example, on both a 1774 tithables list and a 1786 list of enslaved at Mount Vernon notes that he owns two women, "Fatimer" and "little Fatimer," likely a misspelling of the common Muslim name Fatima, the Prophet's daughter.[24] The *Georgia Gazette* ran a notice on May 24, 1775, for three missing men, including twenty-two-year-old Sambo "of the Moorish country" (that is, North Africa). Sambo was a common corruption of *Samba,* meaning "second son" in the Pulaar language of the Fulbe people, many of whom were Muslim; the addition of the descriptor "Moorish" strongly suggests that he was Muslim.[25] An 1816 slave register from the John Stapleton Plantation in South Carolina includes Dido the "Moroccan"; Mamoodie and his wife, Eleanor, who had a daughter named Fatima; and Sambo, who was "African born," perhaps outlining a Muslim community on that plantation.[26] Additionally, "A MOOR SLAVE MAN, about 25 years of age, named MAHOMET" ran away in Savannah in 1792.[27] Colonial documents from Louisiana also include numerous Islamic names, some followed by the word *Baraca,* likely an alteration of the Arabic *baraka,* a blessing or spiritual presence that flows from Allah; it was perhaps appended to their names in connection to a western African Sufi cult or meant as a form of protective talisman during their enslavement.[28] Other names that appear frequently in such records and suggest or evidence a Muslim link include Bullaly or Bilali;

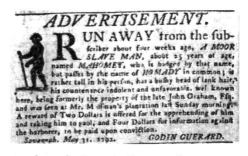

Runaway notice from the Georgia Gazette, *June 7, 1792, showing the self-liberation of an enslaved man named "Mahomet." (Courtesy of Special Collections and Rare Books, University of Missouri Libraries)*

Solomon; Mamadou or Muhammad; Naailah or Nila; Hammett, Hamed, or Ahmed; Moustafa; Moosa or Musa; and Salem or Salam.[29]

However, relying solely on names as an indicator of religious affiliation can underestimate the number of Muslims present in America. Although many Muslims persisted in keeping their given names after arrival, others were given Christian names by their enslavers. Salih Bilali was called "Tom" upon arrival on St. Simon's Island, Lamine Kebe became "Paul," Muhammadu Aishatu became "Philip Finlay," Muhammad Kaba Saghanughu shifted to "Robert Peart," and a self-liberated man was identified in a Savannah runaway notice as "JEF-FRAY, sometimes BRAM or IBRAHIM," the latter likely his given name.[30] Still others saw their names almost unrecognizably anglicized: Bilali Muhammad became "Ben Ali," Yusuf ben Ali became "Joseph Benhaley," and Ayuba Suleiman Diallo became "Job ben Solomon." Omar ibn Sayyid's name was both anglicized, as "Moro," and turned francophone: he became "Moreau." Other common translations of Muslim names into English include Dawda to David, Ayuba to Jacob or Job, Musa to Moses, and Ibrahim to Abraham.[31] These name adaptations and changes reinforce the argument that Qur'anic and Islamic names alone do not give a fair measure of the size of Muslim communities.

Additionally, references to Muslims appear in bills of sale, runaway notices, and other documents produced by white society under ethnic and cultural affiliations, both real and imagined. These include Malé, Manding, Fulani/Fullah, Hausa, Wolof, Vai, Yoruba, and their numerous spelling variations, among others.[32] Example runaway notices list a "Sambo," who was "of the Fulla country," and "Moosa . . . of the Fullah Country."[33] The combination of their names and the association with "Fullah country" strongly suggests that they were practicing Muslims at the time of their enslavement, even if the writers of the runaway notices did not explicitly make the connection. British traveler John

Stewart plainly links Islam and the Manding, however, when he derisively writes that "the Mandingoes are a sort of Mahomedans, though they are too ignorant to understand anything of the Alcoran, or of the true nature of their religion: some of them, however, can scrawl a few rude Arabic characters, but without understanding or being able to explain much of their meaning. Probably they are scraps from the Alcoran which they have been taught by their imams, or priests."[34] For Stewart, it was clear that the Manding ethnicity and Muslim religious identity were linked, and they were often conflated to the extent that one term necessarily implied the other in written documentation.[35]

These records also fantastically associated enslaved Muslims with geographic locations, especially North Africa, which implied a Muslim heritage. This was most often symbolized by the word "Moor."[36] As mentioned above, Sambo was "of the Moorish country," an ancestry also claimed by or grafted onto Ibrahim Abd ar-Rahman, Anthony Jansen Van Salee, and Selim of Virginia.[37] S'Quash was described by a ship captain as having "clear-cut, aquiline features [that] were extremely dark, like a Moor, and his straight black hair and beard . . . were not kinky. *He was obviously not a Negro.*" The captain insisted that S'Quash was in fact an Arab slave trader, and a descendant of S'Quash's purchaser maintained this history, noting that he was "an Arab of a family long educated of his day and class in that he had been to Cairo and could read Greek as well as Arabic."[38] This connection with Arabic and North Africa was seen as a marvel that "endowed [the enslaved person] with independent and impressive cultural glamour" that created an amplified stratification within the enslaved population.[39] This exotic association would, of course, also reflect well on the worldliness of the enslaver. Aside from ethnic affiliations, runaway notices also list African points of departure (e.g., Gambia, Guinea, or Senegal) where there were significant Muslim populations.[40] Ethnic affiliations, geographic associations, or last location on the African continent do not conclusively prove Muslim identity, but the spread of Islam in western Africa, combined with the tendency of American slaveholders to conflate ethnicity with place of origin or departure, increases the probability that many of the enslaved mentioned were Muslim.

Even more illuminating than the sources produced by white society are the documents produced by the enslaved themselves. Some of them left behind written documents and letters in Arabic that contain Qur'anic quotations, autobiographical information, philosophical treatises, and daily observations. They even occasionally contain requests to return to Africa, as when Omar ibn Sayyid wrote in an 1819 letter to John Owen, "Indeed I wish to be seen [again] in our land called Africa in a place of the sea/river called Gambia."[41] However, many of Sayyid's documents are mislabeled with titles such as "23rd Psalm" or "The Lord's Prayer," disguising their actual contents. For example, one work

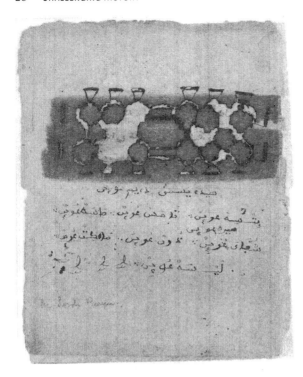

This document, mislabeled "The Lord's Prayer," is actually a list of the Owen family, who enslaved Omar ibn Sayyid until his death. It lists Jim and Martha Owen and their children Thomas, Betsy, Margaret, John, Mary, Sophia, and Eliza. (Courtesy of State Archives of North Carolina, PC.812)

labeled "The Lord's Prayer" is actually a list of members of the family that enslaved him.[42] Sayyid was not the only enslaved person who encouraged or allowed the misrepresentation of his writings, although others were perhaps more blatantly duplicitous in this process. For example, Abd ar-Rahman sold written copies of al-Fātiha in an effort to raise funds to free his wife and children, but he told the recipients he was writing them "The Lord's Prayer."[43] The ability to write in Arabic, a largely unknown language in the United States at this time, offered discreet advantages in choosing content, expressing views, and disseminating beliefs. The writer could profess loyalty and love to Allah at a time when conversion to Christianity was taken for granted or forced, condemn slavery through Qur'anic verses, and subvert their enslaver's commands using a foreign language.[44]

By far, the least-studied sources for recognizing enslaved Muslims in America are the objects they used to enact their faith. These enslaved Muslims share, of course, in the general material culture of enslavement: whips, shackles, containers for food, objects of daily life, and tools. But they also created and used distinctive objects for their religious practices. Numerous sources mention "little mats," undoubtedly prayer rugs, and "beads" held in the hands while praying, surely *misbaha*. In a late-1930s WPA interview, Katie Brown

recalled of her great-grandfather that "Bilali and his wife Phoebe pray on the bead. . . . They bow to the sun and have [a] little mat to kneel on. The beads is on a long string. Bilali he pull bead and he say, 'Belambi, Hakabara, Mahamadu.' Phoebe she say, 'Ameen, Ameen.'"[45] Yarrow Mamout, of Georgetown, also reportedly used a prayer mat, which he may have been buried with.[46] However, to my knowledge no documented rugs or beads have ever been specifically associated with Islamic practice among the enslaved, and excavated objects should be reevaluated as more is learned about the lives of people on plantations and at the archaeological sites where the objects were found.

Bilali, a resident of Sapelo Island, Georgia, routinely carried something else that marked his devotion and was seen as essential to Islam: a Qur'an.[47] Some enslaved were said to have carried their Qur'ans with them across the Middle Passage; a few, including Omar ibn Sayyid and Salih Bilali, managed to secure Qur'ans (in both Arabic and English) after arrival in the United States, in part through the American Colonization Society.[48] Others wrote their own or significant portions of it, including a "negro slave of Capt. David Anderson," Charles Larten, Ibrahim Abd ar-Rahman, and Ayuba Suleiman Diallo.[49] Additionally, a French traveler references a "Mandingo . . . Caucasian man of Africa . . . [who] will uncover for you forgotten or original versions of the Qur'an."[50] Sources also note the presence of Qur'anic amulets among the enslaved, often inscriptions written on paper or parchment, worn around the neck or on the body in leather or cloth pouches.[51] These amulets were used to protect the self and the family, as well as to grant success to those self-liberating.[52] Two fascinating eighteenth-century examples show both the geographic spread of amulets and the continuity of their contents across forms. The first, carried from Saint-Domingue to Philadelphia by Pierre Eugène du Simitière in 1774, begins with the Bismillah followed by Surah al-Ikhlâs (112). Although the object was not produced in Philadelphia, it would have been familiar to the Black residents there, as is evidenced by a small, eighteenth-century metal amulet found at Fort Shirley, located roughly 150 miles to the west. This diminutive charm features the phrase "No god but Allah," part of the Shahada.[53]

Finally, enslaved Muslims were often noted for their unique clothing, such as "flowing . . . tunics," "robes," "wide pants," and "shawls" in conjunction with "turbans" or caps "resembling Turkish fezzes" for men and "loose white cloths" or veils for women, almost all of this garb in a cloth of "dazzling whiteness."[54] Numerous paintings and images from the time showcase these characteristic garments, including a 1733 painting of Ayuba Suleiman Diallo by William Hoare in which Diallo requested to be painted "in his own Country Dress."[55] The result was a striking portrait showing Diallo in a white turban and tunic with a Qur'an hanging around his neck. Omar ibn Sayyid also appears in

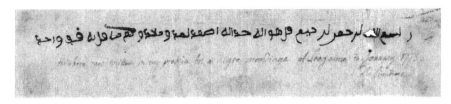

An educated Muslim priest enslaved in Léogâne, Saint-Domingue, created this amulet in 1773 for a Swiss-born naturalist named Pierre Eugène du Simitière; who brought it to Philadelphia. It is inscribed with the Bismillah and Surah al-Ikhlâs (112): "In the name of God, Most Gracious, Most Merciful Say, 'He is Allah, [who is] One, Allah, the Eternal Refuge. He neither begets nor is born, Nor is there to Him any equivalent.'" (Arabic Fragment, 1773, Box 10, Folder 4, 961.F.5d, Pierre Eugène du Simitière Collection, 1492–1784, Library Company of Philadelphia)

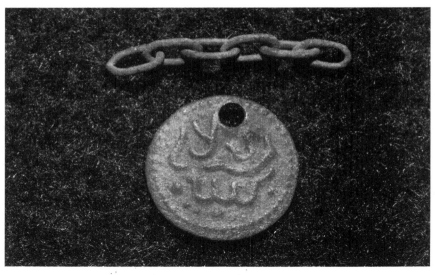

This diminutive copper charm was found during excavations of Fort Shirley, in central Pennsylvania, in 2009. It features the phrase "No god but Allah," part of the Shahada. (Fort Shirley (36HU94), Jonathan A. Burns, Director, Juniata College Cultural Resource Institute)

multiple photographs wearing a skullcap or traditional African cap, as does Yarrow Mamout.[56] Their insistence on wearing such distinctive clothing despite laws dictating the dress of the enslaved acted as a subversion of white domination that reclaimed their human, cultural, and social value, in addition to symbolizing their faith.[57]

These material objects were combined into Islamic ritual along with a noted particularity about the direction these people faced when praying: always east. Beads, rugs, manuscripts, Qur'ans, amulets, and clothing were an integral and precious part of Muslims' material world that functionally negated their status as enslaved and the forced acculturation that came with that status. These objects are both part of the material culture of enslavement and representative of resistance to it. They are also an essential aspect of the story of the Muslim men and women who built this country, and, as Lovejoy notes, they demonstrate that the "range of cultural adjustments possible for slaves was much more complex than has often been supposed."[58] Given this overwhelming documentary and physical evidence, why are enslaved Muslims not more present in the historical record and consciousness?

Why Are Muslims Missing?

Most of these material objects have been either misinterpreted or ignored in historical accounts of slavery and enslaved religious practices and cultures. Only in the last decade have scholars begun reassessing this material, but this has been severely handicapped by two key factors.[59] First, a lack of identified objects. This is due to both the loss of objects through inherent fragility (disintegration of textiles or paper, for example) and the assessment of extant objects through the lens of "enslaved material culture" rather than "*Muslim* enslaved material culture." Second, and relatedly, this lens of Muslim enslaved material culture did not exist in America during the lifetime of these enslaved men and women. In fact, a combined lack of knowledge about Muslims, ignorance of the importance of material culture, and sheer disregard for the enslaved led to a critical loss of these primary sources and an almost total absence of contemporary secondary sources exploring or even documenting them.[60]

The few contemporary sources we have describing documents are heavily flawed and subject to less-than-reliable translations, and existing translations and correspondence are hamstrung by the lack of knowledge surrounding Islam and Arabic from the sixteenth to nineteenth centuries. As Isaac Bird, a Syrian missionary and noted translator of Arabic manuscripts, states of an enslaved-produced document including a passage from the Qur'an,

> If I mistake not, there is a small amount of bad spelling in the manuscripts, a good deal of bad grammar, & a good deal more of bad sense, or no sense at all. Sentences of the last mentioned character, I have in a few cases, passed over without attempting any solution, others I have been obliged to express with the best meaning I can guess at. In the religious portions of the composition there seems to have been an effort to

imitate the style and languages of the Koran. If I had been more familiar with that book (*the whole of which I have never read*) I might have succeeded in my attempt more to my satisfaction.

The writer in question, Sheikh Sana See, was not "imitating the Koran"; he was quoting it directly—a detail that a more well-versed translator would surely have noticed.[61] Further, much of the "bad spelling" and "bad grammar" could have one of three explanations: the writer was expressing a local dialect of Arabic, such as Hassaniyah, rather than the standard Arabic that Bird would have been familiar with; the Arabic may have been mixed with or completely representative of Ajami, the use of the Arabic alphabet to express African languages (e.g., Hausa, Swahili, and Yoruba); or the writer was transliterating non-Arabic words into Arabic characters, rendering them unrecognizable as Arabic words.[62] The last was the case with a manuscript produced by a man named London, enslaved in Savannah. William Brown Hodgson, a scholar and diplomat, faced repeated challenges with the translation of some of London's manuscripts before realizing that London was transliterating English sounds into Arabic characters. What London wrote then morphed into "Fas chapta ob jon. / Inde beginnen wasde wad; / ande Wad waswid Gad, / ande wad was Gad."[63] London was inscribing the Gospel into Arabic characters. In a similar vein, Sayyid transliterates Charleston as "Dhāluston," Fayetteville as "Faydel," and Raleigh as "Rūlī."[64]

Translators entirely separated the Arabic language from the cultures and religion that contextualize it, leading to significant errors in recording the importance of these documents and their contents for posterity. Problematically, not only are these incomplete or inept translations still relied upon, but numerous Arabic manuscripts and documents written by the enslaved now exist *only* in translation, removing significant historical context in addition to the information provided by spelling, dialect, and original place names. It is thus imperative that existing documents are retranslated, analyzed, and contextualized to extend our knowledge of who these enslaved Muslims were. However, documents cannot tell us everything.

More integral to a new understanding of the world of African Muslims in early America is a reexamination of the material culture they left behind. In general, research on enslaved Muslims is primarily being conducted by historians, who, as Diouf notes, prefer written documents as sources.[65] As a result, aside from the casual and unknowing written references of observers regarding the use of faith-specific objects (beads, prayer rugs, and clothing), these objects have largely escaped historical accounts or have been disassociated with Islam. Existing documents should be used in concert with objects to discover and

explore enslaved Muslims' experiences. Can we associate a white, slave-made jacket and pants from Louisiana with the religious preferences of the enslaved families there? Is it possible to link white osnaburg cloth from Mitchell King's South Carolina plantation with the enslaved man named Sambo that he purchased in 1812? Are the blue and white beads from an African burial ground in Virginia possibly the remnants of *misbaha*?[66] The narratives inside these objects are waiting to be rediscovered and announced to the world.

For far too long researchers have relied on extant markings on these documents from libraries, archives, and museums without examining the documents for ourselves. This is even more true of material culture such as textiles and beads. What I am proposing is a recoding, or a resignifying, of these objects, or at least the acknowledgment that they may contain within them more than one explanation, one story. This entails combining objects with new research (into enslavers' documents, genealogies, newspapers, etc.), new translations, and inter-museum communication to expand these stories to their full potential. It also entails cross-disciplinary collaboration among Africanists, Americanists, anthropologists, archaeologists, ethnomusicologists, folklorists, Islamicists, linguists, and material culturalists, among others.

Additional documents and objects chronicling the experience of Muslims in early America remain to be found, and more information about these men and women—as individuals, as representatives of the Muslim community and their African and African American peers, as informants of their social settings, and as storytellers speaking for otherwise unrecorded millions—awaits discovery.

Museum Models

The limited existing material culture makes it extremely difficult for museums to functionally display and discuss enslavement, let alone the various religious beliefs of the enslaved. But this is what makes it so vitally important to do so. Recent exhibitions in the United States in which objects related to enslaved Muslims appear include *Drapetomania: A Disease Called Freedom* (2000), *America I AM: The African American Imprint* (2009), and *My Name Is Omar: A Life in the Struggle for Liberation* (2014–2015). However, they suffer from two shortcomings. First, they do not situate these men and women within the complex historical context surrounding Islam in America and the larger background of Islam in Africa. Second, they portray the represented Muslims as exceptional, even singular, individuals rather than as part of a much larger and linked community. The latter is compounded by the limited number of 'famous' enslaved Muslims who are represented repeatedly, thereby delimiting the diverse experiences of the community to their singular experiences. These exhibitions do at least acknowledge an enslaved Muslim presence in

antebellum America, in contrast to the majority of exhibitions, which leave the Muslim faith entirely unremarked upon, often subsuming Muslims under the general discussion of Christianity and conversions among the enslaved. These limitations dilute critical voices into a sea of generalities. A 2018 digital exhibition, *Enslaved and Freed African Muslims: Spiritual Wayfarers in the South and Lowcountry,* has taken significant steps to correct these errors.[67] Although the focus of the exhibition is geographically limited to the South—specifically the Lowcountry—and there is still a foregrounding of well-known enslaved Muslims, it strongly situates Islam as an African religion, integrates Islam into the complex American religious landscape, and acknowledges that Islam was practiced, adapted, and passed down among generations of enslaved. It acts, therefore, as a stepping-stone for exploring the wider influence of enslaved African Muslims in the entire United States, including their integral role in building the nation.

Four museums—America's Islamic Heritage Museum (Washington, DC), the International Museum of Muslim Cultures (Jackson, Mississippi), the New African Center (Philadelphia), and the Arab American National Museum (Dearborn, Michigan)—are also working to change the lack of knowledge surrounding African Muslims in America with larger, more in-depth exhibitions.[68] However, their locations, relative obscurity, and, most importantly, lack of permanent collection objects unfortunately prevent their message from reaching diverse audiences or from delving in-depth into Muslim enslavement. Their potential to serve as a corrective to the lack of narratives around Muslims in America is thus seriously diminished.[69] Additionally, some historic plantations are beginning to acknowledge the presence of Muslims among the enslaved workforce, including George Washington's Mount Vernon and the Whitney Plantation in Louisiana. Both sites digitally acknowledge the presence of enslaved Muslims at the site. Mount Vernon by using names found on Washington's enslaver's lists and the Whitney through naming practices and historical data about the regions from which enslaved persons were forcibly migrated to the plantation.[70] However, they lack interpretive structures at the sites themselves that would allow visitors to more readily engage with the religious and cultural realities of Islam in situ.

Case Study

I will conclude with a brief case study of a permanent history gallery at the National Museum of African American History and Culture, *Slavery and Freedom,* and how NMAAHC examines enslavement through the African Muslim lens. The exhibition explores the complex and intertwined stories of slavery and freedom as a core component of America's history, beginning in the

NMAAHC incorporates Muslims and Islamic empires from the very beginning of the exhibition. Objects appear in both the Europe (top) and Africa (bottom) cases discussing the development of the transatlantic slave trade. (top: Iberian Tray, Smithsonian Institution, Department of Anthropology; bottom: Ayuba Suleiman Diallo, National Portrait Gallery, London, NPG L245) (Photographs by Alex Jamison and Walter Larrimore/NMAAHC)

Portrait of Omar ibn Sayyid (right center) in a montage showing
how the African Americans who endured enslavement created cultures
instilled with wisdom, beauty, and vitality. (Daguerreotype, State Archives of
North Carolina, PC.812.1) (Photograph by Leah L. Jones/NMAAHC)

fifteenth century and continuing until the end of the Civil War. It is the historical anchor of the museum; as such, it is paramount that the exhibition lays the foundation for exploring the full lives of the people who were enslaved in America.

In consideration of both time and the available collections, as well as the general themes of the exhibition and the need for frequent rotations, there were four broad approaches to representing religion among the enslaved: (1) discussing religion in broad and encompassing terms rather than using specific religious names or titles unless directly warranted (e.g., "religious gathering/service" instead of "church"); (2) including people of various religions in all the themes discussed rather than confining them only to a religion-themed case; (3) focusing on the whole of a person's experience, rather than solely on their religious beliefs; and (4) using the words of the enslaved themselves to discuss religion and spirituality. This approach allowed NMAAHC to include Islam in a much broader array of spaces and on more labels than limiting Islam solely to the discussion of religion among the enslaved.

There is also a specifically Muslim presence throughout the galleries. This includes acknowledging the spread of Islam throughout Europe and Africa by including Islamicate objects and depictions of Muslim persons in both the

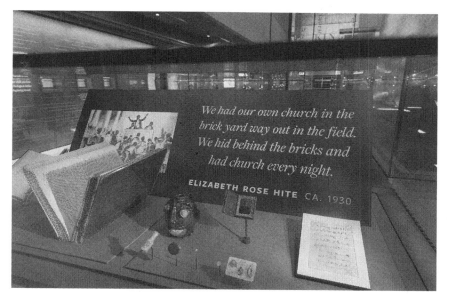

We had our own church in the brick yard way out in the field. We hid behind the bricks and had church every night.

ELIZABETH ROSE HITE CA. 1930

Case displaying the religious traditions practiced by the enslaved, including Islam. It features a copy of the Sūrat al-Nasr (110) written by Omar ibn Sayyid (far right) and an ambrotype of Sayyid (center). (North Carolina Collection, Wilson Library Special Collections Library, University of North Carolina at Chapel Hill) (Photograph by Walter Larrimore/NMAAHC)

Europe- and Africa-themed cases that discuss politics at the beginning of the slave trade, as well as highlighting images of enslaved Muslims in photo montages in the "Life and Work" section. A case discussing religion showcases an Arabic document alongside Christian and western African traditions to visually display religious diversity and how these traditions existed alongside each other in enslaved communities. And all labels use original names when known (e.g., "Ayuba" instead of "Job"). NMAAHC is further beginning to cultivate an online presence that discusses Islam in America, a presence that will continue to expand through the Center for the Study of African American Religious Life.[71]

Despite including Islam throughout the gallery, there are an extremely small number of labels devoted to discussing Islam among the enslaved. Thus, it is necessary that all of the labels work on multiple levels. They introduce facts about enslaved Muslims, discuss their lives in America, explore their experiences as individuals, and discuss the specific objects on view. They also, when read in concert, narrate the larger story of the Muslim experience. A label that appears in the religion-themed case exemplifies this multiplicity:

Enslaved African Muslims in America
Enslaved Muslims carried their faith to America. Here they formed
communities and used Arabic to challenge their enslavement. Omar ibn
Sayyid, shown in this ambrotype, was enslaved when he wrote the Sūrat
al-Nasr, a verse from the Qur'an. His enslavers mistakenly believed it was
the Lord's Prayer and proof that Sayyid had converted to Christianity.

However, it is entirely possible to walk through the galleries without noticing
this story, and the case devoted to religious expression remains dominated (via
objects, text, and graphics) by a Christian narrative. In the coming months
and years, as we rotate objects and refine the galleries, I hope we will be bet-
ter able to create awareness of the enslaved Muslim community and how it
persevered under American slavery. This may come in the form of more labels,
both in number and in content (e.g., pointing out what the names on bills of
sale can teach us about religious diversity), or through the inclusion of unas-
sociated beads or textiles next to an Arabic manuscript to recode the objects
as potentially religious and Muslim. This also includes digital initiatives, such
as featuring more Muslim men and women on our mobile app and website.
Perhaps through all of the above, and hopefully through many other inventive
ways I have not yet considered.

Lamine Kebe, enslaved for nearly forty years in the American South,
"lamented the great ignorance of [Americans] on the subject [of Islam], and
wished to correct their many erroneous opinions."[72] My fondest hope is that
the National Museum of African American History and Culture is able to ad-
dress some of this ongoing "ignorance" to help initiate and develop a national
conversation that fosters and augments our collective memory of these men
and women and their faithful prayers to the east.

More Than Just a Way across the Water

The Identification, Preservation, and Commemoration of Ferry Sites in South Carolina

EDWARD SALO

In December 2005 and January 2006, Charleston's daily newspaper, the *Post and Courier,* featured stories describing a new water taxi service across the Cooper River connecting Charleston and Mount Pleasant.[1] The potential tourist development spurred by this new taxi excited the writer, but local residents knew that water transportation between the two cities was not new. In fact, as early as 1713 a ferry crossed the Cooper River connecting Charleston and Mount Pleasant, and this remained the primary mode of transportation over the river until the construction of the Grace Memorial Bridge in 1929.[2] Even with the presence of the state-of-the-art bridges over the mighty rivers of Charleston, it appeared that the ferry was returning to the Lowcountry.

Public fascination with the new water taxis brings to light many questions and issues for public historians regarding the importance, memory, and cultural meaning of ferries in South Carolina, especially in the Lowcountry region of the state. In this age of rapid transportation, why would people take a slower mode of transportation? Why would people pay to cross a river that they could cross on a bridge for free? Why was the return of the ferry so important to the people of the area? More importantly, what does the ferry represent in South Carolina's Lowcountry history, and what does it represent in the Lowcountry's historical memory?

Often overlooked by historians and archaeologists, ferries played an important part in the transportation network that developed during the colonial period and continued to operate until the twentieth century. Underwater archaeologist Christer Westerdahl argues that ferries and inland road networks were important because they were part of a larger maritime cultural landscape that included ports, harbors, wharves, and other structures. Ferries were "the

first *transit point* at which river-based cultural area [met] the outer world."[3] For instance, ferries in South Carolina were the local connection to the larger Atlantic world network within which South Carolina operated and developed. Without ferries, South Carolina would not have developed as an economic partner in the Atlantic world network. They served as the connection between maritime and inland culture. It is their role as connectors that makes them a significant public history topic. At ferry sites, we can explore not only transportation history but also issues related to the labor force, business and military history, and other topics. It is important that public historians go beyond the transportation history and explore how ferry sites can present other aspects of history.

Through their material culture, ferries offer many different paths for the historian to explore. As Rebecca Conard explains in her study of railroad depots in Iowa, "History offers another way of viewing the tangible remains of the past: historians are not trained to see the world around them in terms of stylistic or artistic elements, nor are they trained to see old buildings as structures to be rescued. . . . The historical perspective leads one to consider the underlying reasons for and consequences of past activities which have affected the status of tangible resources still with us. By extension, it forces one to examine the philosophies and motives that shape current decisions."[4] Maritime landscapes, like ferries, offer an opportunity to explore historical themes other than just transportation. As illustrated in this study, public historians can use ferries to discuss diverse topics such as the changing roles of African American labor, the creolization of technology in South Carolina, and the development of the state's legal history. In addition, maritime landscapes offer an opportunity to use historic preservation for economic and urban renewal.[5]

The Importance of Ferries in South Carolina's History

Ferries contributed significantly to multiple themes of South Carolina's history. However, for an unexplained reason, many historical studies of America's maritime heritage ignore the role of ferries.[6] Because of the very nature of South Carolina Lowcountry's geography, it was vital, from the start of the colony, to have a means to cross the many rivers that flow from the interior to the Atlantic Ocean.[7] The number of ferries that developed in the first fifty years of the colony is apparent in a 1730 map of the political division of South Carolina, which shows ferries at several rivers, such as the Savannah, Combahee, Edisto, Cooper, Ashepoo, Ashley, Broad, Pee Dee, Wando, and Santee.

Because of the importance of agriculture to the colony, the initial settlement in South Carolina focused on the Coastal Plain and specifically the Charleston area. By the early 1700s, to meet the needs of the growing population, expansion of the South Carolina colonial settlement from south of

Charleston toward Port Royal and Beaufort resulted in the establishment of several unregulated private ferries along the rivers of the Lowcountry. In the South Carolina backcountry, on the other hand, river fords, not ferries, predominated as river crossings.[8] To manage the developing transportation infrastructure, the South Carolina Colonial Assembly in 1703 chartered the first regulated ferry in South Carolina on the Santee River.[9] The Colonial Assembly fixed rates and regulated the conditions of ferry operations, allowing the owners to operate the ferries for a profit.[10]

Ferries served as important travel stops before the Civil War, but they also developed an additional use that supported the slave-based society of the South. Historian George C. Rogers Jr. suggested that ferry crossings became checkpoints for governmental officials to apprehend runaway slaves, wayward indentured servants, and deserting seamen. Some ferries required at least one white man on board to inspect the travelers. If a passenger's identity was questioned, then he was required to obtain a certificate of identity from the justice of the peace.[11] In 1801, as a means to control the movement of slaves, the South Carolina General Assembly passed legislation forbidding the transportation of slaves on ferries without written permission.[12]

Many historians have argued that the rivers in South Carolina's Lowcountry, especially along the Ashley, Cooper, and Combahee Rivers, affected the development of the colony's economy and culture, making it distinctive from the other colonies.[13] Historian Lawrence Rowland contends that in the Beaufort District, the Commons House of Assembly established needed ferries and parishes to ease travel to church and for commerce as settlers developed portions of the district.[14] The importance of rivers in aiding transportation during the early colonial period is well documented; however, by the 1720s, the primary means of travel was over land.[15]

The creation of ferries also reflected a region's political power. Historian George Lloyd Johnson Jr. argues that in the mid-1700s, backcountry residents desired a better transportation network as a means to develop commerce with the coastal markets. Better transportation also aided the growth of towns and social interaction. Of course, at that time the political power in the state resided in the Lowcountry, so it was not until after the Revolutionary War and the expansion of the backcountry with new settlers that roads, bridges, and ferries arrived there.[16]

Contemporaries also observed the vital role of ferry transportation in the new nation. French social and political commentator Alexis de Tocqueville asserted that the country's internal transportation system strengthened the bonds of the Union, which resulted, he claimed, in "Americans becoming assimilated" into one culture and one nation.[17] After the Civil War, the development of the railroad network and, later, highways and air transportation

would result in other major changes to the national landscape as citizens expanded westward, creating new economic centers.[18]

Because of the ferries' locations on trade routes of local or regional significance, many other commercial services (e.g., warehouses, trading posts, and taverns) usually developed nearby.[19] These early commercial institutions frequently contributed to the development of the local economy and sometimes served as catalysts for the creation of a new town. Taverns were especially important social, political, and economic institutions in American colonial life.[20] Many current cities and towns located near historical ferry crossings owe much of their initial development to the economic importance of the ferry. In Virginia, for example, the location of towns was usually the result of an individual's efforts. Typically the individual established a settlement either in a valley or near some other economic center such as a ferry.[21]

Ferries remained important in South Carolina's Lowcountry for a longer period than in many of the other colonies. Geographer Fred Kniffen argues that ferries diminished in New England because of wartime lessons. After the Revolution, because of the length of time required for large armies to cross rivers by ferry, New Englanders saw the need to construct covered bridges as an alternative. However, because of South Carolina's geography, the agrarian nature of the economy, and its political ideology, the ferry remained important until after the Civil War. Thereafter, ferries continued to lose their importance as railroads expanded across the state. In 1898 the state government stopped regulating private ferries. With the advent of the automobile and Progressive Era bridge-construction program of the 1920s, ferries all but ceased to operate in the state.[22]

Although ferries played an important part in the development of South Carolina, until recently preservationists have all but ignored them in the preparation of National Register nominations and state historical markers, two indicators of the perceived importance of a historical resource in South Carolina. Compared to those in neighboring states, South Carolina's preservation community has been slow to identify ferries and ferry-related resources in the state. Many of the important ferry sites in South Carolina do not have a historical marker to illustrate their importance. Many plantations that included ferries in their operations do not have the landings listed in their National Register nominations, but many of the older National Register nominations of plantations ignore many archaeological sites, not just ferry sites.

South Carolinians have remembered historical ferries and their contributions to the state's transportation history in other ways, including the naming of roads and businesses after them. Also, current cultural-resources-management work at the Combahee Ferry in Beaufort County illustrates a new emphasis on the identification and preservation of a ferry site.

Using examples from South Carolina and other states, we will explore issues related to the identification, preservation, and commemoration of ferry sites in South Carolina.

Identification of Ferries in South Carolina

As with many other historical resources, the identification of ferry sites usually occurs as part of the Section 106 review process or a South Carolina Institute of Archaeology and Anthropology (SCIAA)–sponsored research project. Based on cartographical and archival records, archaeologists have located hundreds of landings on aerial photographs, terrain analyses, and historical property plats, yet archaeologists have conducted archaeological investigations on only a handful of those sites.[23] Archaeologists have studied several of the few extant significant ferry sites in the Lowcountry.[24] The major ferries investigated there include Milton Ferry in Mount Pleasant, Strawberry Ferry in rural Berkeley County, Bonneau's Ferry and Ashley Ferry in Charleston, and Combahee Ferry in Beaufort County.

For example, in 1993 Brockington and Associates investigated Milton Ferry in Mount Pleasant as part of a compliance survey. The company did not investigate any of the underwater or intertidal resources, and because the owner did not go forward with development, no data recovery occurred at the site.[25] The survey revealed that the site had a tavern and stables; however, because of the limited survey area, Brockington did not examine any of the landings to determine if they were used for a ferry. Because of the limits of cultural research management (CRM) survey areas, resources such as ferries are often not explored.

Two years later, William Barr prepared his extensive study of Strawberry Ferry in Berkeley County.[26] Archaeologists have also studied the Ashley Ferry (38CH1506), established in 1711 on the Ashley River, and Bonneau's Ferry (38BK1267), established in 1712 on the eastern branch of the Cooper River. Neither of these sites is well preserved. The two landings associated with Ashley Ferry are in poor condition. Phosphate mining operations destroyed the southeastern landing of Ashley Ferry. Also, the landing and the ridge location of the Ashley Ferry town were subdivided into a residential housing development known as Ashley Town Village. Interestingly, during the survey of the Ashley River SCIAA archaeologists contacted the developers, who indicated they had no knowledge of the historical ferry site.[27] The site of Bonneau's Ferry has also deteriorated, with both the northeastern and southwestern landings poorly preserved.[28]

In addition to the actual ferry sites, several abandoned ferryboats lie at the Brown's Ferry site (38GE57), and five wooden plantation barges, one possibly a large ferryboat, lie at the Laurel Hill Plantation landing (38GE251) on the

*Ferry on the Ashley River. Image Courtesy of
College of Charleston Special Collections.*

Waccamaw River.[29] These boats offer underwater archaeologists opportunities for future studies of ferryboats.

Since the 1980s, new bridge projects eliminated several opportunities to study former ferry sites. For example, as part of the cultural resources survey of the replacement of the US Highway 21 bridge, SCIAA recommended an underwater survey for the right-of-way and surrounding environs because of the potential for abandoned watercraft associated with the Port Royal Ferry. For unknown reasons, that plan was never implemented.[30]

During the intensive cultural resources survey and archaeological testing of 38BU1216, part of the US Highway 17 Widening Project in Beaufort and Colleton Counties, Brockington and Associates staff identified the Combahee Ferry Historic District. Although the project included the point at which Highway 17 crosses the Ashepoo River, the site of the ferry, the archaeologists did not locate any ferry remains.[31]

Development of Underwater Site Database

During the early 1990s, the SCIAA Underwater Archaeology Division (UAD) prepared a database that included site types such as ferry landings, plantation landings, forts, mills, and shipyards. By the late 1990s, this database contained 859 total shipwrecks, plantation landings, ferry landings, bridges, artifact scatters, causeways, wharves, mills, shipyards, and forts. Based on the chart, ferries were approximately 1–2 percent of the database but represented approximately 16 percent of the total underwater sites in the database.[32]

SCIAA originally designed the site database as a compliance tool to assist its staff in more systematic management of known and potential submerged sites. The database has evolved over time and can be effectively used and refined to answer the UAD's specific management questions.[33] Of course, these databases are designed to protect the archaeological sites from looters, but archaeologists also want to use sites for educational purposes. Individual

sites will probably require coordination by the stakeholders, archaeologists, and public historians to ensure that the sites are not opened to looters: the plethora of historical maps of the Lowcountry makes finding ferry sites easy for amateur archaeologists.

Identification of Ferries in Nearby States

South Carolina is not the only southern state to under-study ferry sites. Georgia has a similar historical pattern of ferry development, but researchers have not conducted adequate study of its ferries. In a recent study of archaeological sites in Georgia, New South Associates identified 231 recorded transportation-related sites, and of that number only four sites were river-ferry sites.[34] Needless to say, the state archaeologist argued that ferries and causeways were "transportation site types that have not yet been considered in the historical archaeology of Georgia."[35] New South Associates archaeologists suggested that other sites may contain elements of ferries. For example, shoals, often the sites of mills, frequently supported other activities such as ferries, bridges, taverns, stores, and towns.[36] Both of these recommendations are probably appropriate for South Carolina as well.

The states in the Chesapeake region have also investigated ferries in the area. Like their South Carolina counterparts, plantation owners and merchants along the rivers of Maryland used ferries and barges to transport their raw materials to the major cities. During the 1994 Maryland Maritime Archeology Program survey of shipwrecks, archaeologists identified two ferries: Wayman's Wharf Barge 1 (18CA104) and Wayman's Wharf Barge 2 (18CA105). Both were ferries that operated between 1860 and 1900.[37]

In 1993 and 1994 the state of North Carolina and the Wilmington District of the US Army Corps of Engineers conducted the Cape Fear–Northeast Cape Fear Rivers Comprehensive Study. Through a review of cartographic references, project historians examined more than 145 maps and added them to a computer-generated AutoCAD base map of the project area. In addition to accounts of numerous ship losses, the maps illustrated six ferry crossings, twenty-three fortifications, thirty-five plantations, fifty-four shipyards, and a wide range of related maritime activities.[38]

National Register Nominations of Ferries

A survey of the National Register of Historic Places (NRHP)–listed properties in South Carolina indicates the scant attention that ferry sites and boats have received. Former keeper of the register Carol D. Schull comments that the NRHP "should help us understand and appreciate our heritage and what specific places mean in American history."[39] If that is true, the number of NRHP-listed

ferry sites in the state should illustrate their importance to the state's history.[40] It should be noted that NRHP sites for archaeological remains, like ferry sites, can have the exact location redacted to protect the site from looters.

But that is not the case in South Carolina. Granted, several ferry-related properties are listed there. The first so designated was the Strawberry Chapel and Town of Childsbury, a former town and ferry site located at the "T" of the Cooper River. According to the nomination, the Town of Childsbury was "an important ferry site," but the statement of significance provides no other discussion of the ferry operations at the site.[41] Also, the nomination neither identified nor discussed the archaeological remains within the ferry district.

At the same time that the state prepared the Strawberry Chapel and Town of Childsbury nomination, the South Carolina Department of Archives and History (SCDAH) was preparing the Village of Rockville Historic District nomination. The village of Rockville was an early summer resort in Charleston County. The nomination mentions that the district was "important architecturally, agriculturally, militarily and in the areas of transportation and recreation."[42] William Seabrook, an Edisto Island planter, acquired the tract, established a landing for the Edisto Island Ferry Company, and laid out lots for summerhouses. The nomination highlights the social history of Rockville but also states that "Rockville was one of the main landings for the Edisto Island Ferry Company due to the directness of the land route to Charleston."[43] Whereas the nomination details the importance of the Edisto Island Ferry Company, the only resource in the nomination related to the ferry operation was the Micah Jenkins House, the ferry house for the Rock Landing and the oldest house in the area. There was no mention of the actual ferry landing or any remains from the ferry in the district.

The Cainhoy Historic District nomination, prepared in 1980, presents the history of a village that developed from a "ferry landing to a small but thriving river port." The authors of the nomination state that the significance of the district is "in its role as an early transportation link between Berkeley County and Charleston."[44] The nominated district includes the How Tavern, which operated in association with the ferry and several buildings in the village. However, like that of the Strawberry Chapel and Town of Childsbury Historic District, the nomination has no discussion or inclusion of ferry-related archaeological resources.

Gallivants Ferry Historic District in Horry County was placed on the National Register in 2001. The nomination does not include any specific ferry structures but focuses on the Holiday family's tobacco farming.[45]

In the 1990s SCDAH began work on several large National Register nominations in the Lowcountry, including the areas around the Ashley and Cooper Rivers. The nomination for the Ashley River Historic District mentions the

importance of bridges and ferries to the economic development of the area; however, there are no ferries listed as contributing elements.[46]

Very few archaeological remains of ferries are listed on the NRHP. For example, Jill Hanson, a National Park Service historian, nominated four pairs of earthen bridge abutments along a road trace at the Congaree Swamp National Monument because of their association with "roads and ferries [built] across the swamp to provide a means of transporting produce and livestock to markets in cities such as Charleston."[47]

The documentation of several transportation-related NRHP-listed properties historically associated with ferries does not discuss or list the ferry. For example, the nomination for Ashley River Road, listed on November 22, 1983, states that the resource includes an 11.5-mile section of SC Route 61. The nomination mentions that the road historically terminated at the Ashley River ferry, but the ferry site was not included in the nomination.[48]

The Combahee Ferry Historic District includes eighteen resources: eleven terrestrial and underwater archaeological sites and seven aboveground architectural or landscape features. Elements south of the Combahee River lie on lands owned by Nemours Wildlife Foundation beyond the US Highway 17 right-of-way or the public boat ramp owned by Beaufort County; elements north of the Combahee River are now part of the modern Laurel Spring Plantation. The period of significance for this district is roughly 1700 to 1930; this represents the period of operation of the ferry. The historic district contains resources associated with four major themes: (1) the development of South Carolina's transportation network, (2) military activities during the Revolutionary War and Civil War, (3) the development of rice plantations, and (4) the development of local economic institutions (e.g., taverns/stores).

The Combahee River Historic District, which is a section of the region centered along both sides of the Combahee River, is a remarkably intact landscape. Many historic and objects from the eighteenth, nineteenth, and twentieth centuries are still standing, and archaeological remains of settlements, fortifications, and other structures that supported agricultural activity are generally intact. In addition, landscape features such as rice fields, banks, canals, a causeway, roads, and a cemetery, many of them documented on eighteenth- and early nineteenth-century plats and maps, are extant and marked on US Geological Survey topographic maps and aerial photographs. Although the cultural landscape has evolved with changing land uses, the district retains its historical rural setting of banked and ditched marshes and swamps, upland pine and hardwood forests, narrow tree-lined roads, and river views largely unobstructed by modern development.

Several resources contribute to the development of South Carolina's transportation network at the Combahee Ferry site. Site 38CN256 is the submerged

remains of the ferry crossing. Also present near the ferry site is the possible remains of a vessel (38CN255) and several scatters of archaeological materials related to maritime activities or the construction of a historical bridge (38CN19, 38BU2137, and 38BU2138). These sites illustrate the transportation activities that occurred here.

Commemoration of Ferries in South Carolina

Although ferries may be identified during CRM surveys, the general public rarely learns of the information. When a survey leads to a historical marker, however, the public typically learns that a significant property is nearby. James B. Jones Jr. of the Tennessee Historical Commission argues that roadside markers and National Register listings are two of the "most visible and easily recognized components of . . . public history."[49]

As of 2006, South Carolina officials have memorialized very few historical ferry sites with highway markers. A review of the *South Carolina Highway Historical Marker Guide* lists only a handful of markers that highlight important ferries in the Lowcountry. Several of the markers were the efforts of local historical groups. The Dr. Henry Woodward Chapter of the South Carolina Society Daughters of the American Colonists erected the Britton's Ferry marker in 1971. The Three Rivers Historical Society erected the Witherspoon's Ferry marker in 1979 and the Potato Ferry marker in 1989.[50]

Historical place names often document the prior existence of a ferry. Names are important archaeological clues.[51] On a superficial level, place names can provide evidence of the possible location of archaeological sites. As archaeologist Jane McIntosh states, "A name may show the purpose of a feature was remembered . . . long after it fell into disuse."[52]

Several important modern roads in the Lowcountry maintain their links to the ferries of the past through their names. For example, Clements Ferry Road ended at the ferry on Daniel Island and was one of the principal routes to the north from Charleston. Mathis Ferry and Bee's Ferry roads are also in Charleston County. Some commercial enterprises use the old ferry names as well. Hibben Ferry Apartments is located near the site of the old ferry in Mount Pleasant.

Ferries have played an important role in the development of South Carolina, yet preservationists have all but ignored them in terms of National Register nominations and state historical markers. The preservation communities in Virginia and Georgia have also been slow to act, but Tennessee has done a better job in identification and commemoration. South Carolinians should do more to identify these significant properties.

To adequately identify, assess, preserve, and interpret ferries and ferry-related resources, I am proposing a multiphase program that will use the existing

historic preservation infrastructure of the state but focus on ferry-related resources in a way that will allow professionals to better understand ferries and the public to better appreciate their significance.

Phase I: Identification of Ferries in South Carolina

The first step is to identify what ferry sites remain. The first resource in the identification of ferries is cartographic information, which can locate the sites of former ferries. In addition to larger maps, plats of individual properties and associated deeds sometimes contain the locations of mills, dams, ferries, and other water-related sites.[53] The South Caroliniana Library, South Carolina Department of Archives and History Search Room, South Carolina Institute of Archaeology and Anthropology, South Carolina Historical Society, College of Charleston Library, South Carolina State Library, University of North Carolina–Chapel Hill Library, University of Michigan Library, New York City Public Library, Library of Congress, and various public libraries in South Carolina all contain collections of Lowcountry maps that illustrate many of the ferries in the state.[54]

These maps could serve as the basis for a new geographic information system (GIS) layer that would assist CRM professionals in the identification and study of ferry sites.[55] This layer should be placed on ArchSite, South Carolina's online cultural resource information system. ArchSite provides online access to a comprehensive source of cultural resource information and creates a digital process for archaeological site recordation.[56] Before conducting a cultural resources survey in the state, CRM professionals consult ArchSite to identify any documented cultural resources within the project area.

Phase II: Reexamination of SCIAA Site Files

Archaeologists have recorded some ferry sites as archaeological sites, but that information is not complete. Many times archaeologists recorded ferry sites as regular river landings or did not examine the other side of the river to see if ferry remains existed.[57] To correct these records, SCIAA should have a graduate research assistant reexamine the site forms for archaeological sites located near ferry sites that appear on the cartographical GIS layer prepared in Phase I.[58]

Phase III: Field Reconnaissance of Potential Ferry Sites

Using the cartographical GIS layer prepared in Phase I and the revised site forms prepared in Phase II, SCIAA personnel should conduct reconnaissance of potential ferry sites along Lowcountry rivers. From a boat (if they do not have right of entry), the archaeologists should be able to determine if the site has retained any integrity or if it has been disturbed by the construction of

a bridge or other activities. After the reconnaissance, new archaeological site forms or site-form updates should be prepared and included in the cartographical GIS layer prepared in Phase I.[59]

Phase IV: Preparation of a National Register Multi-property Cover Form for Ferries

Because of the potential for numerous ferry sites and ferry-related properties in South Carolina, one of the best techniques to manage ferry-related historical properties would be for SCDAH and SCIAA to prepare a National Register multiple property nomination (MPN) that addresses historical ferry sites, ferries, and ferry-related resources as a distinct and significant property type.

The MPN can also be used as a management tool; the thematic approach may furnish essential information for historic preservation planning because it evaluates properties on a comparative basis within a given geographical area and because it can be used to establish preservation priorities based on historical significance. The focus on significance and priorities will be useful in Section 106 review.

Phase V: Development of Research Questions for Ferries

As part of the MPN form, archaeologists need a prepared list of research questions to guide their investigations of future ferry sites.

Early studies of ferries in the South offer some basic research questions. In the mid-1970s, as part of his study of ferries in Tennessee, geographer Tyrel G. Moore Jr. suggested three primary research questions: Where and when were ferries used for stream crossings? How did their location and function change through time? What do ferries reveal about the places and routes they serve?[60] These basic questions provide researchers with a fundamental understanding of the history of the ferry site. However, most of these questions can be answered through strictly archival and cartographical resources and require no archaeological investigations.

SCIAA has been active in the theoretical study of ferries. In 1989 Bradford Botwick prepared a research plan for underwater archaeological sites in South Carolina. His research design discussed the various underwater site types, including ferries, and resulted in a set of research questions for ferries.[61]

Phase VI: Additional Historical Studies of Ferries

Unfortunately, very few ferry crossings are extant within the Lowcountry. Those that do exist are generally in very poor condition and lack integrity.[62] Because there is not a large archaeological sample of sites to investigate, the importance of historical research at these sites is evident. To understand the individual sites, historians at the universities of the state could focus some of

their undergraduate and graduate students' research on the history of individual ferries.

Phase VII: Dissemination of Ferry Information

I propose the development of a website designed specifically to highlight the cultural and historical significance of ferries in South Carolina. The website would contain information related to the history of ferries, links to specific open-source records related to ferries such as *Mills' Atlas: Atlas of the State of South Carolina, 1825; Statistics of South Carolina Including Its Natural, Civil, and Military History, General and Particular;* and volume 9 of *The Statutes of the State of South Carolina.* The website could also contain archaeological data, academic papers, and other sources related to ferry investigations. The site can be funded as mitigation for adverse effects on a historic site.

In addition to providing primary sources to students, the internet can be used to provide virtual history museums (VHMs) that interpret historical events. A VHM can be created by anyone and can present history in different ways.

Phase VIII: Interpretation of Ferries

After ferries are identified, it is important to provide public interpretation of the historic sites. The interpretation of ferries can also aid heritage tourism. Heritage areas, historical societies, and SCDAH can promote the heritage tourism of the ferries in the state through programs such as the National Register's Online Travel Itinerary, which creates self-guided tours to historic places listed on the National Register based on text and photographs supplied by the city or area. Several heritage trails, corridors, and so forth in the state of South Carolina have online maps of the area. The South Carolina National Heritage Corridor and the Gullah Geechee National Heritage Corridor, both units of the National Park Service, have significant potential for ferry interpretation because of their shared focus on the cultural landscape.

Whatever type of interpretation plan is developed, it should contain multiple interpretive products and illustrate the many significant aspects of the history of a ferry site.

The history of ferries in South Carolina offers public historians the opportunity to use a historic site related to transportation and discuss the political, economic, social, transportation, and military history of the Palmetto State. Ferry sites can be interpreted regarding "difficult history," such as slavery and African American history in general. Archaeological sites could tell a more complete and more interesting story with ferry history (plantations with

waterfront property), skilled labor and freedom of enslaved ferry laborers, and how they could help interpret enslaved life (spread of information/part of information networks). Though not owners of ferries, African Americans played a dual role in the history of South Carolina ferries. On one hand, they were among the many operators, first as slaves and later as freedmen. However, although African Americans operated the ferries, the South Carolina government passed a series of laws starting in the early 1700s that restricted their use of the ferries as a means of controlling the entire race.

For slaves, operating ferries was a skilled position that brought esteem, yet because of their connection to the larger transportation network, ferries were also places where slaves could attempt to escape. For example, historian Peter Wood identified hundreds of African slave boatmen, of various skill levels, working the waterways of South Carolina during its colonial period. The levels of ability of the slaves ranged from unskilled oarsmen to skilled navigators and captains. Of course, the slave's level of skill would correspond with the slave's value at market. Wood noted that African slaves even operated the small crafts that ferried people from large ships in Charleston Harbor to the port.[63] Also, Africans continued to adapt the river flats and other plantation watercraft to reflect their maritime traditions. The ferry sites would be a place where public historians and archaeologists could tell the story of skilled slaves and their importance to the development of the state. In South Carolina, African Americans operated the ferries, first as slaves and later as freedmen; however, laws restricted their use of the ferries prior to the Civil War.

In addition to the tangible aspects of freedom, slave ferrymen also gained direct contact with travelers from outside their normal social realm. The African slaves might meet famous politicians, religious leaders, or ordinary citizens from other colonies. They might also meet slaves from other plantations or regions traveling along the roads. This interaction of slaves with other slaves and outsiders was one of the fears of the owners, who saw this interaction as possibly leading to rebellions.

Like African slaves who worked in town as skilled artisans, slaves who operated ferries gained opportunities and freedoms that most field slaves lacked. These freedoms and opportunities could at the extreme plant the seed of rebellion in the slaves, but most certainly the view of the outside world did make many slaves crave greater freedom. Although this freedom was refreshing, events outside Charleston soon altered the colony's view of the growing African population and created a series of regulations of the slaves in regard to ferries.

After the Civil War and during the Jim Crow era, African Americans continued to work on ferries, but in many cases, when they rode as passengers, they did so in separate sections of the boats. Segregation did not dissuade

African Americans from using ferries to connect their worlds to wider ones, however. In the Progressive Era, for example, modern ferries opened travel to the Sea Islands, integrating the largely isolated Gullah culture into the larger state. In the 1950s African Americans developed a ferry service as a means to bring social mobility to their communities.

Today, we drive over roads and bridges without thinking of the engineering importance of them or how they fit into the state's infrastructure. Yet it is this transportation network with the nodes of bridges (or ferries) that has influenced the political, social, economic, and cultural history of the state. The ferry sites offer us the opportunity to tell the stories at unique places. As noted above, the ferries can help us explore the African American experience (both enslaved and free). This proposed plan will provide adequate identification, assessment, preservation, and interpretation of ferries and ferry-related resources, and it will allow professionals to better understand ferries and the public to better appreciate their significance.

Power, Representation, and Memory in the Great Dismal Swamp

KATHRYN BENJAMIN GOLDEN

A huge morass of swampland straddling the Virginia/North Carolina border along the Eastern Seaboard, the Great Dismal Swamp once stretched from what is today the James River in Virginia to the Albemarle Sound in North Carolina, a space comparable to the size of the state of Delaware: roughly two thousand square miles.[1] Through the nineteenth century, the swamp encroached upon its surrounding cities and counties even more than it does today, at less than half that size and perhaps as little as just 10 percent of its original size.[2] In Virginia the swamp was enveloped by the counties of Princess Anne (now known as the independent city of Virginia Beach), Norfolk (including the cities now known as Portsmouth and Chesapeake), Nansemond (now the independent city of Suffolk), and Isle of Wight (including the towns of Smithfield and Windsor); the North Carolina counties were Gates, Chowan (including the city of Edenton), Currituck, Camden, Pasquotank (including Elizabeth City), and Perquimans.

This Tidewater region, known today as the Hampton Roads, stands out as one shaped by the nation's earliest and arguably most entrenched and developed systems of Anglo-settler slavery.[3] But the region can also be distinguished by its rich history of some of the most remarkable histories of African American resistance to enslavement. Of all of the maroon communities that existed throughout the slaveholding US South, the largest and most enduring of these asserted, created, and defended their freedom in the Great Dismal Swamp in southeastern Virginia and northeastern North Carolina. For enslaved people the close proximity to major port cities such as Portsmouth and Norfolk, countless waterways, many rivers, and the presence of 2,000 square miles of swampland made the region prime for flight from enslavement, overt resistance, and marronage. Yet today no historical markers, museums,

monuments, or memorials exist to commemorate the lives of the maroons or their incredible range of free and independent activities in and around the swamp. In the current swamp the few publicly visible and available accountings of its human history also remain marginal and suppressed.

Recent studies on race, representation, and commemoration at sites where meaning is contested read race and power through public narration and the knowledge and memory that it produces about the Civil War, the Underground Railroad, or slavery itself.[4] To date, there are no studies on the relationships among race, power, public history, and memory pertaining specifically to the representation and commemoration of US slave resistance and particularly marronage. A large part of this absence results from slow and scant scholarly recognition and acknowledgment of US marronage to begin with. Ethnography that I conducted between 2013 and 2015 on race and public historical representations of resistance and marronage in and around the Dismal Swamp is consistent with past studies in finding that those with the power and resources to selectively dictate the narrative value some versions of history over others in accordance with their own aspirations and desires.[5] A close look at representations of marronage in and around the Dismal Swamp reveals that the institutions capable of publicly narrativizing its significance suppress the history and memory of revolutionarily resistant and independent African American communities through trivializations, minimalizing language, and/or blatant erasure. This is fundamentally a consequence of institutional priorities and the accommodation of white southern sensitivities around race.

Making visible African American *resistance* threatens present distributions of power and also resurrects the imminent threat of repeated resistance against racial oppression and pervasive inequality in the afterlife of slavery. In fact, even the act of commemorating such resistance through the concepts of Black independence, marronage, or revolt can be understood as a form of resistance against a power structure currently dependent upon the subjugation and disfranchisement of persons of African descent. Representation and commemoration of resistance and marronage remind Black and white communities of the range of possibilities for action against race-based oppression in a society that continues to be shaped by slavery's legacy of enduring structural and attitudinal racism. A more whole, unbroken, and equally integrated narrative of African American power and resistance in the Dismal Swamp that accounts for the resiliency of autonomous maroons and their varied forms of resistant actions (including their involvement in organized insurrection and mobilization against slavery) is a particularly foreboding version of the swamp's past and thus continues to be constricted and suppressed. These mechanics of race and power form a political quagmire of silences and invisibility throughout the swamp landscape paradoxically shaped by these self-empowering acts.

Because "every state institution is a racial institution" and "most institutions are white-centric and more often than not work to maintain whites' racial advantage,"[6] the subjugation and underrepresentation of non-white knowledges and the historical experiences, truths, and contributions of racialized groups are a political act that accustoms us to selective memory and strategic narratives of power, place, belonging, and identity as normative. Historical representation of slavery and marronage evident at historical sites led by institutional organizations such as the National Park Service, the US Fish and Wildlife Service, the North Carolina Department of Environment and Natural Resources, and a host of museums and historical societies throughout the Dismal Swamp region is in large part shaped by what Manning Marable has termed a pervasive "historical logic of whiteness" that minimizes and erases historical narratives threatening white power in the present.[7] Race and power intertwine to make dominant historical representation a political practice reflecting predominantly white values, objectives, and perspectives, or the values, objectives, and perspectives of those with the authority, ability, and resources to narrate the past and its significance within the present. Ultimately, institutional representation is influenced by power politics privileging white agendas, experiences, and desires.[8]

A great deal is lost in current representation of the Dismal Swamp's historical and present significance. The histories of US marronage are extraordinary in their range of Black people's creative will to defy and oppose the imposition of place, bounds, and capture. Commemorated, they hold extraordinary potential to empower groups that have been marginalized and oppressed in the aftermath of slavery's enduring legacy. Our abilities to acknowledge, commemorate, remember, and honor the history of African American independence, resistance, and resilience in and around the swamp offer Black communities new ways to experience pride and local and national belonging while also offering the country a lesson about the sincerity of American values, the indomitable human spirit, and a more honest and complete version of history and memory toward a truer and more authentically just society.

US Marronage and the Maroons of the Great Dismal Swamp

Marronage is a hemispheric, in fact, a diasporic phenomenon that speaks directly to the power and resilience of African descendants not only to resist but also to organize, create, and survive through one of the planet's greatest atrocities.[9] As Alvin O. Thompson has put it, "Marronage is the most extreme form of resistance, since it involved opting out of the system of oppression altogether and establishing a new kind of society in which the former enslaved persons took (or sought to take) control of their own lives and destinies."[10] Herbert Aptheker emphasized that for the slaveholding class, maroon

communities, these "ever-present feature[s] of antebellum southern life, . . . were seriously annoying, for they were sources of insubordination, . . . offered havens for fugitives, served as bases for marauding expeditions against nearby plantations, and, at times, supplied the nucleus of leadership for planned uprisings."[11]

Marronage is the combined act of flight and resettlement in wilderness spaces outside of dominant society or, if people were born into a maroon community, sustained autonomous life in the wild lands surrounding plantation spaces. Unlike the maroons of Latin America and the Caribbean, those in the US South created alternative lives in the face of unique adversity: that of the highly repressive and paternalistic settler slaveholding society. Maroons of the Old South were itinerant individuals but also part of self-sustaining, multigenerational communities. They were "petit" (short-term) maroons before recapture or return to the plantation, but they also established enduring or permanent lives in the natural environment outside of the plantation world.[12] The majority of US maroons lived in the backwoods, swamps, and forests that were peripheral to plantations and farms, cities and towns.[13] These maroons were regularly described by authorities as "runaways," "lurkers," "banditti," "gangs," "fugitives," and "outliers."

The Dismal Swamp maroons significantly affected the outcome of the American War for Independence and influenced colonial, early national, and antebellum political, economic, and military agendas.[14] Through their determined refusal to be enslaved they revolutionized the nature of African American resistance and struggle for freedom so much that dominant white society felt it necessary to draw up large bodies of the militia, establish nocturnal planter patrols and committees, initiate slave codes, and enact curfews.

The maroons of the Dismal Swamp of Virginia and North Carolina established the oldest known enduring maroon communities in the United States. From the seventeenth century to the end of the Civil War, the Dismal Swamp served Black people in flight and resistance as a space of safety from enslavement. Based on folklore, oral histories, letters, archaeological evidence, periodicals, travelers' logs, and other eyewitness descriptions of the swamp, historians agree that until 1865, thousands of Black men, women, and children lived in its interior, although their estimated numbers vary between thousands and tens of thousands.[15] Many maroons remained elusive and were never discovered, so their true numbers will never be known. Other maroons maintained a constant local pressure of ambushes, seizure of property, burning of plantations, carrying off of provisions and livestock, and inciting the enslaved toward organized flight and revolt. Into the nineteenth century, networks were secretly established across plantations, waterways, urban spaces, forests, and the swampland between maroon groups and enslaved communities.[16] The

maroons of the deep-swamp interior had little reason to venture out toward the swamp's outskirts, while the peripheral-swamp maroons used the wild land as a refuge while engaging the outside world.[17]

The maroons who enter the documentary archive did so because of their failure to evade capture. Of the few whose names we know, Osman, a deep-swamp maroon, was described as "a gigantic negro, with a tattered blanket wrapped about his shoulders, and a gun in his hand," his expression "of mingled fear and ferocity."[18] Mingo, Ned, and other unnamed maroons were greatly feared by the citizens of Princess Anne County, Virginia, six hundred of whom petitioned the governor to hunt and execute "the murderous Mingo."[19] Described as "commonly armed with a gun, sword," Mingo and his accomplices were described as "lying out hid and lurking in the swamps, woods, and other obscure places committing murder, killing hogs and doing other injuries to the inhabitants" living at the outskirts of the northeastern Dismal Swamp.[20] The archaeologist and historical anthropologist Daniel O. Sayers has discovered evidence of continuous intensive human habitation in an interior area of the swamp representing less than 1 percent of its entirety, including six independent structures, believed to be cabins, three "large depressions . . . likely water-catchment pits," one fire pit located near the cabins, a "community defense structure" of some sort, and artifacts ranging from fragments of a white clay pipe to lead shot and gunflint, all dating between the seventeenth century and the period of the Civil War.[21] The lives of other swamp maroons, the great majority of whom remain nameless, maroon methods of survival, and specific practices of self-emancipation are currently the subject of new works highlighting this important chapter in US history and the history of the African Diaspora.[22]

Dominant Representation throughout the Hampton Roads

Throughout the Hampton Roads, the waterways and surrounding region encircling the Dismal Swamp and connecting southeastern Virginia and northeastern North Carolina, there are dozens of historical sites and museums dedicated to preserving, conserving, and commemorating the histories of the region. However, historical representation of the Dismal Swamp as a space shaped by the legacy of slavery, Black freedom struggle, community, or marronage is made visible at only a very small subset of these sites. The Great Dismal Swamp National Wildlife Refuge in Suffolk, Virginia, and the Dismal Swamp State Park in South Mills, North Carolina, are two of the most important sites throughout the Dismal Swamp and the surrounding Hampton Roads region that publicly narrate and represent the historical and present significance of the swamp. Of particular importance to the question of the politics of

power in institutional representation of US marronage are the practices em-
ployed by the US Fish and Wildlife Service at the refuge in Suffolk, the North
Carolina Department of Environment and Natural Resources at the state park
in South Mills, and the National Park Service. These state and federal institu-
tions "own" the swamp or maintain the authority to comtrol the narrative of
its historical significance for public consumption and interpretation within the
swamp today.

Interviews with Great Dismal Swamp Wildlife Refuge and Dismal Swamp
State Park managers, directors, superintendents, and rangers, as well as with
docents, guides, and other persons charged with the responsibility of publicly
representing the history of the swamp or histories of slavery in institutions
such as local plantations and museums, help to reveal how slavery, resistance,
and marronage are valued and represented (or not) at historical sites through-
out the swamp region. Site visits, pamphlets, websites, and observation analy-
sis of representational practices—such as historical narration through tours,
signage, and curating—also assist in developing a greater understanding of the
valuation of historical Black resistance, along with the relationships between
representation, race, and power at these sites

Between May 2013 and August 2015, in addition to visiting the Dismal
Swamp State Park and National Wildlife Refuge within the swamp, I visited
twenty-five historical sites and sites reflecting the historical significance of
the Hampton Roads and the Dismal Swamp in the cities and counties that sur-
round the swamp. These included museums, plantations, visitor centers, and
historical walking trails in three counties and eight independent cities that
form the most populated communities in the Hampton Roads Metropolitan
Statistical Area (MSA), which surrounds the Dismal Swamp.[23]

Institutional representations of slavery and resistance at these sites
continue to marginalize and minimize the histories of US slavery and resis-
tance. The silencing and rendering of marronage as marginal or ancillary
in institutional representations of the swamp are demonstrated through the
general absence of the narrative of slavery, an actual effort to maximize the
environmental significance of the swamp and minimize the social and cultural
significance, and the persistent deprecation, obscuring, and erasure of histori-
cal Black self-empowerment gained through reciprocal violence, autonomous
community, and resiliency despite tremendous adversity.

The Absent Narrative of Slavery

Throughout the Hampton Roads and indeed, until recently, throughout the
country, there remains a paucity of representations interpreting and com-
memorating the legacies of slavery in public spaces.[24] Although US slavery

has aroused new interest in popular culture as represented in film and media,[25] there remains a concerted effort to suppress, erase, and forget this unfortunate and uncomfortable event in American history.

Efforts to ignore, suppress, or forget slavery are especially strong even, and perhaps especially, on the very ground where it occurred not very long ago. Eichstedt and Small's 2002 study, *Representations of Slavery: Race and Ideology in Southern Plantation Museums,* points out that hundreds of surviving plantations visited annually by tourists are run by organizations that steadfastly avoid almost any discussion of slavery in general, of slavery as integral to the operation of these estates, or of the enslaved themselves. They find that of the 122 plantation tourist sites studied across eight states including Virginia, *"nearly 83 percent of all plantation sites in this study have symbolic annihilation* (or outright erasure) *as one of their primary strategies in relation to slavery."*[26] The study affirms the contention that institutional representational practices "construct narratives of US history that valorize whiteness and mystify the experience of enslavement," all the while making public damaging representations that "contribute to a very particular collective memory and, by extension, collective identification that legitimates contemporary inequalities."[27]

Plantation tourism across the South represents these historic sites through narratives that "marginalize the stories of the enslaved and whitewash history at the expense of those who through their toil made these landscapes and homes possible."[28] Plantation heritage tourism tells and sells tales where "the planter-class legacy takes primacy over the legacy of the enslaved" and where "mythic representations of slavery, the enslaved, and the planter-enslaver" dominate.[29] Such mythic narratives include "the faithful slave" and "the good master," commonly woven together to produce "a positive image of the planter and his family."[30] Along the James River in Virginia, northwest of the Dismal Swamp, plantation museums describe "a guiltless and romantic past—by featuring their beautiful architecture, rich family histories and period furnishings" in support of a dominant narrative where "slavery is either ignored or sanitized."[31] Here, "democratic ideals are strongest," and plantation museums throughout the state of Virginia, many of which were once the homes of this country's "Founding Fathers," pride themselves as having a place in "the birthplace of democracy," all the while brushing slavery and all of its implications aside.[32] All these representations are shaped by "uneven power" and a dominant culture of eagerness to "selectively remember (and forget) racialized violence and dispossession."[33]

Across the six plantations I visited in the Tidewater, all of which are located near the mouth of the James River, closest to the northernmost edge of the remaining Dismal Swamp, representations of slavery were consistent with these findings.[34] Five of these engaged in trivializing, minimalizing,

and/or marginalizing representations of slavery, and the sixth plantation demonstrated outright erasure. Throughout the Hampton Roads there are few plantation homes open to the public. According to information made available to the public at visitors' centers throughout the region on both sides of the interstate border, Ferry, Chippokes, Endview, Smith's Fort, Lee Hall Mansion, and Bacon's Castle are the only plantations operating as museums as of 2015.[35] At these plantations all docents, directors, and guides I encountered were white men and women. During each tour their strongest interpretive emphasis focused on representations about the lives and lifestyles of the white families who owned and lived at these estates over time. Additionally, the greatest weight in representation across these plantations, and across the region's museums in general, reflects the dominant patriotic narratives of the area's colonial splendor as the birthplace of American democracy, freedom, and independence or of the area's military struggles, triumphs, and general glory of the Civil War years. All of these plantations exhibited written, spoken, or spatial representational practices that segregated slavery from the dominant narrative of the plantation and marginalized, minimized, reduced, and/or erased the significance of slavery as fundamental to the economy, culture, and life of the plantation and beyond.

Other museums throughout the Hampton Roads also fail to represent the historical significance of slavery or do so only marginally and minimally. Riddick's Folly house museum and the Isle of Wight County Museum each maintain completely absent narrative representations of slavery despite it being instrumental to the foundation of the history presented there. The Museum of the Albemarle, established to represent and commemorate the history and culture of Elizabeth City and the Albemarle Sound, does marginally represent slavery through depictions of the historical contributions of enslaved communities through labor. However, no signage, exhibits, or literature about the institution of slavery itself as culturally, economically, or sociohistorically fundamental to the development of the region is made available to visitors. Nor is there any representation of the history of marronage, despite the fact that there are several displays exhibiting the history of trade, commerce, and travel through the Dismal Swamp canals.[36]

The Erasure of the Dismal Swamp Maroons

The dominant narrative about slavery around and among the communities surrounding the Dismal Swamp is one of denial, erasure, avoidance, and marginalization, so it is little wonder that the politics of race and power in representation of Black resistance to enslavement, and particularly marronage, is also reflected in institutional representational practices within the Dismal Swamp itself. The Dismal Swamp Canal Trail, managed by the City

of Chesapeake Parks, Recreation, and Tourism; the Great Dismal Swamp National Wildlife Refuge in Suffolk; and the Dismal Swamp State Park in South Mills constitute the three points of public access into the swamp. The Canal Trail presently offers no public representation about the significance of the swamp as a site of marronage or as a space deeply implicated in the history of US slavery. However, both the refuge and the state park do integrate representations of the Dismal Swamp as a space that is significant in the history of the Underground Railroad and throughout the period of US slavery. Representations of maroons at these sites are visible for public viewing but do not represent a full narration of the power and historical agency of individual maroons and maroon communities to incite resistance on the part of enslaved communities surrounding the swamp. Representations also do not narrate the swamp's geographical significance as a locus for Black revolt, overt resistance, and violent struggle for freedom. Moreover, although representations of Black flight, resistance, and marronage are integrated into the dominant narrative and made visible to the public at both the refuge and the state park, they remain marginal and thereby unequal, for they are primarily backgrounded by representation and narration of the swamp as a space of ecological and environmental significance or as a space of recreation.

The Dismal Swamp Canal Trail runs along the eastern border of the swamp, the well-traveled US Route 17. The City of Chesapeake Parks, Recreation, and Tourism opened the 8.5-mile multiuse trail to the public in April of 2006. The trail was paved over Old Route 17, once used to ferry barges along the Great Dismal Swamp Canal. Beginning in 1793, this intracoastal canal was hand dug by enslaved laborers. A causeway road, Old Route 17 was also constructed by enslaved young men, many of whom were barely teenagers.[37] Construction was completed in 1805. The current US 17, also running parallel to Old Route 17 and the canal, was constructed in the 1920s for automobile travel. The canal trail now allows for biking, birding, photography, picnicking, fishing, boating, horseback riding, rollerblading, and dog walking. Since 2006 the City of Chesapeake Parks, Recreation, and Tourism has also sponsored the Dismal Swamp Stomp, an annual marathon attracting hundreds of runners from across the Hampton Roads to the Dismal Swamp.

The Dismal Swamp Canal Trail lacks any commemoration of the enslaved canal laborers whose lives were sacrificed for the commercial enterprise of intracoastal trade and travel. In bolder, truer terms, the canal trail lacks a single form of representation made visible to the public commemorating the enslaved laborers who hand-dug and toiled at the threat of the lash in swamp water often three to eight feet deep and infested with snakes, mosquitoes, and biting flies.[38] Today, visitors to the swamp at the canal trail can enjoy recreation without once thinking about, honoring, or remembering the suffering,

survival, freedom, or resilience of those who built the space. However, visitors can collect pamphlets about recreational activities and the various mammals, reptiles, and amphibians living in the swamp, or even pause to read Civil War historical markers erected by the Virginia Department of Historical Resources and Virginia Civil War Trails—none of which represent the swamp's significance as a site of Black resistance and historical agency.

The Dismal Swamp Canal Trail parks manager for the City of Chesapeake admitted that the trail offers the public plenty of information about the swamp's ecology but "nothing about its people" or history as of yet. Although the trail has been open to the public for more than a decade, and despite the fact that it was even designated as a part of the Underground Railroad Network to Freedom by the US Department of Interior's National Park Service (NPS) in 2004, there remains no indication at this site of the swamp's historical significance. However, the parks manager did explain that the city is working on ten interpretive signs to be erected along the canal trail, five of which would narrate the swamp's ecological importance and five of which would represent the swamp's history and cultural significance. Part of the historical component of this plan would include narrative representation of Black flight through the Dismal Swamp and the surrounding Hampton Roads framed through the history of the Underground Railroad, as well as an extremely brief mention of "the maroon colonists."[39] I was offered no definitive insights into the expected time frame for completion of this project.[40]

The two other sites that permit public access into the swamp are the Wildlife Refuge, managed by the US Fish and Wildlife Service, and the Dismal Swamp State Park, managed by the North Carolina Department of Environment and Natural Resources. In 1974, after a century of logging and continued canal development following the Civil War, the Union Camp Corporation, a paper company based in Franklin, Virginia, donated 49,097 acres of swampland to the Nature Conservancy. This land was in turn transferred to the US Department of the Interior, which signed the Dismal Swamp Act of 1974, authorizing the swamp's current boundaries and establishing the Great Dismal Swamp National Wildlife Refuge, now a little more than 112,000 acres, as well as the 14,000-acre Dismal Swamp State Park in North Carolina. Some estimate that the swamp's current acreage is only 10 percent of the swamp's original size prior to draining, logging, and canal construction. The colonial and pre-colonial swamp stretched from what is today the James River in Virginia to the Albemarle Sound in North Carolina, a space comparable to the size of the state of Delaware.[41] Indeed, the US Fish and Wildlife Service has written that estimates of the original swamp "exceeded one million acres."[42] By 2008, the state park in South Mills, North Carolina, had opened to the public, and the refuge in Suffolk, Virginia, has been open to the public since the 1970s.

After a "ground swell of community support,"[43] NPS mandated the National Underground Railroad Network to Freedom Act of 1998 as Public Law 105–203, "to commemorate and preserve the history of the resistance to enslavement through escape and flight, through the National Underground Railroad Network to Freedom Program" (URNF).[44] Through the extensive leadership efforts of African Americans invested in the history of the swamp and a small community of scholars in cooperation with the US Fish and Wildlife Service and the North Carolina Department of Environment and Natural Resources, the Dismal Swamp was accepted by the Park Service's URNF Program as a site "making significant contributions to the understanding of the Underground Railroad in American history" in December 2003.[45] By 2004, the refuge and the then-uncompleted Dismal Swamp Canal Trail and State Park were each designated as sites within the URNF.

In 2008 the Dismal Swamp State Park opened to the public, offering nature trails, ecological education, and a wide array of recreational activities such as picnicking, kayaking, and canoeing. At the park, visitors can visit the Welcome Center and the Visitor Center, both opened in 2008. The Welcome Center houses pamphlets and other tourist literature about attractions in the surrounding Hampton Roads and throughout the Tidewater region. The natural environment of the swamp is represented here through books, cased displays, literature, and signs, whereas the social history of the swamp is only minimally represented within guides and brochures. It is the Visitor Center that offers integrated representations of the swamp's social, cultural, and ecological significance. Inside, visitors will find an exhibit hall titled "The Changing Face of the Dismal." This exhibit includes two displays that wrap around to form a circle as you walk through them. Visitors can begin with "Denizens of the Dismal," which focuses on the social, human history of the swamp, or "Web of Life," which emphasizes the swamp's ecological and environmental importance. In sum, the exhibit integrates the history of the enslaved canal laborers, Black flight and escape through the Dismal Swamp, and marronage with representations of the swamp as a natural environment teeming with flora, fauna, and animal life. Two signs currently stand outside the Visitor Center along the canal there, both commemorating the swamp canals as spaces built by the "grueling," "treacherous," and "brutal" labor of the enslaved, and both representing the narrative of slavery as significant to our understanding of the Dismal Swamp.[46]

Scenes in the "Denizens of the Dismal" display feature reductive and trivial mentions of the historical significance of the Dismal Swamp maroons. Explanatory text publicly represents enduring maroon communities that were resistant and enduring as merely reactionary escape attempts. The exhibit represents marronage as motivated by individuals who sought to "flee captivity"

or "avoid capture," rather than offering a fuller depiction of maroons as calculating, organized, agentive individuals and groups who resisted captivity through flight and the forging of new possibilities for freedom, independence, and community against extreme odds.

More minimizing representations of enslaved resistance and marronage are found both on site and in tourist literature. Erected by the NPS and the North Carolina Department of Environment and Natural Resources, the "Pathways to Freedom" sign outside of the Visitor Center informs visitors that "from the earliest times, some enslaved people attempted to escape their bondage. The Great Dismal Swamp provided a number of these freedom seekers a place of refuge. Some made homes deep in the swamp where they lived in communities known as 'maroon colonies.' Others used the swamp as a temporary hiding place on their journey to freedom."[47] There is only one brochure among the various pamphlets and guides made available at the park that expands upon the swamp's history of Black flight and resistance beyond the information provided on site. Although the Welcome Center's "Underground Railroad Network to Freedom" leaflet does not mention the term *maroons* and does not include the history of the swamp's maroon communities within the narrative representation of the swamp's relationship to flight in general, it does reiterate that "the Great Dismal Swamp was a known route for runaway slaves" through its elaboration of escape using the network known as the Underground Railroad.[48] No where are representations of self-determined freedom struggle. Representations of maroons as guerilla warriors or as inciters of flight or revolt throughout the Dismal Swamp and its surrounding cities and counties are erased and throughout the swamp landscape.

Interviews with the Dismal Swamp State Park's park superintendent in 2014 and her replacement superintendent in 2015 clarify that, above all, the park itself exists for the purposes of (1) natural resource management, (2) environmental and cultural education, and (3) recreational opportunities.[49] In fact, the North Carolina state parks system mission statement is "to conserve and protect representative examples of the natural beauty, ecological features, and recreational resources of statewide significance."[50] The historical significance of sites has not traditionally been an institutional priority. The former park superintendent, who had worked at the park for eight years at the time of the interview, stated that "we tend to focus on the environmental issues—you know, we're not trained historians, but working with the cultural history of the swamp is a goal, and we're optimistic."[51] She admitted that she welcomes Eric Sheppard's leadership in the area around the park's human history. Sheppard, the president of Diversity Restoration Solutions, a cultural heritage awareness initiative, is a descendant of the enslaved canal laborer Moses Grandy and has been instrumental in the representational inclusion of narratives on slavery

and African American historical agency in the swamp at the State Park Visitor Center and on the grounds. Although the park offers regularly scheduled interpretive nature programs, the superintendent explained that Sheppard's tours about enslaved canal labor and the Underground Railroad through the paved trails at the park are the only historical tours offered to visitors. Nevertheless, she expressed her commitment to building up the history of the maroons: "We have one of the largest maroon communities in the country—that's important to share with people. . . . The more we can get out there about the swamp, the better for making people value this history."[52]

The current park superintendent is less enthusiastic. Regressing back into the older tradition of institutional representation of sites at state parks, he demonstrated very little interest in continuing his predecessor's work on developing stronger cultural education about the social histories of the Dismal Swamp. His goals for accommodating visitors focus almost entirely around the swamp's natural history and environment: "to restore and replenish the swamp's ecology" by planting more trees, to "undo water control structures," and to provide new recreational activities to bring visitors in.[53] One of the few African American staff members at the park shared her belief that the new superintendent is in fact "trying to stop the historical tours" but was evasive about what specific indications led her to believe this.[54] Another African American affiliate of the park, working on the cultural significance of the swamp, stated that the present superintendent "wants us [Black people and Black history] to fit into a box—and I'm not doing it."[55]

Although the state park's on-site representational practices of the Dismal Swamp as a space that is historically and presently significant because of the histories of slavery, flight, and marronage are in fact integrated into the dominant narrative represented to the public, this history remains marginal through minimalizing, trivializing language, persistent devaluation and silencing about the magnitude of resistance and marronage, and the overall marginalization of the swamp's social significance in favor of the ecological and recreational. Narrative integration does not necessitate equal narration, nor does it guarantee equal valuation. Representations of the swamp's significance as a space implicated by Black suffering, violence, overt resistance, independence, and resilience are either minimal or do not exist.

In 2010 the US Fish and Wildlife Service began the construction of the Underground Railroad Education Pavilion at the Great Dismal Swamp National Wildlife Refuge in Suffolk, Virginia. By February 2012, the pavilion opened to the public, offering what is by far the most extensive narrative representation of the Dismal Swamp maroons, their significance within the broader history of US marronage and marronage within the African Diaspora, their resistance, and their creative survival and resilience within the swamp. The display within

the pavilion, titled "Resistance and Refuge," highlights information about motivations for flight into the swamp (temporary escape, permanent independent community building, freedom), how the maroons survived once in the swamp, how the swamp's natural and cultural landscape changed at the dawn of the nineteenth century (the era of canal digging), and how this affected the maroons.[56] This information is also represented in one of the refuge's tourist pamphlets titled "The Great Dismal Swamp and the Underground Railroad," which adds that "as many as 50,000 maroons may have lived in the swamp," emphasizing the great historical impact of marronage in the swamp and throughout the Tidewater.[57] The pavilion is the only on-site representation of the swamp's historical and cultural significance.

Beyond the acknowledgment that the refuge is a designated site in the URNF, there is no information about the Underground Railroad or the swamp's relationship to it in on-site or printed literature representations. Besides noting the fact that Black people escaping enslavement took flight into the swamp either temporarily or permanently, neither the pavilion nor its accompanying pamphlets mention how marronage in the Dismal Swamp is historically connected to the Underground Railroad or why the site's representations of the maroons are framed by the idea of the Underground Railroad and appear under the label "Underground Railroad Education Pavilion." Instead, the pavilion is entirely about flight and marronage as resistance to enslavement and about life and labor in the swamp. In fact, this is the only site throughout the Dismal Swamp Tidewater region that represents the social history of the swamp as significant because of Black historical agency, freedom struggle, and resilience, without the use of trivializing language or minimalizing representations of marronage as a fundamentally resistant and self-determined act.

So, beyond the site's designation into the URNF, why isn't the pavilion ultimately framed by one of these concepts or themes? Certainly there could be any number of reasons, including the fact that the overwhelming majority of the public in this country cannot readily identify the terms *maroon* and *marronage* but are more familiar with "runaway slaves" and the history of the Underground Railroad.[58] Also, it is through the NPS's URNF Program that the refuge established the education pavilion as an initiative to bring greater awareness to the swamp's historical significance as a site implicated by slavery and the efforts that led to its abolition. But despite the refuge's attentiveness to Black resistance and marronage as integral aspects of the swamp's history, the dominant narrative about the swamp's historical significance is not primarily shaped by the site's representations of the legacy of marronage and autonomous resistance, but by the vague and nebulous notion of the Underground Railroad.

Throughout the Hampton Roads the sites that publicly represent the history of the Underground Railroad include the Dismal Swamp Fish and Wildlife Refuge, the Dismal Swamp State Park, and the Waterways to Freedom: The Underground Journey from Hampton Roads walking tour in Norfolk, Virginia, also sponsored by the URNF Program. The leading representation of the Underground Railroad across the region states that the network "was not underground nor was it a system of tracks, but an informal network of secret routes and safe houses used by black slaves" and orchestrated by "conductors" who "came from various backgrounds and included free-born blacks, whites, former slaves (either escaped or manumitted), and Native Americans."[59] A common representation of the Underground Railroad throughout the Hampton Roads comes next: "The network provided an opportunity for sympathetic white Americans to play a role in resisting slavery, and brought together, however uneasily at times, men and women of both races to begin to set aside assumptions about the other race and to work together on issues of mutual concern."[60] The Waterways to Freedom walking tour pamphlet also states that the Underground Railroad was organized by "conductors" who "were often skilled slaves, free Blacks, or whites."[61]

These representations, especially as they are made visible on the very swampland that was once the setting of untiring autonomous Black resistance against enslavement, risk obscuring our abilities to publicly commemorate and represent the history of independent and self-governing networks between and among the enslaved, the manumitted, and the maroons. It is within the wide and varied range of actions of the enslaved to assert and procure their own freedom throughout the history of slavery, autonomous actions that formed countless networks to freedom across the US South and across the African Diaspora, that the Underground Railroad should be understood, not the other way around. John Michael Vlach contends that it is the agency of the enslaved themselves that should be the framework by which we understand the Underground Railroad, yet "the heroism of African Americans is diminished by the use of railroad metaphors that divert most of the attention to 'conductors' and their 'stations.' . . . The Underground Railroad of popular legend casts blacks mainly as the passive 'customers' who were fortunate enough to receive a 'ticket' allowing them to ride on the 'Liberty Line.'"[62] Although the Underground Railroad is undoubtedly an essential part of US history and the histories of slavery and abolition in this country, there was never one sole network of flight to freedom at any time or in any place throughout the course of history. The framing of one singular "network to freedom" or "Underground Railroad" makes it difficult to fully represent the extent of Black historical agency and self-empowerment in the Dismal Swamp without obscuring and

reducing the historical significance of Black autonomy, marronage, and the organization of innumerable resistant communities.

Trivial, minimal, integrated yet unequal, and nonexistent representations of the Dismal Swamp's historical legacy throughout the Hampton Roads, as well as the Dismal Swamp Refuge and the state park's representational use of the Underground Railroad as a framework for narrating the swamp's history of flight, resistance, and marronage, are all practices that reflect the perspectives and priorities of the institutional actors who authorize and control the narrative representation of the swamp's past and present significance. Priorities are often based on funding but are also influenced by the positionalities, interests, and perspectives of the people who operate and manage these sites. The priorities at the Canal Trail in Chesapeake and the state park in South Mills are recreational, but the priority at the refuge is, above all, nature conservation. The US Congress funds the Department of the Interior's Fish and Wildlife Service to "protect and manage the swamp's unique ecosystem," so it is little wonder that representations of the swamp's historical and cultural importance are marginalized by ecological representations and the recreational priorities of birding, hiking, and wildlife observation.[63] But when federal ownership and use of land is entangled with the history and cultural heritage of marginalized or oppressed groups, institutions have an ethical responsibility to represent the history and honor the knowledge and memory that groups possess about the land and its past. This was the motivation for the Underground Railroad Education Pavilion, according to the Dismal Swamp Refuge's visitors services specialist. She explained that the refuge was first contacted by a local Black researcher and historian of flight and resistance in the swamp in 2001, followed by an African American artist who was working on US marronage, and was then put into contact with a small community of scholars, including American University archaeologist Dan Sayers, each of whom were instrumental in the shaping of new historical narratives at the refuge.

But when plans began to recognize the cultural history of the Dismal Swamp in 2001, refuge staff members were initially against moving in the direction of historical emphasis. By the end of 2003, once the swamp had been approved and officially acknowledged by the NPS's URNF Program, the refuge received negative responses from its traditional funders and supporters. A majority of institutional staff and friends alike were at best hesitant about the new plan and at worst outright opposed to installing a historical component dedicated to honoring Black experiences in slavery and especially opposed to honoring Black resistance efforts. The opposition amounted to the refusal to "celebrate Confederate failure."[64]

The representation of African American resistance and marronage through the conceptual framework of the Underground Railroad can be understood as reflecting institutional aspirations to selectively remember the antislavery freedom struggle by concentrating on white aid and leadership as a way to, either intentionally or unintentionally, suppress the memory of the ever-present freedom struggles experienced by, led by, and carried out by Black people themselves. The NPS defines the URNF Program as one that "extols the historical significance of the Underground Railroad in the eradication of slavery and the evolution of our national civil rights movement, and its relevance in fostering the spirit of racial harmony and national reconciliation."[65] It may be easier and more comfortable for many to confront representations of resistance that include or depend upon well-meaning whites than it is to confront representations of freedom struggle that do not. The latter may invoke fear that Black people, inspired by the historical reminder and the unfinished business of freedom, might actively organize opposition against an oppressive system independently of white means, methods, and agenda, again. To a sizable extent, the history of the Underground Railroad is used as a way to put a small bandage on race relations in the present rather than to truly work toward an equal and just society by naming the crimes against Black people, their resistance against them, and their resilience in spite of them to ensure such crimes will not be repeated in any form. Instead, it is used as a platform to ease institutional discomfort by sustaining the proximity of white experiences to the center of the narrative, assuaging white guilt of complicity through the assurance of interracial collaboration, and proclaiming the sites' benevolent aspirations of "racial harmony" and "reconciliation." Fuller interpretation and radical, honest telling holds greater promise for genuine healing, reckoning, and progress.

In February 2020, Virginia Congressman A. Donald McEachin introduced the Great Dismal Swamp National Heritage Area Act, designed to protect and preserve the historical, cultural, and social-environmental significance of the Dismal Swamp to the American people. The act was inspired, encouraged, and supported by the Wilderness Society, the National Trust for Historic Preservation, the Nature Conservancy, and the Great Dismal Swamp Stakeholder Collaborative (GDSSC), a coalition established in part between the Nansemond Indian Nation, the Haliwa-Saponi Indian Tribe, and the Association for the Study of African American Life & History. This important and unfolding development in the public history of the maroons was fundamentally made possible by ongoing scholarship engaging available written and nonwritten archives about the lives of maroons,[66] in addition to grassroots organizing by local Black and indigenous groups: the first inhabitants of the swamp. Scholarly investigations that valued the actions and lived experiences of maroons,

together with this activism, demanded attention be directed to the Black and indigenous human stories in the Dismal Swamp at both state and national levels. Along with the recent work of scholars and activists, Congressman McEachin, who is an African American leader and an agitator for the passage of the act, unquestionably put pressure on institutions such as the US Fish and Wildlife Service and the National Trust for Historic Preservation to begin to take seriously the (in)visibility of Black and indigenous life in the swamp, that including an open honoring of these American maroons. From absence, erasure, and silence then emerges the possibility for recovery, visibility, and more equitable representation of long marginalized groups. Time will tell whether or not such legislation to honor and reckon with the lives of resistant maroons will be passed and whether the landscape of public history in the Dismal Swamp will begin to more fairly represent its human history.

Dominant representations of history and the collective memory it makes possible are not produced separately from the politics of power, very frequently tied to race as the center of struggles to create and control meaning. The history of the Dismal Swamp maroons is not only marginalized, obscured, and silenced throughout the Hampton Roads because it historically challenged dominant white society but it also remains marginal or absent because even the very act of representing this history and commemorating "subversive" acts is viewed as an act of resistance that threatens the distribution of race-based power in the present. Fitzhugh Brundage has noted this as an important pattern of representation in commemoration efforts on sites with contested histories: "Southern whites, like all dominant groups seeking to claim unanimity among themselves and consent among subordinates, purposely sequestered black dissent out of their sight." Stories about African American resistance and the representation of counternarratives to dominant versions of the past are thus often "cryptic, muted, and veiled" or else "regularly obscured."[67] Calling attention to acts that historically disrupted the status quo in the past also disrupts the status quo in the present, especially since the status quo remains firmly ensconced by hierarchies of yesteryear.

 A fuller, more visible, and more inclusive history of the Dismal Swamp, rich with the names, places, and actions of maroon communities, directly challenges unquestioned white supremacy through (1) the empowering and uplifting narratives of a geographically and temporally ubiquitous, independent Black community; (2) resistant organization against oppression; and (3) creative, autonomous, alternative life. The telling of an unmarginalized, nontrivializing, more complete version of the actions and agency of the Dismal Swamp maroons offers new opportunities to reinterpret the past and

reconsider present circumstances toward reconceptualizing and imagining new futures. Fuller representation of the swamp's human history reminds us that not long ago the humanity of African descendants in this country was brutally assaulted on the very land where descendants of the enslaved now continue to live in poverty and confront new forms of oppression, that Black people never historically accepted these conditions without protest, and that even in the "vast body of dirt and nastiness" that is the Dismal Swamp, enslaved people forged spaces of freedom and resilient community.[68] This history is rich in lessons that can empower African American communities because of their historical legacy of resistance and freedom struggle against inconceivable odds, but its public commemoration also presents an opportunity for our collective reflection about the unconquerable and tenacious human spirit, and the living history of anti-Black racism that once made the swamp a refuge for defenders of freedom.

PART II
Seeking Collaborations

Hidden in Plain Sight

Contested Histories and
Urban Slavery in Mississippi

JODI SKIPPER

Behind the Big House is a slave-dwelling interpretation program in Holly Springs, a city in the North Mississippi Hill Country. The city was founded in 1836 by white settlers who benefited from lands available just after the Chickasaw Cession. Its surrounding Marshall County largely developed through cotton plantations dependent on enslaved labor. Small urban centers like Holly Springs were support systems for rural farms and plantations, providing "facilities for moving the agricultural crops to market and for importing farm and plantation supplies."[1] By 1850, the city of Holly Springs had a population of 3,500, with the Mississippi Central Railroad, which ran through Holly Springs just two years later, increasing the city's affluence. Marshall County, which "led the state in the production of cotton and of almost every other agricultural product," had a population of nearly thirty thousand residents, nearly half of them enslaved.[2]

The prosperity of antebellum white Marshall County residents is still evident in the built environment of Holly Springs. For seven years I have worked as a scholar-in-collaboration with the Behind the Big House tour, an education program designed to interpret a built environment through the lens of urban slavery. Large-scale plantation sites have dominated slavery interpretation studies in the United States, with few exceptions.[3] My seven years of observations as a program guide indicate that the historical narratives and interpretations on the tours affect visitors in many of the ways presented in Kristin Gallas's and James DeWolf Perry's *Interpreting Slavery at Museums and History Sites,* yet the potential impact of the historical built environment in urban spaces is underestimated in slavery-interpretation discussions.[4] This is especially the case in small cities and towns, the most representative form of nonplantation slavery and the most unfamiliar to contemporary site visitors.

The goal of this essay is to offer Behind the Big House in Mississippi as one such case study.

For more than eighty years, the Holly Springs Garden Club's Annual Pilgrimage Tour of Homes and Churches (hereafter, the Pilgrimage) has interpreted the city's antebellum period through the structural grandeur and fine furnishings of those mansions once owned by white elites who relied on Black slave labor to maintain those homes; narratives of dedicated slaves and benevolent masters are not uncommon. The Pilgrimage stems from one founded by the Natchez, Mississippi, Garden Club in 1932, a month-long spring event that opened Natchez's "unsurpassed collection of privately owned antebellum mansions to paying tourists."[5] After several Holly Springs Garden Club members visited the Natchez Pilgrimage in 1936, they hosted a "tour of historic sites" as part of the city's centennial event that October. The second house tour in Holly Springs, the Pilgrimage, began in April 1938.[6]

In 2012 Holly Springs residents Chelius Carter and Jenifer Eggleston piloted the Behind the Big House program as what they saw as a complement to the Pilgrimage. Carter, a restoration architect, and Eggleston, a National Park Service grants administrator, discovered that the detached kitchen on their property, the Craft House, was likely a former slave dwelling. They identified twelve others in Marshall County, most of them in Holly Springs, and organized the pilot program through Preserve Marshall County and Holly Springs, Inc., a local historic preservation institution. Since the pilot program, Behind the Big House has taken place each April for a four- to five-day period. It occurs during the Pilgrimage, the city's main tourist attraction, to take advantage of an already established audience.

From 2012 to 2014 the tours coexisted, with intersecting tourists and little to no collaboration. This environment was confusing to tourists. Some intentionally toured the slave dwelling sites. Others accidentally toured them, assuming they were on the Pilgrimage. This temporarily changed in 2015, when members of Gracing the Table, a local group that uses historical narratives to inspire cross-racial community dialogue, mediated talks between some members of the Garden Club and Behind the Big House program developers. For one year, Gracing the Table helped to successfully transform the Pilgrimage into the more inclusive Holly Springs Home and Heritage Festival (and Pilgrimage). This included the intentional marketing of Behind the Big House Program events by the Garden Club and narratives of slavery presented at several Pilgrimage house sites. However, the Pilgrimage returned to its traditional format after some Garden Club representatives determined that the collaboration was not feasible for the next year. In 2016 the tours again coexisted without collaboration and have done so to date. My work with Behind the Big House began in 2012, and my years of historic preservation practice, research,

and teaching were not enough to prepare me for the intersections of pasts, presents, politics, and the tensions "embedded in the history"[7] of communities, especially when difficult heritages are being explored. I have occupied several roles as a scholar-in-collaboration, including being a Behind the Big House tour guide and a Gracing the Table member.[8] In addition, students in my heritage tourism and African diaspora courses began working as program guides in 2013. I require students to participate in a Holly Springs site visit, guided by Carter, prior to working with the program. As a class requirement, each student also submits a written evaluation of Carter's tour. Each student then chooses a site at which to work and is given talking points for that site. Their roles as guides include counting the numbers of visitors, interpreting what is known about each property, answering visitor questions, and asking that each visitor fill out a survey. They then submit a written evaluation of their experiences as guides. You will see some of their comments in this essay.

My multilayered roles have allowed me to witness how Behind the Big House visitors receive information at the slave dwelling sites and to better understand what their responses might tell us about best practices for interpreting slavery at small-city and town sites. Architectural examinations of sites of urban slavery, which might be helpful to such interpretations, are even less prevalent.[9] Recent collections such as Ellis and Ginsburg's 2017 *Slavery in the City* show the potential for such investigations. Small cities and towns, in general, have been largely neglected in slavery studies, outside of Richard C. Wade's *Slavery in the Cities* (1964) and Claudia Dale Goldin's *Urban Slavery in the American South 1820–1860* (1976), with exceptions in historical archaeology research.[10] One goal of this essay is to examine underrepresented urban sites as representations of slavery in the present, using the Behind the Big House tour as a case study. I highlight two sites on the tour: the Craft House, with its 1850s Greek Revival style main house, and Burton Place, with its 1848 brick Federal-style main house. Each site includes a kitchen/quarters structure that is a former slave dwelling. Behind the Big House is a grassroots effort with property owners who live in the main houses at least part-time. Neither of the homeowners is a full-time historian or museum specialist. This leaves them largely dependent on volunteer support, including myself as an academic collaborator. It also gives site owners much flexibility in how they present the built environment and represent the lives of enslaved persons. This program structure permits me not only to observe and participate in this program but also to assess how this program fits within contemporary frames of slavery interpretation. My observations reveal three general points about Behind the Big House program visitors: (1) visitors, across demographics, generally have preconceived notions of southern slavery as a rural phenomenon; (2) several visitors experience what Gallas and Perry call a learning crisis, a cognitive

dilemma that "generates psychological discomfort" when "a person receive[s] new information that conflicts with a preexisting belief or opinion"; and (3) there are racial and age variations in responses to the represented built environment.[11] My hope is that my experience will assist other collaborators helping local communities interpret slavery, especially those at small-city and town sites.

The Craft House Site

Carter and Eggleston own the Craft House. In 1839 Hugh Craft came from Milledgeville, Georgia, to Holly Springs as an agent for the American Land Company. His home, modeled after a Greek temple surrounded by columns, was likely constructed in 1852 "as Marshall County entered its most prosperous and architecturally significant decade."[12]

Craft's surveying and land speculation became quite successful, and he built a small office, no longer extant, on the property's east side. Craft also came to own much of the lot across the street from the present property, where he had barns, a horse lot, and vegetable gardens. The property is most notable as the headquarters for Union Colonel Robert C. Murphy during Confederate General Earl Van Dorn's raid on December 20, 1862, in which Union soldiers sought cover within the main house walls as the Confederates advanced on Holly Springs.[13] Craft family descendants occupied the main house for 141 years. It was subsequently purchased by two other owners and then by Carter in 2002. Eggleston moved to Holly Springs in 2008 and noticed that "Holly Springs has an inarguably inspiring architectural inventory." She added that "what spoke to me was the considerable number of buildings directly related to slavery."[14]

The kitchen/quarters might predate the main house, which Carter explains through Chloe Collier's property transfer to her daughter Elizabeth Collier Craft, Hugh Craft's third wife (Craft was twice widowed), in 1850. From 1839 until 1851 the Crafts lived in a small frame cottage (still extant behind City Hall) one block north of the current property on Memphis Street. According to Carter, Hugh Craft likely took down Collier's cottage to build the present main house, which is clad in stucco, as opposed to the board-and-batten detached kitchen/quarters, which is not. Carter thinks that the kitchen might have been built to suit Collier's cottage rather than Craft's house. This would explain the dissimilar appearance between the two structures. There is no evidence of a previous cottage on the property, and the location of the main house likely makes that footprint ephemeral. According to Herman, "In some situations the construction of the house and its outbuildings occurred at different times. . . . In other instances, the house and its outbuildings were conceptualized and built as a piece."[15] Craft might have also built the kitchen/quarters to

temporarily house the family's enslaved population until the main house was completed, having little to no regard for consistency in the appearance of the two structures.

The freestanding kitchen structure on the Craft property includes "two residential rooms in front of a long rear cook-room that contains a stair to an occupiable attic. . . . All three main-floor rooms employ fireplaces in a central chimney set parallel with the front and rear walls."[16] The structure also includes a cellar with a fireplace.

The 1900 census recorded forty-year-old Lillie Wright as a cook and twenty-year-old Mary Garrison as a chambermaid on the property. These Black women might have occupied the kitchen/quarters at least until 1900. The late nineteenth-century newspapers glued to the walls in both rooms might have been placed there as insulation. The 1850 and 1860 US Slave Census Schedules show that Hugh Craft owned nine people during both census years, although these do not seem to be the same nine people. A copy of the 1860 US Slave Census Schedule is on display in the kitchen/quarters. At least six of them are not adults, at ages sixteen, fifteen, twelve, nine, six, and three. Two former enslaved persons, Tom and his wife, "who were once slaves of the family," visited the property in 1924, and Chesley Thorne Smith, who was raised in the main house, took their photograph on the front gallery of the main house.[17]

Although Tom's wife is unnamed, I did come across a 1910 census listing a Sarah and Tom Lenderman living in a household in Marshall County in April of that year. Tom was fifty-five (born around 1855), and Sarah was fifty-seven (born around 1853). Based on their birth years, they were both enslaved as children. The six-year-old female and three-year-old male listed as enslaved by the Crafts come closest to the ages given by Tom and Sarah in 1910, but it is not yet confirmed whether one (or both) of them lived on the property as children. In addition, Tom's parents are both listed as coming from Georgia, where Hugh Craft was also from. Tom and Sarah were also living together in 1900, with their birth years given as 1850 and 1854, respectively. In this case, Tom's birthplace, along with that of his parents, is listed as Tennessee. Sarah's is listed as Mississippi, while in 1920 it is listed as North Carolina. There is also an 1895 marriage record for Tom and Sarah Lea Lenderman.[18] No children are listed for them in either of the census records.

Tom and his wife's photograph is on display, along with a mid-nineteenth-century daguerreotype of the Craft family, with what appears to be a well-dressed Black man to the family's right and the kitchen/quarters in the background. This man might have been a butler, coachmen/carriage, or driver/wagoner, but he could also have been responsible for gardening, landscaping, and carpentry. Enslaved men in urban environments also served

as furniture makers, bricklayers, tree fellers, mechanics, blacksmiths, railroad workers, wheelwrights, and stablemen. In factories and mills in Holly Springs, enslaved men produced wrought-iron products, bricks, carriages, furniture, pottery, and more.

Burton Place

David Person, a South Texas native who became a part of the Holly Springs community after retiring there in 2002, purchased Burton Place for restoration and repair after hearing rumors that a developer was going to buy the three-acre property for condominiums. The kitchen/quarters on Person's property is featured on the Behind the Big House Program, and his main house has appeared on the Pilgrimage, which selects a few homes for presentation each year. The kitchen/quarters on Person's property is a plainly finished brick building, one room deep and three rooms wide. In addition to the kitchen, the other two rooms, each with a separate entrance, might have served as residences and workrooms for enslaved persons. The 1860 slave census schedule for the Burton Place property notes two slave houses, which could refer to those two rooms.

For slave owners, the placement of the urban slave quarters was about having visual authority over enslaved persons' movements.[19] Even up to the mid-twentieth century, the segregated spaces established by white enslavers, who also controlled the Black bodies in those spaces, persisted.[20] The middle room of the kitchen/quarters structure at Burton Place was occupied into the 1960s by a local African American woman who worked as a nanny for descendants of the original property owner, Mary Malvina Shields Burton.

In 1836 Mary Burton came to Holly Springs with her husband, Dr. Phillip Patrick Burton, to capitalize on the county's sale of land. The couple divorced six years later. To manipulate a legal system preferential to men, Burton's brother acted as trustee of her estate at the time of her divorce. As a result, she was able to become a wealthy Marshall Countian, modeling her refined house after those in her native Rockbridge County, Virginia. According to the 1850 US Slave Census Schedule, Burton enslaved eight persons. By 1860, that number had increased to eighty-seven. Seven enslaved persons were recorded at the Burton townhome in Holly Springs. The other eighty likely lived and worked on Burton's plantation in the county, where twelve slave houses (no longer extant) were recorded. Thanks to Deborah M. Davis, a genealogist and descendant of persons enslaved by Mary Burton, we know the names of sixty-seven of those enslaved by Burton in 1860. Those names are on display in one of the quarters, along with the slave census schedule. Davis and other family members volunteer as program guides, sharing genealogical research along

with family oral histories to visiting tourists. This information humanizes those, such as Davis's ancestors, who lived and worked on Burton's properties.

The Tours

The Hugh Craft main house is the headquarters for the Behind the Big House program, but it is not on the Behind the Big House tour. Carter and Eggleston are consistent in their efforts to centralize the structures that housed enslaved persons, and closing off the main house to tourists serves that goal. During the four- to five-day program, one to two weekdays are generally reserved for school group visits. At the Craft House, each school group is given an orientation on slavery in Marshall County and then proceeds to the home sites, each within a few blocks of each other. Other tourists are given program maps and brochures along with general information about the tour. Each quarter's site includes slave census schedules and a visualization of the antebellum property, sketched by Carter. Each site also has guides who interpret the spaces occupied by the enslaved community.

The program uses well-known interpreters such as Joseph McGill Jr., founder of the Slave Dwelling Project;[21] Michael Twitty, Afro-culinary historian, chef, and author of *The Cooking Gene;* contemporary homeowners such as Carter and Person; local community volunteers; and University of Mississippi students and faculty. The students are my African diaspora course students who choose the Behind the Big House program as research projects or graduate students in my southern heritage tourism course required to work as guides during the program. I spend nearly one-third of the African diaspora course discussing the transatlantic slave trade, and then enslaved communities in the antebellum South. This includes lectures on the built environment and the differences between urban and rural spaces. The southern heritage tourism class largely focuses on the politics of cultural heritage tourism in the South, including slavery-related sites. I require that all students tour the sites prior to the program.

McGill, Eggleston's friend and former colleague, began giving Behind the Big House program tours in 2012 and has done so to date. He offers a more general, less site-specific narrative about the experiences of enslaved persons. In addition, from 2015 to 2019 Twitty demonstrated food-preparation practices in the yard space between the main house and detached kitchen at the Craft House. He not only narrated African diasporic contributions to southern foodways but also illustrated that "food preparation was a daily reproduction of the divisions between" enslaved persons and their owners.[22] Twitty alternates between preparing food on an outdoor cooking fire and guiding visitors through the detached kitchen.

Some historic sites of slavery "continue to emphasize the white planter family's lifestyle and worldview over the contributions and struggles of the enslaved"; Carter's tour is designed to focus the tourist's gaze on enslaved persons.[23] Carter first gives historical context to the settlement of Holly Springs and Marshall County. He then discusses the importance of cotton as a commodity and its connection to a global economy, comparing the impact of cotton in the antebellum period to the impact of oil in the contemporary world. He also gives architectural histories of the homes on each site and imagines the domestic roles of enslaved persons. The story of the built environment places the slave owners in Holly Springs within the category of those who "owned more slaves than they could reasonably accommodate within the rooms of their dwelling," differentiating them from urban residents who owned few or no people.[24] This does not mean that some enslaved persons were not kept in rooms within the main houses but that their living spaces could be dispersed in both main houses and in separate quarters. The layout of the sites in Holly Springs was not as intricate as those I witnessed on a visit to the Aiken-Rhett House in Charleston,[25] for example, but was indicative of small-town wealth dependent on a booming slave economy. Vlach refers to these as urban estates "shaped by plantation ideals" and "urban compounds," reflected in Carter's site sketches.[26] He drew these sketches so that tourists can imagine the site in its historical context, with fenced-in yards with workspaces, gardens, wells, and outdoor food-prep and laundry spaces.

Carter's tour is very much about the role of history in the present. He engages the impact of slavery on contemporary race relations in Holly Springs and subsequent oppressive acts, such as Black Codes, Jim Crow legislation, and sharecropping/tenant relationships between former enslaved persons and former slave owners. He also refers to female owners as "Ole Miss," a direct way of getting visitors to think about the origin of the University of Mississippi's nickname and its rootedness in slavery.[27] My students, and some site visitors, believe that slavery ended with the Civil War and was followed by the end of Black oppression. This narrative approach is important to tourists' comprehension of the continuation of the impacts of slavery into the present and the systematic attempts to undermine Black progress in the United States. Carter is also aware of contemporary sensibilities around university connections to slavery and how his narrative can bring attention to symbolic, including linguistic, connections such as "Ole Miss."

The Craft House is across the street from the public library, ticket headquarters for the Pilgrimage.[28] There, Pilgrimage tourists purchase tickets to visit several home sites and are given maps and brochures. The Craft House is the first antebellum structure that they see from the library's parking lot, so most Pilgrimage visitors head there, assuming that the house is on the

Pilgrimage tour. Most head directly to the main house, and then guides redirect them to the detached kitchen. Some show a lack of interest and opt out of the experience. Guides encourage others who seem to be curious about the kitchen/quarters to tour it.

Some of the earliest visitors get more than they bargain for when the smoke from Twitty's fire penetrates the kitchen/quarters. This visitor experience, although unintended, is discomfiting for most. Eyes sting even after the doors of the quarters are closed. Some visitors realize that the experience might have been a normal one for enslaved persons subjected to the sights and smells of food prep in their homes. The pleasure of the slave owners' subsequent meal was entangled not only in the detached kitchen's risk of fire but also in the risk of personal injury to the cook. Slave owners intended for these "scenes of subjection"[29] to be separate from the enclosed main house. The two structures are literally feet away from each other yet symbolically worlds apart.

That first year that I volunteered as a guide, 2013, most of the guests were white and in family units. A few came in tour-bus groups. Some were visiting from other parts of the Mid-South region; others were visiting from the Midwest, had heard about the program, and wanted to experience it. The few visitors of color (mainly African American) were either volunteers associated with the tour or locals who had heard about the program. Other Black Holly Springs locals avoided the Pilgrimage in protest of its glorification of the Old South and would not venture out to the sites, even with the presence of the Behind the Big House program.

During my first experience as a Craft House guide, several guests seemed hesitant to enter the kitchen/quarters, hoping to tour the adjacent main house instead. Those who entered had no idea what the structure was, and when they were told, guest responses ranged from surprise to sympathy to denial to shock. I narrated what we knew about the house and then allowed guests some time to tour and reflect. One local white couple spent a significant amount of time in the dwelling, asking detailed questions. The woman in the couple later said that she was a descendant of the owners of a plantation in rural Marshall County, and she decentered the narrative from the slave dwelling to that of her great-grandmother being forced out of the "big house" by "the Yankees." She asked if the two women who lived in the slave dwelling were married. I explained that marriage was likely illegal for them but that they might have had partners in other locations. She asked, "What kind of Christian people would allow such a thing to happen?," a response in line with what Gallas and Perry describe as the tendency of white families from the South to frame their families as exceptions to accepted norms of enslavement.[30] She could not understand how Christians could forcibly separate couples. She clearly

separated her Christian, plantation-owning family from the insecure plights of the enslaved women who lived at the site. This visitor was also more familiar with large rural landscapes of antebellum slavery, evident in her statement about the property once owned by her ancestors. As a dwelling with separate living spaces, an upstairs loft, and a cellar, the Craft House kitchen/quarters is also relatively large compared to rural cabins. I wondered if the relative size of the detached kitchen caused a woman whose ancestors were enslavers to somehow distance the enslaved women who occupied the home from the rules that applied to most enslaved persons in the antebellum period. This initial observation led me to become more aware of other visitor responses to the built environment that might indicate unfamiliarity with urban sites of slavery.

Although one of the largest antebellum cities in the state of Mississippi (after Natchez, Vicksburg, Columbus, and Jackson), in 1860 Holly Springs had a population of just under 3,000 persons, compared to 38,000, 40,000, and 169,000, in Richmond, Charleston, and New Orleans, respectively.[31] The last three are more well-known urban sites of slavery, but small cities and towns like Holly Springs were the most representative form of nonplantation slavery. Yet the memory of slavery in the United States largely prioritizes rural plantations and, to a lesser extent, large urban experiences.[32] What I present in this essay strongly indicates that this gap in American memory affects how visitors experience narratives of slavery in smaller municipalities.

Visitor Responses

The Craft House kitchen/quarters is a well-preserved wooden structure with a decorated interior of beds and other furnishings not associated with the former home or with the antebellum period. Even with these anachronisms, Carter's goal was to have the structure feel like a home without being tied to consistency in one general time period. The artifacts are just meant to seem relatively old. Without a record of the original contents, he made personal decisions about what items would relay that message to tourists. Regardless, the furnishings do not seem to affect visitor responses as much as race and age do.

My observations show that visitors generally engage the site along a Black and white racial binary, with "dissonant interpretations of the same site between two cohorts of visitors."[33] Black visitors, in general, see the Craft House slave dwelling as cramped and unimpressive. White visitors, in general, comment on how surprisingly large the structure is or how comparable it is to the homes in which they grew up. The structure seems to affirm the constrained, trivial homes of their more-recent ancestors (for example, parents or grandparents). White visitors seem to undermine spatial restraints by comparing the structure to smaller ones they have seen on rural plantation sites or by comparing the experiences of enslaved people to their own childhood homes.

In the above case the new information, the catalyst for the learning crisis, seems to be the relatively large size and "comfort" of the kitchen/quarters when a smaller, more ramshackle structure is expected. These visitors seem to connect to former enslaved persons by emphasizing comparable personal experiences. This cognitive mechanism is a rationalization process that unconsciously makes the experiences of the enslaved better than initially thought of by the visitor, something that Gallas and Perry identify as "rationalizing the old narrative."[34] That attempt to connect to enslaved persons can sometimes extend to connecting to descendants of enslaved persons. One elder white woman approached me, a Black woman, and stressed the importance of recognizing our shared southern histories. "This history belongs to us," she said, "not to those other people trying to come into our country." I did not inquire about the identities of "those other people," but I did not have to. The comment was made shortly after Mississippi Governor Phil Bryant signed Senate Bill 2710, which prohibited local governments from establishing sanctuary policies sensitive to the needs of undocumented immigrants and their families. Although the woman did not explicitly name a group, she inferred that I, as a "native" Black southerner, should understand that those considered Hispanic or Latinx were not valuable or welcomed. My blackness represented a nativist frame that was more acceptable to her. To me this interaction indicated that the woman was willing to accept difficult racial pasts but not racial inclusivity in the present.

Differential responses can also be observed through different age groups, for the perspectives of older tourists are more likely to reflect these binaries. In addition, visitors "proceed through the learning crisis" discussed in Gallas and Perry "brought on [by the] conflicting historical narratives" by showing emotional discomfort in facial expressions.[35] Older white visitors also ask questions to affirm the narrative they expected to hear instead of the one they were given. Asking if and hoping that the Crafts and Burtons were good slave owners and asking if former enslaved people chose to stay on as laborers after the Civil War are the most typical examples.

These inquiries usually assume that (1) former enslaved persons wanted to remain with former owners and (2) those who remained did so out of love for their former enslavers, not as a response to limited options for elderly persons impartial to new forms of labor or out of restricted labor opportunities for the general Black population after emancipation. The 1870 Marshall County census shows a drop in the Black population, indicating attempts to migrate out of the county. Visitors tend to be surprised by counternarratives that stress former enslaved persons' desires to find other family members at the end of the Civil War or to create new homes for their families and themselves.

Visitor expectations also seem to reject the reality of some newly freed people being limited to laboring for white families by postwar poverty and

the lack of economic opportunities. Even when enslaved people chose to stay on for other reasons, such as relative comfort with their pre–Civil War lives, Reconstruction-era politics could interfere with these decisions. The father of antilynching activist Ida B. Wells-Barnett, James "Jim" Wells, who lived in Holly Springs, is one example. Wells initially chose to stay on with architect Spires Boling, for whom he was an apprentice, after the end of the Civil War. The Wells family would have likely lived there longer, but Boling punished Wells because of his refusal to vote as a Democrat as Boling suggested. Jim voted as a Republican at a time when he and other former slaves began to realize the promise of Reconstruction, which was "particularly divisive in Mississippi."[36] Boling locked up Wells's tools, integral to his livelihood as a carpenter, and Wells soon moved his family off the Boling property.

Younger white visitors tend to travel with family members who seemed to have educated them about slavery or with teachers in the local schools. Others are my students, who, by the time of their visits, tend to have a broad knowledge of slavery and the complications of its representations in the present. As a result, the responses of those relatively older than them do not generally reflect theirs.

Black visitors, in general, tend to lament the conditions of enslaved persons regardless of the size or presentation of artifacts in the homes. Most, outside of my student population, tend to remain quiet or to take on a fictive kinship to those who were enslaved on the property, with comments such as "I can't believe what was done to us." Neither the sizes of the structures nor the aesthetic sanitization of the kitchen/quarters with later period furnishings seems to matter. If connections are made to the historic sites, then they are usually made to displayed artifacts, such as the cast-iron cooking pots with which they were familiar as children.

Younger Black visitors are generally students from the local Marshall County school district or from local private schools. Others are students in my courses. The former show a range of responses, from enthusiasm at answering questions about the sites to general silence. Some take images with their smartphones. Others focus on a scavenger hunt, created by Carter and Eggleston, given to them in advance by their teachers. These worksheets include questions such as "Where was the cooking done?," "How many slaves did Mr. Craft own?," and "Where did the slaves sleep?" One of my graduate student docents noticed that students from local schools, across racial demographics, who had attended in previous years, "retained quite a bit of knowledge from previous visits. Often, students would discuss different aspects of the tour among themselves even more than they asked questions of me."[37]

In general, Black and white visitors respond differently to the built environment, yet age ranges seem to play key roles in those responses. I rarely

heard comments complimentary of the quarters' structures from African American visitors, although several of my African American students expressed that they "did not expect the slave quarters to look as good as they did" or were pleasantly surprised that the Craft House was not located on a "massive piece of land" with "old shackles and a whipping post or some type of grim symbol of slavery."[38] Students reacted this way despite classroom discussions on urban slavery and the images of the properties shown to them prior to their site visits. These reactions indicate the power of historical memory and of popular-culture representations of slavery, even when counternarratives are presented. For the most part, students referred to the houses as cramped or as much smaller than they had imagined. As one student commented, "Some of the rooms were small enough to be bathrooms"; for her that "was a very humbling experience."[39] The slave dwelling made another feel nauseous, dizzy, and overwhelmed. Such responses were generally no different from white students, such as one who immediately felt unsettled in the Craft House, then "sad and perturbed." The student added, "To think that people were taken from their homes and forced into labor has always given me a nauseous feeling, but going into a place that has been legitimized really caused me to feel sadness."[40]

David Person's kitchen/quarters at Burton Place are more ostentatious, in form and decoration, than those at the Craft House, and visitor responses reflect that difference. Person's quarters display late nineteenth-century and early twentieth-century furnishings along with fake food as props in the kitchen area. Person begins his tour with the main house, giving historical contexts to Native, African, and European American contributions to the development of Holly Springs. He has commissioned artwork on the walls of the central room in the main house to illustrate each of these experiences. Person interprets the main house, from the perspectives of those enslaved, by highlighting back stairwells and how enslaved persons moved through restricted spaces. He also presents hero narratives, comparable to more-traditional antebellum tours, such as that of Sam Houston, who slept in one of the rooms when he visited Mary Burton. He then guides visitors to the kitchen/quarters, not as an option but as an integral part of the site experience.

At the Burton Place quarters, elder white tourists tend to focus on the "nice" furnishings, such as the antique tea sets that Person has on display. Like Carter, he wants visitors to feel like they are in someone's home while he doubly displays these items, which are also for sale. The tea set provokes questions about teatime for enslaved persons, mainly from older white visitors. It seems to be another case of this demographic rationalizing narratives, wanting to believe that enslaved persons were allowed what they perceive to be domestic privileges.[41] White tourists who seem to be middle-aged vary more in their responses. Some question the authenticity of the furnishings

in the spaces. Those in family groups sometimes show fractures in desires to visit the space. For example, one woman's husband actively rejected the slave dwelling by clearly refusing to enter the space, even as his wife entered.

Despite Person's decorative choices, one African American Behind the Big House volunteer was so emotionally affected by entering Burton Place that she fainted. Others shed tears. In these cases, as in others, neither the specific site histories nor the displays seem to trump Black visitor perceptions of enslavement and emotional responses to its conceivable horrors.

Imagining the Possibilities

McGill's Slave Dwelling Project began in 2010. In April 2011 McGill began an online record of his experiences through a blog. After his first Behind the Big House program experience, he wrote the following:

> In seeking extant former slave dwellings sometimes they are hidden in plain view especially when we factor in urban slavery. Some property owners may own some of these structures and not know their history. Some may know the history but for various reasons choose not to make it known to others. I am often asked how many extant slave dwellings still exist. I respond that factoring in urban slavery makes placing a number on those dwellings difficult. It could be less of a challenge to answer that question if we had more places like Holly Springs, Mississippi that are willing to tell the whole story of their built environment.[42]

McGill's remark that the program tells "the whole story" is a very generous one yet likely made in contrast to interpretations of most antebellum sites, which do not tell a story of slavery at all. Owners of sites featured in Behind the Big House effectively go beyond more-traditional antebellum "sites of slavery," but they less successfully consider its potential to make the most common form of urban slavery more visible.[43] I am not suggesting that Behind the Big House interpretations seek to represent a monolithic urban experience but that interpretations introduce site visitors to an experience outside of the current rural/urban binary, one that complicates this specific type of urban slavery. What Behind the Big House has yet to do is create a narrative that allows visitors to imagine the resistance, social interactions, cultural events, and neighborhoods that enabled enslaved persons to create communities in this urban landscape. Even with limited documentation specifically related to the experiences of enslaved persons in Holly Springs, some inferences can still be made about their lives that speak to visitor questions and comments. I contend that challenging visitors to think through the possible lives of enslaved persons might help to complicate their preconceived notions of the lives that

enslaved persons lived. Below, I present some features of the Behind the Big House program as potential challenges and offer solutions for interpretations.

Southern urban towns and small cities "were centers and extensions of the plantation region," and enslaved persons' communities likely crossed rural/urban lines.[44] This means that their neighborhoods might have transcended those described by Kaye as adjoining plantations through which enslaved people visited one another and attended dances, holiday celebrations, weddings, religious services, and other cultural events.[45] This frame for cross-plantation relationships does not capture the relationships between enslaved people in urban and rural contexts, many of whom shared biological kinships; or a slave owner like Mary Burton; or enslaved people within urban communities like those owned by Burton and the Crafts, who might have had personal relationships. Although enslaved persons in Holly Springs participated in cultural events, it is difficult to determine whether they were largely restricted to their compounds or to the city of Holly Springs, or if they perceived Marshall County as their neighborhood more broadly.

It is also difficult to determine the structures of family ties within those homes. Five of the seven persons enslaved in 1860 on the Burton Place urban property are identified as mulatto and may have been a family unit. They include thirty-six-year-old male, Patsie; thirty-two-year-old female, Adeline; four-year-old Mary; and unidentified twelve- and six-year-olds. Thirty-four of the persons enslaved on Mary Burton's rural property are identified as mulatto, a complicated "racial" category often reflective of the census enumerators' interpretations of enslaved persons' phenotypes. All identified as mulatto on Burton's 1860 slave schedules are marked as fugitives from the state. Crutchfield noted that more fugitives from the state, in her research, are identified as mulatto than those identified as Black.[46] This is likely not an accurate status but rather a way for census officials to more easily identify them from those raced as Black, such as Alex, a forty-five-year-old male, and Mary, a forty-year-old female, living on the Burton Place urban property. It is unclear if they are related to the other five. The census does not list them according to age, and it is unclear if they are listed in family units. If Patsie and Adeline and Alex and Mary were domestic partners, then their two families might have lived in separate quarters on the estate. Guides can highlight these "racial" distinctions on the census records and ask visitors to consider whether these separate classifications might indicate different social experiences in the enslaved community at the Burton home.

There are six children (ages ten, seven, five, three, two, and one) listed in the Craft House kitchen/quarters in 1850 and the same number in 1860 (ages sixteen, fifteen, twelve, nine, six, and three). It is possible that some of these

children could be the same. In 1850 a forty-year-old male, thirty-five-year-old female, and twenty-six-year-old female were enslaved on the property. The forty-year-old male is likely the one in the daguerreotype on display. In 1860 a twenty-five-year-old female, twenty-eight-year-old female, and likely adult male (age not legible) were also living there. If the Craft family's postwar practice of housing a female cook and a chambermaid was a consistent one, as in the cases of Lillie Wright and Mary Garrison, then the two adult females each census year indicate that custom. This structure signals that the slave-owning family either disproportionately depended on enslaved children for labor or showed some regard for family units. It is unclear if the enslaved children and adults represent biological family units. The differences in the enslaved persons who seemed to occupy the Craft kitchen/quarters between 1850 and 1860 might also indicate an inability to create stable home environments and reflect persons "forever giving up their neighborhoods and incorporating folks into their new place."[47] There is one prominent scholar on antebellum slavery in Mississippi, University of Southern Mississippi professor Max Grivno, who describes this region of the state as a tough frontier, in flux.[48] In this case, displacement might have been the norm. Slavery here developed and ended quickly, on the heels of the involuntary migration from upper seaboard southern states that fractured families. This could also mean that urban/rural enslaved populations in town and small-city sites like Holly Springs, which developed quickly, moved between urban and rural homesteads based on the needs of the owners, or between Holly Springs and other comparable cities. Guides can ask visitors to imagine the impacts of these forced migrations on the stability of family units.

Enslaved female cooks, chambermaids, and washerwomen had intimate and complex relationships with slave-owning women in the households such as Elizabeth Collier Craft and Mary M. Burton. These were relationships of dependency with the privileges of the enslaving households dependent on "the oppression of the other. . . . Their world and the household was both a landscape of dominance and control and one of ambiguity, contraction, and confusion."[49] The wealth of the enslaving woman was dependent on the cooperation of those she enslaved, by force and constant negotiation. At the same time, enslaved women were dependent on enslaving women for their survival and for the relative stability of their families. These circumstances were mitigated through power, with enslaving women, at times, wielding that power through physical violence and verbal abuse.[50] Each "household," or "co-residential, social, and economic unit,"[51] was dependent on habitual practices, a routine understood by all parties, which could easily be threatened by changes when persons left or came into the household. This was critical for enslaved persons, who carried little weight in decision-making processes. One key to

understanding these dynamics is to imagine how enslaved persons responded to those instabilities.

One of my students posed an admitted "onslaught of questions" after a first visit to Holly Springs. One was "How did they [enslaved persons] resist their bondage?"[52] The creation of families and forms of religious worship are constants across regions and environment.[53] In addition, more-popular notions of feigning illness, breaking tools, and slowing down work might also fit into interpretations of these urban sites of slavery. Some conclude "that the urban slave experience was unlike that of the rural field hand because of the greater opportunity and wider contacts offered to the urban slave," yet this perspective seems to ignore variants in the urban slave experience.[54] The potential anonymity created through large cities might offer opportunities for supportive networks, outside of masters' gazes, yet small cities and towns might have been more restrictive.

I did not have many answers for my student, only hypothetical considerations. What I do hope is that we will have more answers to these questions as we understand the diverse characteristics of sites of slavery as well as engage in further research on descendants of those who might have been enslaved at Behind the Big House sites in order to understand past relationships. We have some hope with descendants of those enslaved by Mary Burton, who have not only helped us with genealogical information but also act as guides for Burton Place tours.[55] This effort will require more sustained historical research, outside of what has been done by Carter and Eggleston, and by one of my former anthropology graduate students, Suzanne Davidson.[56] Beyond those efforts, we have mainly been restricted to student volunteers for research support.

It was certainly Carter and Eggleston's hope that as the Behind the Big House program matured, narratives of slavery would be more holistically incorporated into Holly Springs tourism and not exclusive to the Behind the Big House program. Narratives of slavery would be ubiquitous in Holly Springs, and Behind the Big House would be a model replicated in other parts of the state.[57] That has not yet happened. The program is a stand-alone one that was intended to make the Pilgrimage more whole and then, through Gracing the Table, to transform representations of slavery throughout the city.

Public historians such as Mary Battle argue that "multi-institutional collaboration is needed to help cohesively develop and link representations of African American history throughout the [Charleston] area." I think that this rings true for most "historic tourism area[s] collectively undergoing transformation,"[58] but this is not yet the case for Holly Springs. I was able to help with the development of a stakeholder group to (1) assess the many important sites in Holly Springs and their conditions, safety, and contributions; (2) update the history and accuracy of information on important sites; (3) upgrade the

narrative and the presentation of the tour experience in Holly Springs; (4) establish a docent program that certifies competent and accurate narratives; (5) interface with Holly Springs tourism in seeking grants and funds for experts and training; (6) upgrade the communications between the city's tourism agency and community stakeholders; and (7) establish mutual goals with other cities and sites in the North Mississippi Hill Country. I also helped arrange a visit from a historic preservation planner to give a presentation to the stakeholders' group and others interested in tourism as a form of economic and community development in Holly Springs. The city not only has potential for tourism development around urban slavery but also around Reconstruction-era politics (through citizens such as Ida B. Wells-Barnett and Hiram Revels) and the development of Rust College, the oldest historically Black college in Mississippi.

These efforts are very premature and would have not likely been possible without the development of the Behind the Big House program and other grassroots African American heritage projects such as the Ida B. Wells-Barnett Museum and a committee working for the restoration of Isaac Chapel School, the last remaining Rosenwald School in Marshall County.[59] One of the major challenges has been getting all interested parties to recognize Black history as a shared history, not one exclusive to African Americans or more-progressive whites. Carter, Eggleston, and Person, all whites, have modeled the potential for white antebellum site owners to prioritize Black history as a shared history, a practice necessary for local transformations of slavery interpretations.

Creating and Maintaining Digital Public History

The Lowcountry Digital History Initiative

LEAH WORTHINGTON

To keep digital public history projects from becoming ephemeral, unmaintained websites, public history practitioners, scholars, and community members can work together to plan a project that will be both relevant and sustainable. In using the Lowcountry Digital History Initiative (LDHI) as a case study, this essay explores how public history professionals can employ the local or regional context to develop a well-used public history project that does not simply highlight but rather centers underrepresented histories. The essay addresses the types of collaborations that have allowed for the creation of more than two dozen permanent exhibits (and growing), and it outlines the early planning decisions that helped make LDHI successful and sustainable. It also outlines LDHI's labor distribution as a model of how to build onto existing infrastructures and form campus partnerships to reduce the cost of an ongoing digital public history project. By outlining how theme and geography were used to establish the project's scope, LDHI offers a blueprint for those working in libraries, history, or public history who are determining a path forward for a digital history project. Finally, this essay shares how graduate students have been successfully and permanently incorporated into the project in a way that assists in preparing them for the field of public history and also adds value to the project.

Local Conditions as the Spark

In 2010, marking 150 years since secession and the Civil War, a few hundred people in Charleston chose to celebrate by attending the Secessionist Gala, an event organized by the Charleston-based Confederate Heritage Trust group. This is to say, in 2010 people were joyously celebrating the history of South Carolina's secession. Secession was, of course, an action taken by South Carolina and subsequently other states in hopes of protecting their right to enslave

Black people. Yet gala organizers denied that either secession or the gala had anything to do with slavery.[1] Their public denial and reorganization of historical fact represent much about how elite whites and much of the tourism industry have chosen to tell Charleston history in the twentieth and twenty-first centuries. Public historians and scholars in the region who were fighting against the romanticized narrative of southern history and the Lost Cause fiction were aggrieved as they watched the three hundred gala attendees, most donned in period dress, dance and clink glasses in celebration of secession—an event that secured institutional racism as a fundamental element of the state of South Carolina.

At the same time, members of the Lowcountry Digital Library (LCDL) team began pondering a potential role in responding to the gala and the general miseducation and willful denial of historical facts by many local people in Charleston and the Lowcountry. At the time of the gala, LCDL was a nearly year-old regional digital library servicing small to medium institutions in the Lowcountry.[2] Housed in the College of Charleston Libraries, the digital library was built and operated by a small team of College of Charleston librarians with academic backgrounds in history, public history, fine arts, and library science. Observing the gala unfold, they sought a way to reach and reeducate Charlestonians, South Carolinians, and the American public on the history of the region. Angered by events like the Secessionist Gala, John White, then the codirector of LCDL, began considering how all of the digitized archival material on LCDL could be interpreted for the public to increase awareness of the factual, rather than romanticized, history of the South. Mary Battle, then-LCDL staff and public history doctoral candidate writing about the need to change slavery narratives at tourism sites in and around Charleston, had experience with digital history projects. White and Battle saw an opportunity to launch a new project to increase the public's knowledge of African American history in the region. With the energy of the entire LCDL team, their idea became the LDHI.

This essay explores the ways in which LDHI became part of a growing group of Charleston-area public history workers seeking to drastically change the public narratives of Charleston and the Lowcountry's history. After outlining the workflows of the project, the essay discusses why these workflows were chosen and how they are fruitfully employed. Although LDHI's mission is to change the historical narrative from romantic to real, and from fiction to fact, an ongoing digital project requires a well-oiled machine to continue participating in educating people about history. Therefore, details about overall and daily operations are discussed for the benefit of practitioners considering a similar project. The essay goes on to explore how LDHI's regional focus and thematic scope have assisted in producing a sustainable digital humanities

project that, in addition to national and global use, is heavily used by the local public. It also examines how two aspects of project scope—geography and theme—have positively contributed to LDHI staff and collaborators' ability to reach public audiences and sustain the project.

Differing from LCDL's noninterpretive presentation of the region's archival material, LDHI's is a digital exhibition platform interpreting the region's underrepresented histories. It uses the digitized archival materials from LCDL as well as other archival institutions to assist in that interpretation. White, Battle, and the rest of the newly formed LDHI team, Heather Gilbert and Tyler Mobley, began working with scholars and graduate assistants to create a website with multiple permanent digital exhibits about the Lowcountry's underrepresented history and culture. The set of collaborators and the staff expanded and changed as exhibit creation continued. Since 2014, additional exhibits have been continually added to the original set so that as of 2020 LDHI has twenty-five permanent exhibits, and it now averages the addition of two new exhibits each year. Based on each exhibit's topic and scope, they range in length. Some are as short as a six-page/section exhibit, whereas robust exhibits are nearly twenty pages/sections. They deal with broad topics such as Emancipation and Reconstruction and specific historical moments such as a labor strike or a racially motivated massacre. LDHI's open-access, easy-to-navigate format allows all members of the public—including the local population, tourists, public history practitioners, tourism professionals, higher education educators, and K–12 teachers across the country—to learn about the region's history with a focus on race, class, gender, and labor.

Collaborators: Giving Voice to the Lowcountry's Underrepresented

The willingness and interest of so many scholars, students, artists, community members, and community organizations to collaborate on authoring an exhibit has led to LDHI becoming a vibrant exhibit space with many different underrepresented histories in one place. LDHI's collaborative efforts have resulted in, for example, bringing new voices to the American public, creating a bilingual exhibit, connecting Lowcountry history to Atlantic world history, and sharing local histories with local people and the millions of visitors who come to Charleston each year.

The codirectors and early collaborators sought to help the public understand the interconnectedness of colonial Charleston and the Atlantic world during a period when colonial powers were establishing slavery. Reflecting Charleston's history as an early and important colonial port city, one of the first exhibitions, *African Passages, Lowcountry Adaptations,* provides historical context for how the Lowcountry fits into Atlantic world history. The exhibit discusses how slavery was developed in the Atlantic world, particularly in

the colonial South Carolina Lowcountry, exploring how the colonial period's events set the stage for antebellum slavery, the Jim Crow South, and other legacies of slavery. This early exhibit helps contextualize subsequent ones focusing on particular narratives within Charleston's Atlantic world history, such as *Voyage of the Echo: The Trials of an Illegal Trans-Atlantic Slave Ship* and *Liverpool's Abercromby Square and the Confederacy During the U.S. Civil War.*

In addition to the LDHI coordinator's and graduate students' contributions, the exhibits open the door for both academic and public history professionals to author an exhibition. For example, *Voyage of the* Echo provided an opportunity for a doctoral candidate to share their research interest with the public. *Liverpool's Abercromby Square and the Confederacy* was coauthored by a traditional faculty member, a doctoral candidate, and a student, all of whose research involves the Civil War but who are at varying stages in their career or education.[3] In creating a collaborative space for public history work, LDHI exhibits allow people at different stages of their career with widely varying levels of experience in writing exhibition text to participate in the process.

Even among underrepresented voices, LDHI assists in highlighting historical actors whom the public have rarely, if ever, encountered. Two exhibits focusing on lesser-known voices in the historical Lowcountry are *Enslaved and Freed African Muslims: Spiritual Wayfarers in the South and Lowcountry* by Muhammad Fraser-Rahim and *Las Voces del Lowcountry* by Marina López and Kieran Taylor.[4] The public's general unawareness of enslaved and freed African Muslims in the United States is well documented in Ayla Amon's essay "They Wore White and Prayed to the East," found earlier in this volume. In addition to Amon's and the National Museum of African American History and Culture's efforts to help Americans grasp the socioreligious range of enslaved and free Africans in the United States, Fraser-Rahim approached LDHI about collaborating on an exhibit highlighting the history of Islam in the US South and the Lowcountry. He went on to earn a doctorate (categorizing him in one way as a traditional academic), but Fraser-Rahim has also worked for the federal government and continues to work in the private sector on counterextremism. He also engages the public in discussions about Islam in the United States, including a Spoleto Festival USA panel discussion on Omar ibn Sayyid designed to "expand on the historical context and cultural significance of Rihanna Gidden's newly commissioned opera, *Omar.*"[5] Fraser-Rahim's exhibit published with LDHI resulted in the exhibit being referenced in online publications and resources, including a lib guide.[6] Therefore, with LDHI an established and ongoing digital public history project, collaborators from many different career backgrounds have heard of and then sought out LDHI as their publishing platform.

A more recent and local history is illuminated in *Las Voces del Lowcountry,* where Marina López and Kieran Taylor used the oral histories of Latinx people in the Lowcountry as the foundation for their exhibit to build awareness of a late twentieth-century immigrant population that is often invisible to many in the Lowcountry's dominant culture. As coordinators of the Citadel Oral History Program, López and Taylor worked with both LDHI and LCDL to make their oral history collections available through LCDL in an uninterpreted archival format and then create an exhibit with LDHI where the oral histories were used to share the history of Latinx people in the Lowcountry with the public. With López as a bilingual collaborator, LDHI was able to produce its first completely bilingual exhibit in Spanish and English. López also collaborated with local Latinx artists and community members to use art and oral histories to let them tell their own story of immigration and how they have contributed to the Lowcountry's economy and culture. Like all history shedding light on underrepresented people, López and Taylor's exhibit assists in bringing the Lowcountry's Latinx community out of obscurity, humanizing them by giving their history a voice. *Las Voces del Lowcountry* also highlights the benefits of digital projects because the projects have the ability to expand. After the exhibit was published, in 2017, the authors contacted LDHI's coordinator about the options to expand the historical context in the exhibit, so it was updated in 2020. The ability to update allows for new research to be incorporated, helping eliminate outdated information.

Although LDHI started with a focus on Lowcountry African American history topics such as slavery, Emancipation, and Reconstruction, over time the added narratives of underrepresented histories have expanded the time periods and geographies discussed in LDHI exhibits. LDHI's ability to establish itself as a permanent, reliable publishing platform for public history has resulted in an increase in collaborators choosing LDHI as their publishing partner. The expansion has led to the inclusion of even more voices and experiences being unearthed for the public while still maintaining LDHI's mission of bringing underrepresented histories of the Lowcountry to the public.

Designing Sustainable Mechanics: Labor Distribution and Exhibition Creation

As an ongoing digital history project, LDHI involves the expertise and assistance of several different groups and individuals to ensure that the project remains sustainable.[7] Partnering authors write the text of the exhibit. Graduate students assist with fact checking, image research, copyright and permissions, and exhibition layout. The technical services librarian builds and maintains updates to Omeka, the web publishing platform. A group of peer reviewers is chosen to review each exhibit. A coordinator/codirector initiates and coordinates each exhibit among all involved groups and manages daily tasks.

In terms of housing and institutional support, LDHI is housed in the College of Charleston Libraries as the sister project of LCDL. With the institutional support of the College of Charleston, LDHI's model of labor distribution allows costs of the project to remain reasonably low while publication remains steady. Because LCDL was already established, this allowed its team to add LDHI onto its existing digital project framework, which meant that LDHI's start-up costs and technical planning were minimized.

Typically, LDHI's first step in beginning an exhibition is to identify a scholar and/or community group or member who would like to collaborate and write text about a topic or event that matches with their research background or area of expertise. In its early years of operation, LDHI existed in an academic world where digital humanities and digital history projects were still gaining recognition as legitimate forms of scholarship. Although it is still sometimes a challenge for authors to discuss digital publishing with their academic departments, much of academia has moved toward a level of acceptance of the digital history and humanities fields. Some academic departments are even accepting that the research and writing of exhibitions are worthy of some level of consideration in the tenure review process. Often in the early years of this project, the team approached scholars and/or community members to gauge their interest in collaborating on an LDHI exhibit. After the difficult work of establishing LDHI as a sustainable, credible publishing platform, scholars with wide-ranging research interests have also reached out to LDHI staff to pitch their ideas for a new exhibition. Therefore, LDHI now both seeks out and is sought out for exhibition publication. In recent years scholars have largely approached LDHI, filling its publication schedule to capacity.

Much of the overall process of exhibition creation has remained the same over the years, but the early steps to start a new exhibit were adjusted to account for the new level of attention that LDHI garnered from potential collaborators. The recent level of external interest in authoring an exhibition created the need for a formalized LDHI proposal process. Now, after an initial conversation between the potential author and the LDHI coordinator, the proposal process ensures that collaborating authors understand LDHI's mission, envision an exhibition that aligns with the mission, and have a feasible project. The two major criteria that illustrate a potential project's alignment with LDHI's mission are (1) that the narrative focuses on underrepresented history and (2) that the narrative contains a focus on Lowcountry history.

Once the proposal is submitted, the LDHI coordinator works with the interested author to discuss several important topics: the author's ideas, potential adjustments to the exhibit's topic or perspective, archival and digital resources for document and image research, the potential use of additional tools (maps or timelines), and an overview of the exhibit-building process.

These discussions are often dominated by practical considerations. Many scholars and community partners have not written exhibit text before, which is notably different from the structure and style of a monograph or journal article. Therefore, if the collaborating author is a scholar, the coordinator helps navigate how content can be organized to effectively translate complex historical narratives into an exhibit format. The conversation is also used to guide collaborating authors on which digital tools will be most helpful, if any at all. For example, although maps are often eye-catching, they are not always capable of conveying the meaning that authors would like. A timeline might be better, or in other cases a photograph gallery might best assist viewers in processing the meaning of the text. The coordinator also explains the advantages along with the limitations of a web-publishing platform such as Omeka. With collaborators ranging in their goals for the exhibit and their experience level, these initial conversations help establish agreed-upon expectations for the final product.

From this point forward, the workflow to build an LDHI exhibition reflects the project's original workflow, designed by Mary Battle. After the author(s) draft their text, it is returned to LDHI for an internal review and sent back to the author(s) for revisions. After the internal review, the text is then sent out for an external review in the form of an open peer review editorial process. During the revision process, LDHI graduate assistants have already begun image research, tracking down copyright information, and obtaining permission to use the documents and images they find for the exhibit. This requires graduate students to be trained by the coordinator on image research and copyright law pertaining to cultural heritage material. The coordinator then oversees the graduate assistants as they lay out the exhibit in Omeka. Once the exhibit is laid out in Omeka with both text and images, the author(s) review the exhibit to offer feedback and ask for changes. With the sign-off of the author(s), the exhibit is published.

For any public history departments, digital libraries, or digital humanities teams considering starting an ongoing project similar to LDHI, it is worth pausing a moment to share a few challenges. Most authors, whether scholars or community members or public history practitioners, are often extremely busy. Therefore, the timeline of production for each exhibit varies. Those working toward tenure may want to speed up the production if their department allows the exhibit to count in a significant way, or they may want to slow the production down if they need to complete a traditional publication before their tenure review. This variance can cause slower periods and then, rather suddenly, extremely busy periods, and these changes are not always easy to predict.

In terms of managing human resources, slower periods allow the coordinator time to conduct research and create connections for future projects

and assign maintenance projects for graduate students. Each exhibit contains areas that need to be checked and updated to avoid dead or broken links. A required software update to the web publishing platform can slightly change small components of exhibit layout, such as the way that images align or links display in captions. Maintenance such as this can be corrected by graduate students in these slower periods. Social media can also be planned for months in advance to free up time when exhibit publishing keeps everyone busy. Unlike monographs or journal articles, digital exhibits need cleaning and maintenance to stay completely functional and look appealing to viewers. Slower periods of time, then, act as an ideal time to do this cleanup. For the coordinator, this is also a great time to research and reach out to potential collaborators. Social media, community connections, public lectures, and local conferences are all areas that the coordinator monitors for possible future collaborations.

A challenge that collaborating authors might face is the style of writing and the focus of the history involved in an LDHI exhibition. The length, tone, and organizational structure of exhibit text are dramatically different from those of a monograph or journal article. The coordinator should be prepared to discuss this with the author ahead of time. Because public history projects are often much more collaborative than traditional academic history writing projects, it is helpful for the coordinator to share this information with the author before the writing process starts. Unless the collaborator has previously enjoyed a cowriting experience, advanced conversations about the collaborative drafting process avoid having authors startled by the level of feedback they receive after submitting their first draft or the contributions of ideas and text from the coordinator or their collaborators.

For scholars, community institutions, cultural heritage workers, and others interested in changing collective memory and public history narratives by creating digital public history content, they have to consider how the language and concepts can be adapted so that they are accessible to the public. Therefore, the coordinator adjusts, sometimes drastically, the language and style of exhibition text in the drafting period. Lengthy, complex sentences or exhibit sections and subsections that are too long are edited for concision. For LDHI particularly, the coordinator assists in adjusting the perspective so that the historical actors centered in the narrative are underrepresented people. The language around slavery and enslaved people is particularly central in the LDHI drafting review process. The Lowcountry's history is so inseparable from its history of slavery, as Mary Battle explained, that simply adding African American history does not effectively convey historical realities.[8] LDHI applies that theory to all of its narratives by centering the underrepresented history and historical actors. Some authors' research expertise is centered in

Lowcountry history yet not particularly focused on underrepresented history. Although the proposal helps authors to understand the mission of LDHI, tone and perspective still sometimes need adjustment for the exhibit to align with LDHI's mission. Just as any manager of a physical site about slavery or African American history is aware, conversations about perspective, language, and focus require consistent reinforcement with authors as well as existing and new graduate assistant staff whose interest is regional history rather than underrepresented history. Conversations from the outset about LDHI's mission allow potential authors and graduate assistant staff to understand this perspective early on.

LDHI's labor model for building digital exhibitions has proven continuously successful. The success of the model rests in its ability to allow each person involved in an exhibit to do the skilled work they have been trained in. Collaborating scholars or community members are already experts on the topic and are skilled writers; with guidance from the coordinator, they are also guided through questions of transitioning academic language and tone to language that is designed for public audiences. The peer reviewers are chosen because they are already familiar with a topic and can provide insight into the specific topic they are reviewing. The technical services librarian—already responsible for updating software, working through bugs, and ensuring server space for digital projects—can provide checks and insight into the present operation and the future needs of the publishing software and server space. The coordinator continues to provide the same project-management skills to each exhibit, even as the topics and people involved change according to the project. The system is designed so that each task is assigned to the person most skilled in that area or who has been trained specifically for the task.

The departure from this skill-based labor model is the experiential learning-based model of labor for the History Department graduate students who usually begin their two-year assistantship with no digital history experience. Therefore, part of the coordinator's task each year is to train the new graduate student in image research, copyright training, and necessary software skills. The College of Charleston's Graduate History program has provided support for LDHI by assigning at least two graduate students to the LDHI assistantship, generally lasting two years, which is the length of their graduate program. To ease the labor of teaching two people from the ground up every two years, the graduate students are staggered, with a first-year student and a second-year student working together.

The two-year assistantship with a staggered first- and second-year graduate student system has two major benefits, one for the student and one for LDHI. The major benefit for the student is the length of experience. By moving

beyond a semester-long internship or even a year-long assistantship, graduate students are able to not only learn the initial skill set but also master those skills and gain a broad understanding of how digital history projects operate. With two years, they also have time to work on new skills. For example, they can also work on social media in the form of writing mini-narratives related to existing exhibits or write posts that feature upcoming exhibits. This provides them with a small but valuable experience writing for the public. The coordinator reviews and provides feedback on the content until the graduate students master the skill. Therefore, they move from specific task-based assignments to understanding the process more completely and even anticipating next steps without being assigned them. With the time length of their assistantship, they are also able to see a project from start to finish. All of these skills—from using digital asset management system/web publishing software to providing regular updates to team members, from image research to fact checking—translate to a concrete skill set on a curriculum vitae or résumé. In an increasingly job-driven environment, this outcome appeals to graduate students who want to leave their graduate program with scholarly training *and* job skills.

LDHI benefits from the two graduate assistants staggered in incoming years in a few ways. Graduate students are asked to find a common day of the week to work each semester. This allows for team meetings and, just as importantly, provides time for the graduate students to work together on the project. Their shared work time reduces the training time by the coordinator for the first-year graduate student. A first-year student directing small, detailed questions to a second-year student about how to use an aspect of the publishing software or where a resource can be found reduces micro-interruptions for the coordinator while still allowing everyone's work to progress. The model of having a first-year graduate assistant work alongside a second-year graduate assistant results in them learning from each other and effectively collaborating on tasks. It also allows for interactions among the coordinator and graduate students to focus on bigger-picture issues related to both the upcoming exhibitions and the professional growth of the graduate student.

LDHI also benefits from History Department graduate students because their course work has them simultaneously engaged in questions of historical inquiry and the presentation of historical narratives. Thus, their training in historical theory and methodology leads them to conduct image research that avoids anachronism and use social media with historical content that is committed to solid research and accuracy. Therefore, for both graduate students and LDHI, their labor on the exhibit projects and their staggered entrance factor together to create a system that provides positive outcomes for all collaborators.

Practical Planning Considerations

LDHI's five years of operation have allowed us to reflect on what decisions were made early on that have continued to help sustain the project and build a growing audience, resulting in LDHI exhibitions reaching tens of thousands of people. Practical and technical planning was important to LDHI's viability. Furthermore, when examining the scope of the mission, it also becomes obvious that there are clear advantages to planning a digital project with a local geographic scope and thematic mission. These two elements of LDHI's structure, with the regional geographic scope as the South Carolina Lowcountry and a thematic mission of shifting the region's public narrative by highlighting underrepresented histories, have had a positive impact on staff, collaborating authors, and audiences.

LDHI's founders were interested in contributing to changing the Lowcountry's dominant narratives that often exclude Black voices, but they needed to carefully plan the project's infrastructure, scope, and maintenance to see success. One of the central struggles for digital humanities and digital history projects is sustainability. Fortunately, the geographic and thematic scope of LDHI have helped, rather than hindered, the project's achievements. To create a viable project that avoids the graveyard of ephemeral digital projects, public history workers and scholars interested in starting a digital humanities or history project should consider several topics, including technical support, labor distribution, and funding.

Unlike the research conducted for many physical applications of public history, digital project teams have to consider technical questions that determine how the project will live online. For example, who will host the project? Does the team currently staff a person with enough technical expertise to operate the publishing software, or will that labor be outsourced? Once the project is established, who will maintain and update the website? Regardless of a project's terminal or ongoing scope, digital projects require maintenance: unattended sites regularly break at various levels. Unmaintained websites also have the disadvantage of becoming defunct websites that are difficult, impossible, or sometimes simply unpleasant to use. Without the benefit of being preserved and cataloged in a traditional library system, digital projects must plan for their own future existence. Therefore, long-term maintenance and preservation should be determined from the outset. LDHI backs up text of exhibits on a server, preserves screen shots of each page to capture layout, and saves image files both internally within the web-publishing software and externally in cloud-based storage. LDHI is also hosted on the same server that the LCDL uses, and it is maintained by the technical director, who is responsible for LDHI and several other websites. This combination of preservation practices

and permanent staffing support has allowed LDHI to continue to grow without worrying about the future.

In terms of labor it is helpful to plan out the project's staff makeup while also considering a scenario where any one of those members leaves the project. Simple problems such as log-in information can become unnecessarily challenging, though an easy problem to solve ahead of time by tracking log-in and password information. The project team also needs to address larger considerations such as who will contribute website content and how long their participation is required. They should determine if the project's content will be a one-time publication or require new and ongoing scholarly contributions. If it is a terminal project, is there a larger project it could be folded into so that audiences find it more easily? Contributing to a larger project, instead of creating a small, stand-alone project, has the added benefit of relying on existing and continued technical support, which is often difficult to manage for a stand-alone project. The early planning stage also allows time to determine who will run daily operations: write manuals, engage with potential new contributors, review exhibit text, train students, and manage students' daily workloads. Changing technology can also means retraining. Satisfying the mission of presenting underrepresented history is the goal, but determining labor distribution and systems to replace team members will set up a strong foundation to ensure the project's long-term success. To continue successfully producing new exhibitions, LDHI's team was flexible about configuring and then reconfiguring the labor of the coordinator. At times, the coordinators have been a daily-operations coordinator who works with a director to run LDHI or, as is the case presently, the coordinator is also the codirector, taking the lead or participating in all levels of operation.

An inescapably important consideration of digital humanities projects is funding. Anyone wanting to start a digital project should consider consulting with those who work on similar projects to determine both initial and continued costs. In researching local or regional granting agencies, LDHI discovered granting agencies seeking to fund projects like LDHI. For projects housed within an institution, it is helpful to investigate if the institution can provide short-term and/or long-term institutional support. Even with limited funding, projects like LDHI are possible, but it takes careful planning through labor distribution to keep costs low. In terms of institutional support, LDHI falls under the umbrella of the College of Charleston's Lowcountry Digital Library. Therefore, LDHI labor is added to existing faculty's scope of work, meaning that the project does not require staff hired for the sole purpose of the project. Seeking out campus partnerships can also assist in distributing a degree of the funding. LDHI worked with a history graduate program that shared LDHI's value of providing digital public history work experience to graduate students.

With practical job skills in digital history, LDHI graduate assistants leave with a stronger résumé, which can contribute to their positive graduate program experience. The challenge of obtaining cross-departmental support is worth the effort because the project is more successful with this type of support and the students gain genuinely important skills and experience that they take into their postgraduate pursuits. These practical questions about technical support, labor, and funding can assist in successfully guiding decisions about a project's parameters that will have beneficial outcomes for collaborating authors, staff, and audiences.

Scope and local context are additional factors worthy of a digital project planning team's considerations. For LDHI, scope in the form of theme and geography has enabled the project to build on itself in ways that decrease labor and increase productivity over time. The choices that LDHI's original planning team made regarding thematic and geographic scope were tied to their awareness and involvement in local public history concerns. The LDHI team became part of the group of public history workers who sought to correct false and romanticized narratives in Charleston's public history spaces, but the parameters they set for the project had additional long-lasting positive impacts.

The decisions the LDHI planning team made about the geographic and thematic scope were not happenstance but rather reflected the need for change in Charleston's long history of dominant collective memories and public remembrances favoring elite whites and excluding African Americans. The history of the coastal region of South Carolina is inseparable from the history of colonial and antebellum slavery and African American history after Emancipation. However, the region's elite whites and white tourism industry, both of which long predated the field of public history, formed the region's identity around the exclusion of Black history and the elevation of elite white history.[9] Fiction and fact were whipped together by whites into a narrative that allowed them to comfortably deny the violence and pain they inflicted on enslaved and free Black people before and after Emancipation.[10] After more than a century of elite white control of supposedly historical narratives shaping tourists' knowledge and collective memory, the Lowcountry's white public history workers and community members began recognizing what African Americans had always understood: southern history needed to replace southern mythology.[11]

Members of the Black community, Black scholars, and Black public history workers in the past and present have always seen the dominant narrative as exclusionary and problematic in its racism and incompleteness.[12] Despite annual Emancipation celebrations of remembrance and education of the public by community activists such as Esua Jenkins and Septima Clark, who taught adults history and civil rights, African Americans have had their own collective memories often ignored or violently snuffed out by the dominant collective

memory. In the twenty-first century the group of public history workers has expanded so that African American history is moving into the mainstream of public history in the Lowcountry, and LDHI is among those working to continue to correct the region's public history and collective memory.

Beneficial Parameters: Theme through Topic and Region

With the goal of replacing local historical mythologies with actual historical narratives in Charleston and the Lowcountry, LDHI's founding team used regional parameters and the category of underrepresented history to frame the project. By limiting the scope of the project to a small region and a narrow topic, LDHI has been able to seek out collaborators who share the same goal. By assessing the local public history landscape for people who have been marginalized in the local mythologies or histories, the scope of a needed public history project is often self-evident. When considering creating digital history for the public, therefore, it is worth considering how the topic and place will fill a gap in the local historical narrative and draw a larger audience.

Battle's research on Charleston's public history narratives about slavery had a guiding influence on setting the parameters of LDHI. Central to her research was the argument that an add-on style of inclusive history does not effectively or accurately interpret Charleston's history.[13] Furthermore, the method of only adding on inclusive history to otherwise elite white-centric interpretation in Charleston and the Lowcountry warps the entire narrative into falsehoods. An audience cannot effectively absorb inclusive history and interpretation, Battle explains, in a museum or a tourist site that "emphasizes nostalgia over critical understanding of the city and region's colonial and antebellum past."[14] In other words, if tourism professionals or public history workers running a site of slavery address it only by providing an African American history tour option or slip in light acknowledgment of slavery when the rest of the site's interpretation is entrenched and committed to helping visitors fantasize about white elite architecture, objects, and people, that site has obstructed the public's ability to form accurate knowledge and remembrances of Charleston's past. In fact, it allows anyone in the public who favors comfortable fictions or their imagined heritage over historical facts to continue to ignore uncomfortable realities about the Lowcountry's slave-centered history in favor of a self-serving, Disney-esque fantasy. Interpreting a site of slavery with the add-on method risks helping—and has helped—Americans and even the global public form a false collective memory about the history and legacy of US slavery.

At a minimum, glossing over or directly ignoring violent and painful histories is ethically problematic. Charleston's institutions and individuals who have embraced denying or ignoring history have resulted, for example, in

events as absurd as the Secessionist Gala, with its organizers and attendees willfully misremembering South Carolina's reasons for secession, undercutting the central role that slavery plays in South Carolina history. The mentality of denial and the erasure of the humanity of African Americans from public history sites has also led to violence. The deadly massacre of nine African Americans in their church, Charleston's Mother Emanuel AME, was carried out by a man espousing the superiority of white people. A single twenty-first-century massacre is one of many in a long string of violent events in the Lowcountry and the United States, revealing how unexamined and falsified history allows racist ideas to thrive and racist violence to continue.

In working to address Lowcountry public history, LDHI's scope has also proven beneficial in practical ways that benefit those on the LDHI team as well as the public. In addition to the parameters attracting a wide range of collaborating authors, the scope also assists LDHI staff: the coordinator and the graduate assistants. The public, whether local or visiting, also benefits from LDHI's exhibitions focusing on underrepresented regional history because in finding LDHI they find a single website containing many narratives about one place. The narratives in LDHI reflect local people and places that tourists or locals come across on a historical marker as well as topics that come up at historic sites or on city tours.

With LDHI emerging as a sister project of LCDL, the project came with built-in benefits for the LDHI staff. LDHI was able to build on existing established partnerships and collaborations among regional institutions, staff already had an enhanced knowledge of the region, quick access to the region's archival sources is possible, and images of landscape and buildings for exhibits are easily obtainable. All of these provide the coordinator with increased productivity in exhibit creation. LCDL has more than twenty regional partners whose digitized archival collections are hosted on LCDL's website. These images, mostly focused on the Lowcountry, provide an excellent starting point for exhibit image research. Local and regional geographic scope allows the LDHI coordinator to naturally be aware of current events where they might find inspiration for future exhibits or use social media to connect LDHI exhibits content to current events. Each exhibit requires the staff to fact-check details of exhibits when authors are writing about a region or topic that is slightly further afield from their area of expertise. The coordinators' process of research and reading about specific histories of the region for each exhibit results in their increased expertise, which is then used in subsequent exhibits. The coordinators' increasing familiarity with local and regional history builds in the same way that scholarly researchers' or reference archivists' familiarity with their materials grows. Therefore, over time the coordinator's assistance to authors in their text-drafting phase is increasingly less labor intensive.

LDHI staff members have observed the benefits of how topic and region attract a range of interested scholars and community partners. With the topic of underrepresented history including not only race but also class, gender, and labor histories, scholars studying any of these topics in the Lowcountry during any time period can participate, allowing a wider net to be cast for potential exhibits. Though a relatively small region, the South Carolina Lowcountry as the geographic parameter works well specifically because the region connects to many different histories. The South Carolina Lowcountry is an Atlantic world port, a region with a huge economy, and part of the American South. These connections open the door for scholars who study anything from colonial western Africa to the twentieth-century civil rights movement to participate. Practitioners considering a similar project will want to take into account how long they would like the project to last. If it is meant to be ongoing, considering the scope of topics, geographic region, and time periods will ensure that the established parameters support the project's goals as it grows over the years.

Limiting the topic to underrepresented history allows for enough focus for potential collaborators to be already connected to one another within an established network. For example, an editorial contributor for one exhibit went on to pursue her own LDHI exhibit. The network of scholars and community partners interested in a focused topic, such as underrepresented history, is wide enough to have a large pool for LDHI to work with but narrow enough for the community of scholars to become increasingly aware of LDHI as a publishing platform for their research.

Potential authors approach LDHI or are approached by LDHI staff because they work on underrepresented history in the American South or the interconnected Atlantic world or because they are focused on local Lowcountry history. In some cases they fit both of these categories, with their research perfectly aligned with both aspects of LDHI's mission: Lowcountry history and underrepresented history. However, in cases where an author's research expertise is specifically regional but the author is interested in working on an underrepresented topic, the coordinator's ever-growing understanding of the region's history assists in helping the author connect their interests to underrepresented narratives.

For graduate assistants, the LDHI scope can be beneficial in a few different ways. Although the number varies from year to year, the College of Charleston History Graduate Program attracts students who are specifically interested in pursuing South Carolina, Lowcountry, and/or Charleston history. The program also regularly attracts students who are interested in African American, labor, or women's history. Therefore, graduate students most often enter their LDHI assistantship with one or more of these applicable research backgrounds,

bringing helpful knowledge of histories in with them, and by the second year of their program they also have a higher level of training in historical theory and methodology. Moreover, the research they do for LDHI also provides them with increased knowledge of the archival holdings throughout the city. It can even have an influence on the topic they decide on for their thesis.

For both locals and tourists, LDHI's regional focus provides a resource that can be used at any time. Because tourists rank history as a top attraction and reason for visiting Charleston, it is more than reasonable to assume that some are searching the internet for answers.[15] With the Charleston region one of the fastest growing in the country, new locals are also able to use LDHI as a resource to learn more about the region they have just moved to.[16] For both visitors and locals who read historical markers about activists Septima P. Clark, for example, or about the remodeled downtown Charleston cigar factory that is now used commercially, they may conduct an internet search to learn more about these people or places. With these exhibits hosted in one digital space and not dispersed as stand-alone websites or single exhibits attached to an institution, visitors to the LDHI site find a resource in addition to an exhibit. The site contains not just encyclopedic entries but interactive exhibitions with images, text, possibly an interactive map or timeline, and links to other LDHI exhibits or external websites where users can learn more about a topic. In this way the College of Charleston, a public institution, is able to provide a public good through LDHI's open-access public history exhibitions.

Fortunately, analytical tools enable us to capture snapshots of who is using LDHI, which turns theoretical assumptions about what LDHI accomplishes into assessable data. Through the use of Google Analytics, we are able to illustrate the reach of LDHI's exhibitions locally, nationally, and globally. For the purpose of this essay, we will explore the analytics as they address local usership.

Successfully Reaching Local Viewers to Change the Local Narrative

To change the public history narrative of Charleston for more than seven million tourists per year, LDHI serves as a tool to educate the general public and to educate (or reeducate) public history professionals, museum workers, tour guides, and others who work at historic sites. Just as important, LDHI wants to reach the general public, including tourists, as they are researching and forming their knowledge and remembrances of Charleston and the surrounding Lowcountry's past. To determine if LDHI is reaching this audience, Google Analytics explains the geographic usership of LDHI.

Google Analytics data collected from early 2014 through late 2019, approximately five years, assist in determining that the local Charleston and Lowcountry populations are benefiting from the information available through

LDHI's exhibitions. Despite being the twenty-third-largest state, with roughly five million people, South Carolina is the state with the highest LDHI user rate. California, the state with the largest population, nearly forty million people (seven times the size of South Carolina), has the second-largest set of users. The top seven US states with the highest user rates are either states with the largest population, states that neighbor South Carolina (Georgia and North Carolina), or South Carolina itself. These initial statistics indicate that although LDHI has countrywide utility, its strongest usership lies within the state that its content reflects. A closer look at state statistics reveals an even more localized usership. Within South Carolina, Google Analytics reveals a regionally specific bubble of LDHI activity. Nearly one in four South Carolina users who visit LDHI's website are located in Charleston. When an examination of the use of LDHI is expanded to include the Lowcountry's coastal surrounding cities (North Charleston, Goose Creek, Mount Pleasant, and Summerville), they cumulatively make up an additional 19.2 percent. The Charleston metro area, then, provides 43 percent of the total South Carolina usership of LDHI. That is 19,088 visits over the course of 5 years, averaging to 3,181 visits annually. The vast majority of LDHI visitors are new, with a smaller percentage of returning visitors. This indicates that some locals are using and reusing the site, whereas others are coming to learn about a specific topic or historical moment in the region before moving on. In a city with a permanent population of barely 136,000, it is very reasonable to conclude that some of these one-time users are from the group of seven million annual tourists.

South Carolina not only sees the highest concentration per population of LDHI users in the world, but additional Google Analytics measurements reveal that Charleston users are seeking out and staying to read LDHI exhibitions more than any other population that visits the website. As evidence that they are seeking out historical topics in LDHI exhibits, Charleston's user bounce rate is more than thirty percentage points lower than the website's average, meaning that fewer people leave LDHI immediately when they are located in Charleston. Furthermore, the average session length is nearly nine minutes, with users flipping through an average of more than six pages per visit. The nearly nine-minute session average of Charleston users not only almost quadruples the website-wide average of 2.18 minutes per visit but also goes far beyond the industry standard of expecting two- or three-minute session lengths on any given website. In short, Charleston's metro area population has proven to be the most interested by visiting more frequently and staying far longer than any other population.

In light of the 2020 national protests addressing police brutality and other social injustices toward African Americans, LDHI was also able to use its more

recent social media presence to share historical facts and shape knowledge about Charleston's history of uprisings, protests, and race-based conflicts. Social media offers a useful platform to respond quickly to current events related to the mission of a digital public history project, and it allows for the public to interact or voice their thoughts.

Graduate students have been central to LDHI's social media presence. After training on writing public history posts about exhibits as well as how and when to respond to followers, graduate students write posts and gather images for the coordinator to review. These posts are rigorously reviewed for historical accuracy, with graduate students supplying primary and secondary sources for the posts. Although an initial time investment is required to learn the style and tone appropriate for social media posts, it provides LDHI with the ability to connect to new audiences. It also provides graduate students with the opportunity to draft historical content for the public.

Using social media also requires less work to respond immediately to current events affecting people's daily lives. As the streets in Charleston and hundreds of other cities filled with protesters demanding racial and social justice for Black Americans, social media allowed LDHI to immediately respond with a timeline of the Lowcountry's history of uprisings and protests. When the infamous John C. Calhoun monument was removed, social media again allowed for a nearly instantaneous response with a history of the monument and its meaning to Black Charlestonians. Both posts received overwhelming active responses, being shared repeatedly by LDHI followers. Social media followings have also brought new partnerships and collaborative efforts with collaborators sharing that they found LDHI's exhibit through our social media. Although using social media involves an additional investment of time, considering some level of social media presence for any digital public history project can increase audience and partnerships, both of which assist in reaching the project's mission.

LDHI has grown into a sustainable, thriving digital public history platform that continues to provide the public with inclusive history as its foundational perspective. This has allowed the public a space to confront difficult, uncomfortable, and painful historical realities while also learning the narratives of marginalized communities' triumphs and achievements. It also provides opportunities for the public and public history practitioners, including cultural heritage site workers, to learn accurate and inclusive histories in hopes of promoting a better understanding of Lowcountry history and its connections to the present.

Partnership and collaboration will continue as a critical and foundational element of LDHI's success. Through author collaborations, social media outreach, and K–12 outreach, LDHI is looking forward to new collaborations. In the near future, LDHI has the goal of expanding its reach to better serve secondary educators by aligning the exhibits with South Carolina State Standards in Social Studies. By working with South Carolina educators, we hope to provide history so that young people can learn more about underrepresented people's experiences not only on field trips or family trips but also directly in their classroom. With the support of graduate assistants, LDHI's recent increased use of social media has seen early success in attracting people from South Carolina to California to learn about underrepresented people of the Lowcountry, and there are clear signs that the public is willing to engage with the difficult history they are presented as social media followers and re-posts increase.

Like many southern and American public history landscapes, Charleston's history of suppressing and denying violent painful history in place of self-serving romantic history cannot continue without consequence. LDHI has leveraged digital tools to join many in the region seeking to change the collective memory of future generations of Americans to reflect historical realities. Denial of history is not only hurtful to those whose ancestors' histories is ignored, but such denial on the part of public history workers is also unethical. Thus, LDHI offers this essay as a blueprint for consideration to others in regions with difficult histories or dangerous imagined heritages. For public history workers in South Carolina and the Lowcountry, LDHI serves as clear evidence that the region's public is seeking out resources to learn history, not myths, and we hope that more in the area will join the growing efforts to center the Lowcountry's underrepresented history.

PART III
Thinking Back, Looking Forward

The Ansonborough Project

Lessons in Historic Preservation

ASHLEY HOLLINSHEAD

In the November 25, 1962, issue of the *Charleston News and Courier,* the Boston Chamber of Commerce applauded the preservation efforts of the Historic Charleston Foundation in Charleston's Ansonborough neighborhood. The Historic Charleston Foundation first announced its plans for the Ansonborough Rehabilitation Project (hereafter the Ansonborough Project) in 1957, and over the next several years the efforts of the Historic Charleston Foundation received acclamations from across the United States, ultimately influencing passage of the 1966 National Historic Preservation Act.[1] The goal of the project was to revitalize the Ansonborough neighborhood using innovative preservation practices. The Ansonborough Project was revolutionary, restoring buildings not as static museum pieces but as part of the living fabric of a community.

With the Ansonborough Project, the Historic Charleston Foundation aimed to use historic preservation as an alternative to urban-renewal programs. Although other cities' urban-renewal programs did not look like Ansonborough, the results of a "revitalized" neighborhood and the displacement of residents were similar. The Historic Charleston Foundation targeted the predominantly African American Ansonborough neighborhood located just outside the then-historic district of Charleston. The use of historic preservation practices to revitalize a neighborhood gained national attention and propelled Charleston to the forefront of the US preservation movement once more.

This essay situates the Ansonborough Project within the history of preservation in Charleston in the twentieth century, removing Charleston's preservation significance from the confines of the interwar period (1920–1940), illustrating that the postwar preservation movement had just as much of a lasting impact on erasing Black voices from the landscape of Charleston. Further, this essay frames the Ansonborough Project within the larger social

issues of the mid-twentieth century, namely issues of race. Therefore, the Ansonborough Project serves as a vital case study for public history workers in how preservation practices can have long-lasting impacts, such as gentrification.

Preservation and Memory

Historic preservation is synonymous with Charleston's twentieth-century history. However, most scholars focus exclusively on the interwar preservation movement (1920–1940), almost completely ignoring Charleston's postwar preservation movement, which was spearheaded by the Historic Charleston Foundation.[2] Public history workers will benefit from examining these more-recent preservation practices because, much like the interwar movement, these efforts continued to shape the landscape of Charleston to the one that millions of tourists come to experience every year. This essay expands on previous scholars' work of the interwar preservation period, exploring the intersection of historic preservation and race in postwar Charleston.

As the English playwright Harold Pinter once said, "The past is what you remember, imagine you remember, convince yourself you remember, or pretend to remember."[3] Therefore, history is not static but fluid, and how people remember the past illustrates power.[4] Historian Michel-Rolph Trouillot expands on this, arguing that history "is the fruit of power," and the "production of historical narratives involves the uneven contribution of competing groups and individuals who have unequal access to the means for such production."[5] Looking at the landscape of Charleston and examining the dominant historical narrative illustrates the power of white history organizations. These organizations, such as the Historic Charleston Foundation, created the early historical narrative of "America's Most Historic City."

In the 1930s people began to fear the encroaching modernization of cities as gas stations, parking lots, and parking garages became common additions to a city's landscape. Cities across the United States began to fear that modernization would mar the landscape and prevent visitors from connecting with history.[6] In 1931 Charleston established the Board of Architectural Review, which required approval for changes made to the exterior of structures located in the Old and Historic District; this expanded on the idea of preserving groups of buildings rather than individual structures in order to showcase a consistent narrative about the landscape.[7] Essentially, this is the creation of the now-popular "historic district." Historic districts aim to illustrate a specific moment in time, and the districts more accurately reflect "perceptions of significance." These districts are often more valuable in understanding the time in which they were created than the time that they reflect.[8] Charleston became the first city in the United States to establish an "old and historic district." The historic

districts used zoning laws to provide oversight on privately owned properties. Charleston was the first to initiate such a large preservation project, and the city became a national leader in the interwar preservation movement.[9] This put Charleston, for the first time, at the forefront of national preservation efforts.

Scholars such as Stephanie Yuhl, Ethan Kytle, Blaine Roberts, and Sarah Platt have written extensively on Charleston's interwar preservation movement, identifying the link between race and preservation.[10] During the creation of this "old and historic district," wealthy, white Charlestonians reimagined Charleston's history to create a more "useable past" for tourists to digest.[11] The narrative of Charleston, pushed forward by preservation practices both during the interwar period and following World War II, ignored "the oppression of slavery, of the failures of Reconstruction, of the humiliations of Jim Crow, of the struggles and opposition posed by the African American community's leaders."[12] Lost Cause narratives, which posit that the Confederacy fought for a just cause during the Civil War, undergirded the interwar preservation movement in Charleston, becoming "inscribed on the landscape through acts of preservation."[13] Race is a powerful social construct, and the intersection of race and historic preservation created, in the words of preservationist Ned Kaufman, a "heritage profession . . . almost as segregated as any sundown town."[14] Preservation is selective, and what people choose to preserve illustrates what is considered to be important.[15]

The postwar preservation movement, spearheaded by the Historic Charleston Foundation's Ansonborough Project, continued the sanitization of Charleston's landscape that began decades earlier, leading to the creation of a white-centric landscape. This picturesque landscape is a large part of what attracts millions of tourists annually to visit Charleston. In fact, the city of Charleston has been voted the number-one travel destination in the United States and Canada since 2010.[16] A *New York Times* article states that Charleston is a "delicate balance between the narrative promoted by the powerful visitor's bureau and the city's history as the capital of the North American slave trade."[17] Charleston, "famous for its old colonial homes painted in pastel colors, iron gates, murmuring fountains, narrow cobblestone streets, moss-draped oaks and rustling Palmetto trees," evokes images of an idyllic landscape.[18] However, it is within this city that if you look closely, you will see the physical evidence of the enslaved Africans and their descendants who built the city.[19] Through selective historic preservation, the physical landscape of "historic" Charleston neighborhoods has been distorted. Instead of an "authentic" landscape, what visitors actually encounter is one that has been carefully curated to reveal certain elements of the city's past while concealing others. Both the interwar and postwar preservation efforts, spearheaded by wealthy, white Charlestonians whose ancestors once owned plantations, transformed Charleston into

the tourist destination that it is today. The Ansonborough Project is a prime example of the white community's creation of a white-centric landscape.

As R. S. Hautaniemi Paynter and N. Muller write, "The lack of historical places on our contemporary landscape that remind all persons of the omnipresence of African Americans throughout U.S. history . . . helps create a cultural amnesia and contributes to the recreation of racism."[20] The Charleston landscape is then, essentially, victim to systemic racism.[21] The erasure of Black voices from the physical landscape reveals the systemic racism that undergirded the twentieth-century preservation practices in the city. The Ansonborough Project in the mid-twentieth century is a relatively little-known preservation movement that has had resounding effects not only on the physical landscape of Charleston but also on its continuance of racial inequalities and public history interpretation. Therefore, this project became a collision between memory and institutionalized racism, where the physical absence of buildings representing African American history echoes as loudly as the silences in the historical narrative.

The Ansonborough Project

Following the end of World War II, cities across the United States initiated federally funded urban-renewal programs aimed at addressing "urban decay" by improving inadequate housing and relieving traffic congestion caused by increasing suburbanization. More commonly referred to as "slum clearance," urban-renewal programs cleared large communities of buildings from urban centers, resulting in extensive structural destruction and the displacement of neighborhood residents. Although the displacement of residents, a majority of whom were African American, was the foremost consequence of urban-renewal programs, it was the destruction of historic structures that garnered grassroots support in white communities looking to protect their local heritage. Amid these concerns, the Historic Charleston Foundation launched its Ansonborough Project, bridging urban-renewal programs with the increased prevalence of preservation-based rehabilitation across the United States.

The Ansonborough Project, taking place from 1957 through the early 1970s, was the first project of its kind, using a revolving fund to finance the preservation of an entire neighborhood. To transform the neighborhood without demolishing buildings of architectural value, the Historic Charleston Foundation purchased, restored, and resold residences within the Ansonborough neighborhood to private investors with protective and restrictive covenants attached.[22] These covenants not only ensured that the residences maintained the "architectural integrity" directed by the Historic Charleston Foundation but also required the approval of the Foundation if the residence was to be sold.[23] In this way these covenants allowed the Historic Charleston Foundation

to dictate the demographics of the "new" neighborhood: young, middle-class, *white* families.

The Ansonborough neighborhood became the pioneer neighborhood for the Historic Charleston Foundation's Area Rehabilitation Project. S. Henry Edmunds, president of the Foundation in 1962, described the Ansonborough neighborhood as an "interesting but definitely blighted area."[24] It was "interesting" for its architecture and "blighted" for its neighborhood demographics. The Ansonborough neighborhood contained "the richest concentration of early architecture" in Charleston, with 125 pre-Civil War houses, four churches, one public building, and the first public city high school.[25] An examination of a variety of documents, including census data and oral histories, illustrates that the Ansonborough neighborhood was a predominantly African American, working-class neighborhood located in the heart of Charleston's historic district. During a 1961 meeting, board members for the Historic Charleston Foundation declared Ansonborough to be "the greatest detriment to the area" because the residences in the neighborhood "were teeming with undesirable negro tenants."[26] The Historic Charleston Foundation's reasoning behind its targeting of the Ansonborough neighborhood reveals the larger social issues of the mid-twentieth century, including racism. However, even during the height of Jim Crow discrimination and segregation, journalist and former resident Herb Frazier recalled Ansonborough as a space of "tranquility in a sea of turmoil," illustrating the community built by neighborhood residents.[27]

Frazier remembered growing up in the Ansonborough neighborhood at the Ansonborough public housing projects, located in present-day Gadsdenboro Park. He remembered the summers most vividly: participating in Little League baseball games, running barefoot, and eating mulberries.[28] Another former resident, Albert Simmons, recalled similar memories of corner stores selling new shoes and seafood, vegetable stalls, and lumberyards before concluding that "the houses were in bad shape, but the people were truly genuine."[29] The imagery evoked by Frazier and Simmons' memories illustrates not a "blighted" area of Charleston but a vibrant and stable community not unlike a neighborhood one might expect to discover in urban centers today.

US census records from 1940 reveal that the Ansonborough remembered by Frazier and Simmons was a working-class, majority African American neighborhood. Residents held a variety of both blue-collar and white-collar jobs, including day laborers, seamstresses, domestic workers, and public-school secretaries.[30] Strictly analyzed, census data from Ansonborough residents reveal what some might consider an economically poor neighborhood. Census records further indicate that the majority of Ansonborough residents earned between $200 and $800 annually, significant down from the national average income of $1,368.[31] But even so, Frazier states, "We didn't consider ourselves to

be very impoverished at that time because this was a very nurturing neighborhood." Despite the financial poverty that many residents faced, Ansonborough was a neighborhood of hardworking families in the heart of historic downtown Charleston.

Race played a key role not only in the selection of the Ansonborough neighborhood but also in the selection of which buildings to preserve and the money offered by the Historic Charleston Foundation to purchase the residences.[32] In reviewing properties considered for purchase, the Historic Charleston Foundation came across 8 Alexander, belonging to Rose Solomon. The Historic Charleston Foundation recommended the entire area be purchased and "cleaned up" because of a "dreadful negro shack on a small lot." An African American doctor named Purvis lived on the southeast corner of Wentworth and Anson Street. In relation to his home, the Historic Charleston Foundation wrote that the home was not "an eyesore at present" but that the foundation was "alarmed at problems in clearing up such spots as area develops."[33] Being a doctor, Purvis was a white-collar worker, probably earning a middle- to upper-middle-class income. Because he was African American, however, the Historic Charleston Foundation viewed him as a "problem" in their neighborhood that needed to be immediately removed.

As the Historic Charleston Foundation sought to restore the Ansonborough neighborhood, the foundation additionally sought to root the neighborhood's identity in the eighteenth and nineteenth centuries. As one home advertisement explained, "Its Ansonborough project is designed not only to preserve significant old architecture, but also to provide the kind of in-city residential areas so necessary to the health and prosperity of all modern urban areas. It is based in the joint belief that retaining our special architectural flavor is a sound investment many times repaid in tourist dollars as well as in beauty, and that the heart of our city must be protected from blight in Charleston is to prosper as spectacularly as it did in the 18th and 19th."[34]

Even though the history of enslavement physically shaped and provided the wealth for the city of Charleston for most of these two centuries,[35] the Historic Charleston Foundation systematically glorified this period, exerting white power through preservation. In Charleston the chosen architecture told a collective story of a wealthy, white Charleston, often ignoring that the hands of enslaved people constructed residences for white families whose wealth came from the transatlantic slave trade or from the large-scale rice and cotton plantations located outside the city.[36] These preservation practices contributed to the erasure of Black voices from the landscape, a process that continues to affect public history in Charleston today.

The Historic Charleston Foundation sought to "revitalize" the Ansonborough neighborhood located in the historic core of Charleston not in the

interests of its longtime residents but for the tourists the city hoped to attract.[37] Charleston leadership praised the Historic Charleston Foundation for its efforts in preserving and restoring the Ansonborough neighborhood. Mayor Gaillard said the revitalization of Ansonborough "is most beneficial to our city, both as a tourist attraction and as a means of providing modern homes."[38] By 1969, the Historic Charleston Foundation had almost finished the Ansonborough Project. In total, the foundation purchased and restored 57 pieces of property, all of which were restored as "living units." Private investors purchased and restored another 44 properties, bringing the total to 101 total properties restored, producing 132 "new quality living units."[39]

Although many white Charlestonians considered the Ansonborough Project a success, seven hundred residents in Ansonborough lost their homes because of it.[40] This displacement, today recognized as gentrification, is just one consequence of practices rooted in racism and white supremacy. In the decades since the Ansonborough Project, rapid gentrification has continued to affect the racial makeup of the peninsular city of Charleston. In November 2017 the Race and Social Justice Initiative at the College of Charleston released a report titled "The State of Racial Disparities in Charleston County, South Carolina, 2000–2015." The aim of the report was to look at racial disparities, including disparities in housing, health care, and education. The report concluded that in 2000, the racial makeup of the peninsula of Charleston was 35 percent Black and 62 percent white; by 2015, it was 29 percent Black and 68 percent white.

The story of Ansonborough provides an important chapter not only in the history of Charleston but also in the history of urban preservation efforts over the last sixty years. The Historic Charleston Foundation's preservation efforts were some of the first successful attempts in the United States to preserve an entire neighborhood, as opposed to individual buildings. This shift in preservation, as well as the use of a private revolving fund instead of federal monies, became a model for other cities interested in "revitalizing" neighborhoods to combat urban renewal, a program using federal money to assist with "slum clearance." However, both models resulted in the fracturing of Black neighborhoods across the city, creating challenges for local public history workers to remap "the cityscape in ways that [recognize] African American history and slavery."[41]

The "Storyscapes" Framework

When public history workers focus exclusively on the architectural importance of a neighborhood, the stories of the people who lived there are lost, contributing to the marginalization and discrimination of those communities. The lived experiences of the people who made up the neighborhood are

ignored; in essence, architecture begins to define the neighborhood rather than the people.[42] Kaufman explains that historic preservation "protects man-made aspects of the city-scape" but that the resources that "convey history, support community memory, [and] nurture people's attachment to place" are not so often protected. Essentially, he argues that traditional historic preservation practices such as the Ansonborough Project focused on preserving the built environment while ignoring the social history created within the same landscape. Kaufman proposes a different type of preservation under the name of "story site," a combination of architecture and social history: a site with a story to tell. Collectively, these "story sites" create a "storyscape."[43] Although he is not the first to apply the "storyscape" framework or coin the term,[44] it is a framework created to recognize the shift toward a more inclusive and representative field of preservation.

The storyscape framework preserves vernacular history, preserving history from a bottom-up rather than traditional top-down approach. To best use this framework, historian Richard Rabinowitz states that stories are essential. He writes that "places whisper stories we will never forget." Stories allow public history workers to craft narratives that allow visitors to "feel as [historical characters] must have felt." For example, in a reflection on the exhibit *From Home to City*, Rabinowitz writes about "the point of pause in a person's morning in 1780 and in 1980, during the walk to work . . . the commonality of a human experience."[45] Although architecture can be important, visitors best make connections between place and historical character through stories of personal experiences that transcend time, something as simple as reflections during a morning walk to work or as complex as the feelings of independence in learning to read using a book primer as a child.[46]

To learn the stories of people, particularly people who have been marginalized in traditional narratives, cross-disciplinary work is often required, intersecting oral history, archaeology, and geography. White Charlestonians erased the history of Ansonborough, but creatively exploring the historical sources to discover the "storyscape" of the neighborhood allows public history workers the material to interpret the erased neighborhood. With the emergence of oral history as a discipline and the push for more social history in the 1970s, this has led to more vernacular discussion around the idea of storyscapes. Further, the emergence of public history has allowed the convergence of academic and public stories to explore race, class, ethnicity, and power.

No history is strictly local history, but it can be situated within larger social themes and issues like racial inequities. By examining storyscapes, we can begin to better understand the history of marginalized voices and provide an inclusive interpretation. Kaufman writes that a focus on storyscapes can "do more to harness its persuasive power on behalf of communities and

peoples—not by slanting but by presenting the full truth of profoundly complex and often painful relationships among people and between people and the land. In so doing, preservation can become a vital and progressive force in the struggle toward a more just society based on preservation values."[47]

There is power in place. Places are, according to Kaufman, "both mnemonic devices and as touchstones, provocations to tell history." Sites such as Ansonborough, which have an opportunity to share ethnic, racial, gender, and class narratives, provide a great opportunity to spark dialogue among visitors.[48] Stories can bridge gaps, so storyscapes can be a powerful tool to open a national dialogue on issues of race and racial disparities. Addressing the racism built into a physical landscape is a process, one that can begin with stories and community engagement. Whereas the Ansonborough Project tangibly illustrates the power of history organizations in the erasure of Black voices both literally and figuratively, a closer study of the more-recent efforts of public history institutions in Charleston, including the Historic Charleston Foundation, illustrates a changing trajectory in the field of public history.

Charleston's Public History Field Today

In the decades since the Ansonborough Project, the public history field, both nationally and locally in Charleston, has undergone significant changes. According to historians Kytle and Roberts, "Elite white Charlestonians in the interwar period created an official history that pushed Blacks to the margins."[49] I would argue that the postwar preservation movement beginning with the Ansonborough Project continued the work begun by earlier preservationists. The Ansonborough Project not only changed the demographics of the neighborhood, but when it was later added as part of the city's historic district, the built environment showcased once again a whitewashed history. However, in the past several decades historic sites, museums, and organizations have come a long way in addressing the racism behind these earlier practices. Scholars have significantly noted that until the 1990s, slavery was not "effectively addressed in public interpretation efforts in and around the city."[50] Local heritage sites are making efforts to put Black voices back into the landscape.

Historian Michael Frisch argues that the ways in which we engage with the past illustrate current issues, including issues that surround systemic racism and social justice.[51] For the past two decades public history workers have been trying to interpret a more inclusive narrative. Several institutions, including the Historic Charleston Foundation and the Preservation Society of Charleston, are working to recover the histories of the neighborhoods like Ansonborough, turning the stories of residents and business owners into public history or archival materials for public historians to use. In 2015 Preservation

Society intern Kayla Halberg completed a property-based project that allowed for names and stories to emerge for the Morris Street Business District. This collaborative project with the Lowcountry Digital History Initiative explores African American business culture during segregation, Jewish and Eastern European immigration, and the effects of desegregation on the Charleston peninsula.

The Halsey Institute of Contemporary Art at the College of Charleston opened a temporary exhibit in 2019, *Over There and Here Is Me and Me* by Katrina Andry, focused on the intersections between racial stereotypes and gentrification. The goal for this exhibit was to start local dialogue surrounding current issues of gentrification within the city of Charleston.[52] Currently, there are no permanent exhibits at sites in Charleston sparking conversation around these current social issues rooted in historic preservation practices. By acknowledging the changes in how we remember history—that history is not static—public history workers can ethically interpret underrepresented histories even within white landscapes and spark dialogue surrounding national social issues such as racial inequalities and gentrification.

Other institutions are physically putting Black voices onto the landscape with new structures. The new International African American Museum (IAAM), which began construction in 2019, will open in 2022 to "honor the untold stories of the African American journey at one of our country's most sacred sites.[53] This museum will be located in what was originally a part of the Ansonborough neighborhood.

As an institution, the Historic Charleston Foundation has come a long way since the Ansonborough Project. In a February 2018 social media post, the Historic Charleston Foundation discussed its role in preserving buildings of social significance, not just buildings of architectural significance:

> In a few weeks the beaches around Charleston will be packed to the gills with people who flock here from across the country. Trips to our beaches weren't as straightforward for African Americans just a few short decades ago. Barred from Folly Beach during segregation, families flocked to Mosquito Beach which developed as a resort and safe place from the oppressions of Jim Crow era South Carolina. The site and original structures survive today, but barely. Our staff have been working over the past year to list the site on the National Register [of Historic Places], but recently one of the main surviving structures—the Pine Tree Hotel—has been threatened with demolition. Chris Cody, our manager of Advocacy, is hard at work to assist the owner in saving this important structure, not necessarily for its architectural significance but because "it is socially significant as part of the African American story

in the Lowcountry and as a relic of racial segregation." It is only with the survival of such structures that we can tell the full story of all Charlestonians.[54]

The site to which the post refers is Mosquito Beach, a .13-mile strip of high ground located on the southern border of Sol Legare Island in James Island, sitting in the middle of the Gullah Geechee Cultural Heritage corridor.[55] Today, three buildings remain: Island Breeze, D&F's, and the Suga Shack. This post reveals a significant philosophical shift from the Historic Charleston Foundation of the 1960s to the Historic Charleston Foundation of the early 2000s. The foundation's new approach toward a "socially significant" site echoes the storyscapes framework.

Since this post, the Historic Charleston Foundation has successfully collaborated with African American community members of Sol Legare and the National Park Service to get Mosquito Beach on the National Register of Historic Places, a huge accomplishment based on the preservation practice of considering the cultural significance of buildings. As a part of the ongoing idea of "storyscapes," the Historic Charleston Foundation coordinated an event with the Sol Legare community in October 2018 called "History Harvest," where the public brought photographs, souvenirs, memorabilia, and their stories to better document the history of Mosquito Beach.[56] One year later, in October 2019, Mosquito Beach was unanimously approved to be listed on the National Register of Historic Places.[57] Mosquito Beach speaks to the story of racial discrimination in the built environment and inequality of recreational access. According to the NPS application under the "statement of significance," "The Mosquito Beach Historic District is eligible for listing on the National Register of Historic Places . . . as a significant and well-preserved cultural, commercial and recreational epicenter for the Charleston black community during the Jim Crow era. The survival of the structures, sites and overall ambiance of the strip embody the empowerment and entrepreneurship, as well as the sustainment of culture and tradition, displayed by African Americans during a time of deep oppression."[58] It is through the preservation of Mosquito Beach that one can learn about not only the horrors of Jim Crow discrimination but also about the resistance and perseverance of the African American community. It is this social significance that is more important than architectural significance in the preservation of Mosquito Beach, illustrating, once again, a shift in the Historic Charleston Foundation's philosophy.

The Foundation has also been working on a project to uncover artifacts from the walls of its house museums to interpret the lives of enslaved people who lived there. The foundation's social media sites are heavily used to share the history of African Americans in the Lowcountry, exposing tourists and members

of Charleston's present-day white elites to histories that the Foundation ignored in the 1960s. The institution was first used as a model by white people in cities across the country for erasing neighborhoods that did not support their city's narrative, but preservationists and other public history workers can now look to them for examples on how to ethically engage in preservation and interpretation practices. The objects discovered in these excavations are curated digitally and available to the public. The collections are not segregated, but rather the collection includes decorative and fine arts alongside the discovered objects, leading to what Platt argues is a representative history of a site, showing that these housing sites within the Charleston peninsula are not only spaces for elite whites but also spaces of Black labor and voice.[59] Notably included in this collection is a reading primer and a coral bead, suggesting to the public that these are emblems of resistance among enslaved peoples. And going back to the idea of storyscapes, childhood and culture is something that everyone can connect with.

To understand preservation practice today and to ethically interpret histories, scholars must look at the history of preservation practice across the entire country; they cannot focus only on preservation-based rehabilitation in large cities, but they must begin to study smaller preservation in smaller cities, even when the preservation strategies have a negative impact on the community. The recognition of negative impacts allows for the growth and change of preservation tactics, as with the Historic Charleston Foundation.

Not only does the Ansonborough Project provide a unique window into studying the intersection between race and historic preservation, but it also showcases how institutions that are not hesitant to reflect on their previous practices can change to better interpret underrepresented histories. Historic preservation practices not only show us where we can grow in the field for more ethical interpretation and practices but also show us how we can begin to inclusively interpret landscapes that are traditionally white-centric. Therefore, the Ansonborough Project is a lesson in the field of historic preservation and in how the field of public history has changed over past several decades to center underrepresented voices. Rabinowitz sums this up well: "That Black lives in the past are everyone's concern . . . is a predicate to the idea that Black lives matter today."[60]

"A Thin Neck in the Hourglass"

Looking Back at Charleston Harbor from Colorado . . . and Looking Forward

PETER H. WOOD

> "Sail away, sail away. We will cross the
> mighty ocean into Charleston Bay."
>
> —*Randy Newman, chorus to the title
> song of his 1972 album,* Sail Away

Our expert local guide, Shawn Halifax, pulled off Route 17 near Ravenel, South Carolina, close to a black-and-white sign commemorating the largest slave revolt in colonial North America.[1] The historical marker stood twelve miles southwest of Charleston, at the spot where the Stono Rebellion began on September 9, 1739. The sandy roadside patch near Wallace Creek was overgrown with weeds and uncut grass. It was mid-June 2017, and I had just attended a public history conference at the College of Charleston. Now I was helping Shawn lead a visit to the Lowcountry with half a dozen public school teachers from Colorado, where I have lived for the past eight years. Our group brushed off mosquitoes and clamored out of the van to examine the two-sided marker.

"The rebels," the brief account explained, "marched south toward promised freedom in Spanish Florida, waving flags, beating drums, and shouting 'Liberty!'"[2] As we talked about this distant event, suddenly a shout from a passing car interrupted our conversation: "Nigger lovers!" the heckler repeated in an impromptu drive-by ambush. "Nigger lovers!" Such anonymous bigotry, so commonplace online in the digital age, had an unfamiliar back-to-the-future quality coming from the window of a speeding automobile. The hate-filled catcall understandably shocked us. I was as disheartened as the teachers, though somewhat less surprised. I had lived in the Carolinas for decades as a history

professor at Duke University, and I had been pondering the deep roots of such racist vitriol ever since my initial visit to the Lowcountry in 1970.

I recalled how long it had taken to put the innocuous Stono marker in place. In 1974, during the run-up to the nation's bicentennial, a report for the National Park Service had identified thirty sites that could illustrate and commemorate the long saga of Black history in America. The list included the uprising near the Stono River, almost unknown at the time. That same year the report's author, Marcia Greenlee, filled out paperwork nominating the site for the National Register of Historic Places. The Park Service form confronted her with two dozen boxes naming traditional "areas of significance." Stymied, Greenlee checked the final square, marked "Other," and wrote in the still-unfamiliar category of "Afro-American History."[3] It was not until 2006, more than three decades later, that local Black residents who were members of the Sea Island Farmers' Cooperative finally succeeded in preparing and dedicating the actual Stono marker.

After showing us the Stono sign, Shawn took us to the remote dirt road that had been the first portion of the rebels' path in their failed effort to reach St. Augustine. Bordered with live oaks and Spanish moss, it offered a Lowcountry vista that seemed strange and unfamiliar for the teachers from mile-high Colorado. But it suited the purpose of their journey: to gain greater familiarity with the early roots of Black history so that they could teach effectively about enslavement and its consequences. Our itinerary included such sites as Charleston's Old Slave Mart Museum on Chalmers Street and McLeod Plantation on James Island.[4] Farther south along Route 17, we spent a whole day at the Caw Caw Interpretive Center, near the winding Stono River. A highlight involved canoeing through Caw Caw's huge web of slave-built canals that once irrigated vast fields of rice. By sharing the trip with first-time visitors half my age, I had a chance to explore the coastal landscape, past and present, through their fresh eyes. But I also had a running conversation with myself, reflecting on how much had changed, or not changed, since my initial sojourn in the region nearly fifty years earlier.

When I first explored the Lowcountry, South Carolina was observing the three-hundredth anniversary of the start of English coastal settlement in 1670. I encountered a tercentennial celebration highlighting a peculiar version of South Carolina's past that seemed half-empty. As a graduate student in colonial American history, born in the Midwest and raised during the civil rights era, I was there to explore why South Carolinians—and everyone else, my mentors included—still knew so little about the colony's disturbing early history. Renting a room in Columbia, I settled into the spacious reading room in the old state archives building on Senate Street. As I browsed the shelves, I quickly found that South Carolina's newest high school state history text

contained only two references to "Negroes" before the Jacksonian era. Surely there was more to the story.

In 1972, as I completed my dissertation, I was pleased to hear the popular musician Randy Newman refer to "Charleston Bay" in his ironic song "Sail Away," mocking the deceitful pitch of an American slave trader on the west coast of Africa. (The title invoked the name of a carefree 1961 musical comedy by Noël Coward.) In those days popular culture rarely spoke of enslavement, and if scholars of early America ever mentioned colonial-era slavery, the focus always fell on Virginia. Perhaps I was on the right track. Two years later, when I published *Black Majority*, a book about the introduction of race slavery into the Lowcountry, I referred to South Carolina as "a thin neck in the hourglass of the Afro-American past, a place where individual grains from all along the West African coast had been funneled together, only to be fanned out across the American landscape with the passage of time."[5]

Visiting Charleston with inquisitive teachers reminded me of how the hidden history of Black South Carolina has gradually been unearthed and then presented to the public in changing ways over the past half century.[6] When I explored the Old Slave Mart Museum in the early 1970s, for example, it housed only a cramped display of slave crafts and a small gift shop. Judith Wragg Chase, who managed the dusty museum on a shoestring, explained to me that the building had been erected in 1853 by a sheriff turned slave trader. Thomas Ryan's original property included a jail and a kitchen in the rear (along with—most tellingly—a morgue), but those outbuildings were demolished early in the twentieth century. Later, the structure's central space, once used for auctioning enslaved Carolinians, became an automobile showroom and then a spot to house Miriam Wilson's growing collection of slave artifacts.[7] When Wilson died in 1957, Chase and her older sister salvaged the enterprise.[8]

Our Caw Caw visit also sparked memories. After the Charleston County Park and Recreation Commission acquired this 654-acre site, I had traipsed through these brackish wetlands as a would-be consultant in the late 1980s. The decade had seen the publication of important works regarding Gullah rice growers, and this remote spot struck me as the perfect place to begin interpreting the African origins of South Carolina rice cultivation.[9] Instead, initial development plans leaned heavily toward using the impressive swamps and marshlands to provide public access to the natural world. Most white Charlestonians remained in anxious denial about slavery, and after all, the sheltered habitat contained more than two hundred species of birds, plus scores of different mammals, amphibians, fish, and reptiles. The distressing human history that transformed these swamps into lucrative plantations would emerge more gradually. Now, the saga of rice cultivation receives some well-used space in Caw Caw's busy Interpretive Center.

Back home, Colorado winter set in. As I continued to reflect on these layered encounters from our Charleston visit, two contrasting landmarks stuck in my memory. One was the monument to John C. Calhoun that still loomed over Marion Square in the city's center. Coming from far away, this imposing tribute to a proslavery ideologue felt stunningly outdated and deeply divisive. Seeing the staunchest advocate for that iniquity held aloft on such a high pedestal made me ponder Charleston's professed commitment to serious democratic change. The other marker—much more recent—is a commemorative bench on Sullivan's Island near the entrance to Charleston Harbor. An unobtrusive memorial, it invites visitors to reflect on the huge forced migration of several hundred thousand Africans deported by sea to South Carolina. Fort Moultrie's iron bench, near the water's edge on National Park Service land, acknowledges the port's dark eighteenth-century history. But it also offers a glimmer of hope, for places, like people, grow when they find the courage to acknowledge their own past more clearly.

The enormous monument to Calhoun that still lurked over Charleston stood less than two blocks from Emanuel African American Methodist Church, founded in 1816 by the Black pastor Morris Brown. The original building was burned to the ground six years later in the wake of Denmark Vesey's foiled slave uprising, and the structure that stands two centuries later was the site of an unspeakable racist mass murder in 2015. After paying respects to the fallen at Mother Emanuel, our group walked west along Calhoun Street—still purposefully pronounced "*Killhoun* Street" by many of the town's Black residents.[10] Soon we were facing the gigantic monument erected to honor Calhoun, a key architect of white-supremacist ideology. Perched atop a neoclassical column, an honorific statue of the famous slave owner towered more than one hundred feet above spacious Marion Square. We had to squint upward to glimpse the US senator and vice president who had defined race slavery as representing God's natural order and a "positive good" for all concerned.[11]

It took almost fifty years to put the statue in place, and it took a dramatic surge in the Black Lives Matter Movement, exactly three years after our visit, to finally bring about its removal. Born in upstate South Carolina in 1782, Calhoun had a long career as a politician and planter before he died of tuberculosis in 1850 in Washington, DC. Vessels in Charleston Harbor lowered their flags when a ship returned his body to his home state; church bells tolled, and black mourning crepe shrouded shop windows. The city, with 43,000 people, was still one of the country's ten largest, and most of the town's white minority lined the streets, wearing black armbands, as the senator was taken to his

burial spot in St. Philip's Churchyard. The city's Black majority, in contrast, shed few tears for the shrewd theoretician who had done so much to foster the power and interests of his supposed master race and master class.[12]

Four years after his death, a small group of wealthy local admirers, led by Mary Amarinthia Yates, organized the Ladies' Calhoun Monument Association and commissioned plans for a soaring memorial in the senator's honor. "The design," explains a present-day South Carolina historian, "called for an edifice of about ninety-five feet in height. From the marble base, a flight of stairs would lead first to a set of four statues representing Liberty, Justice, Eloquence, and the Constitution, and then to a platform with a colonnade of Corinthian columns. There would be carved emblems of both South Carolina and the United States. The monument would be topped by an immense, twelve-foot-high statue of Calhoun with his right arm extended upward and his hand pointed toward heaven."[13]

With start-up funds in hand in 1858, the Monument Association chose June 28, Carolina Day, to lay the cornerstone. The ladies made sure that it contained a lock of the great orator's hair and a copy of his last Senate speech (a tirade against any sectional compromise that might limit slavery's continental expansion).[14] But the Civil War halted work on the memorial, and during Reconstruction Charleston's Marion Square (known as Citadel Square until 1882) became a contested space. US Army troops occupied the adjacent Citadel from 1865 until 1879, and the new South Carolina National Guard, made up primarily of Black South Carolinians, used the open field for drills and parades. Curious white onlookers watched the new game of baseball there, and African Americans gathered in the park for political rallies and civic celebrations.

With the end of Reconstruction, Lost Cause elites reasserted local dominance. After renaming and landscaping the central green, they commissioned a Philadelphia sculptor to create a statue to adorn a new Calhoun memorial there. Plans again called for the pedestal to be graced with four allegorical figures—this time females representing History, Justice, Truth, and the Constitution. Only one of these figures arrived in time for the dedication, and when installed at the feet of the great patriarch, critics suggested she might depict a subservient Mrs. Calhoun, who had brought ten children into the world. Reservations aside, sponsors unveiled the long-delayed monument in April 1887 before a crowd of twenty thousand. There stood a larger-than-life representation of the orator, wagging his right index finger at all who passed. But this bronze reincarnation, atop a granite pedestal, lasted less than a decade.[15]

Standard accounts attribute the statue's brief life to shortcomings in the sculptor's awkward work. But Mamie Garvin Fields, born in Charleston in 1888, remembered its demise differently. As a small girl, she and her friends

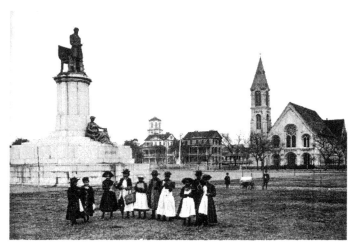

This 1892 image by A. Wittemann appeared in Charleston, SC.
Illustrated. *It depicts well-dressed young Black Charlestonians standing in
Marion Square under the "watchful eye" of South Carolina's most famous
proslavery apologist, the late John C. Calhoun. Four years later, the city's
Lost Cause elite replaced this memorial with a far more dominating and
less accessible monument to Calhoun that stood until June 24, 2020.
(Image courtesy of Wikimedia Commons)*

often passed by the new monument to Calhoun. "Our white city fathers
wanted to keep what he stood for alive," she recalled, so they renamed a major
street after him, which Black Charlestonians "kept calling Boundary Street for
a long time. And when I was a girl, they went further: they put up a life-size
figure of John C. Calhoun preaching and stood it up on the Citadel Green,
where it looked at you like another person in the park." A photograph made
in 1892 shows a group of neatly dressed Black girls, no doubt older friends of
Mamie's, posing respectfully near the granite base, under Calhoun's watch-
ful eye. But these same schoolchildren were regularly taunted, and as Fields
made clear through her bitter and repeated use of the N-word, they sensed the
statue's true purpose.[16]

Fields's powerful memoir, *Lemon Swamp*, explains ways in which Calhoun,
though long dead, had haunted her childhood:

Blacks took the statue personally. As you passed by, here was Calhoun
looking you in the face and telling you, "Nigger, you may not be a slave,
but I am back to see you stay in your place." The "niggers" didn't like

it. Even the "nigger" children didn't like it. We used to carry something with us, if we knew we would be passing that way, in order to deface that statue—scratch up the coat, break the watch chain, try to knock off the nose—because he looked like he was telling you there was a place for "niggers" and "niggers" must stay there.

According to Fields, "Children and adults beat up John C. Calhoun so badly that the whites had to come back and put him way up high, so we couldn't get to him. That's where he stands today," she concluded, "on a tall pedestal. He is so far away now until you can hardly tell what he looks like."[17]

This apotheosis of Calhoun, elevating him toward the heavens, was accomplished in 1896. Lynching was rampant, and white voters had chosen the state's notoriously racist governor, Ben "Pitchfork" Tillman, to represent South Carolina in the US Senate.[18] Revising Calhoun's monument that year moved him above the reach of his detractors while still assuring that his glowering visage would dominate the urban landscape. He remained there when Mamie Fields died in 1987, at age ninety-nine. And his likeness still presided over central Charleston during our 2017 visit, even as statues of Robert E. Lee and Jefferson Davis were beginning to come down across the region. Granted, we were assured that proposals existed for placing an "explanatory" plaque at the column's base or erecting a smaller monument nearby for someone who opposed enslavement. But these responses struck our thoughtful Colorado group of K–12 teachers as ludicrously inadequate and outdated.

We later learned that several years earlier an eminent civic group, the Charleston World Heritage Coalition, had asked the National Park Service to nominate the city to the United Nations as a worthy site to be included on UNESCO's official and prestigious World Heritage List. But in 2016 the NPS rejected this formal request, after reviewers asked how a city aspiring to such recognition could still honor an architect of proslavery ideology so prominently. Similar criticisms met a plan to increase tourism with a new International African American Museum. Could these ambitious efforts ever succeed while the city left in place such a contradictory and towering tribute to proslavery doctrine, erected during the Jim Crow era?[19]

The answer came in June 2020, exactly three years after our study visit from Colorado. Weeks after the police lynching of George Floyd in Minneapolis, Charleston's city council voted unanimously to depose the domineering figure of Calhoun from his skyscraping column. When removal actually took place on June 24, our little Colorado group joined others across the country in exchanging messages of satisfaction and relief. Pondering the removal, I thought of a comment that Walt Whitman recorded at the end of the Civil War.

After Confederate forces had surrendered at Appomattox Court House, the poet overheard a Union soldier observe that the true monuments to Calhoun were the wasted farms and gaunt chimneys scattered over the South.

The modest bench on Sullivan's Island represents a striking contrast to the defunct monument to Calhoun, and I hope it will endure for generations. The distinguished African American writer Toni Morrison placed it there in 2008, almost two decades after she first conceived the idea. In 1989 Morrison had observed that "there is no place you or I can go, to . . . recollect the absences of slaves. There is no suitable memorial, or plaque, or . . . small bench by the road. There is not even a tree . . . you can visit in Charleston or Savannah or New York." So in 2006 the Toni Morrison Society launched the Bench by the Road Project. The Sullivan's Island Remembrance Bench, dedicated at a public ceremony on July 26, 2008, was the first of a score of similar benches that now grace significant African American historical sites around the country.[20] This thoughtful memorial struck me as an ideal place for the Boulder teachers to begin their historical journey.

On the morning that we visited Fort Moultrie, the sky was slate gray, and the air felt especially humid for our group from bone-dry Colorado. Greeting us under the trees beside the bench was Michael Allen, a Black South Carolinian who rose through the ranks of the National Park Service to become a leading interpreter of Lowcountry history and a member of the Gullah Geechee Cultural Heritage Commission. After welcoming us to the Lowcountry, he explained in moving terms how more than four of every ten Africans deported to North America—including his own ancestors—arrived in Charleston; no other East Coast port received so many enslaved people. Forced to grow rice and then cotton, these people made South Carolina the richest state in the new nation.[21]

As we roamed the grounds of Fort Moultrie, Mr. Allen continued his narrative, weaving historical events together with stories of how the Park Service site had slowly begun to acknowledge African American history in recent decades, often overcoming entrenched opposition. We could see evidence in the altered visitor center, where we explored the compact new exhibit titled *African Passages*. It had been encouraged by writer Edward Ball, a descendant of one of the Lowcountry's largest slave-holding dynasties. His best seller about that family legacy won the National Book Award in 1998 and did much to introduce a national audience to the Palmetto State's complex and long-hidden interracial past. *Slaves in the Family* begins with the author's recollection of the taboo that he set out to overturn. "There are five things we don't talk about

in the Ball family," his father used to say. "Religion, sex, death, money, and the Negroes."[22]

As I admired the blown-up historical maps of Charleston harbor that filled the walls of the visitor center, I remembered a lengthy conversation with Ed Ball in the mid-1990s, when he made a research visit to North Carolina. I was teaching in Durham, and we shared an interest in the slave trade and its legacy. Therefore, among many other things, we discussed the nine-page appendix that I had tucked in the back of *Black Majority* two decades earlier. Even in a pre-computer age, I had been able to select the years between 1735 and 1740 and locate sixty-six voyages that reached Charleston from Africa in that brief span (an average of eleven ships per year). Sixteen of the largest vessels each delivered more than 300 slaves. On average, an arriving slave vessel in this period disgorged a human cargo of 175 prisoners. The scattered records told me that over those five years at least 11,562 captives (including 1,559 children under the age of ten) reached Charleston's docks, far more than the town's entire population at the time.

Some of those shackled newcomers no doubt became forced laborers at Comingtee and Quenby, the earliest of the numerous Ball family rice plantations that stretched along the east branch of the Cooper River. We talked about how, as the African trade grew, a "pest house" was established on Sullivan's Island to quarantine survivors of the Middle Passage. It was used intermittently to isolate persons suspected of carrying any contagious sickness ("pestilence"). Weeks later, traders would ferry the surviving newcomers across the harbor, herding them onto Charleston wharves to be sold as chattel. Because so many African arrivals first set foot in North America at Sullivan's Island, in *Black Majority* I referred to this isle in the harbor as "the Ellis Island of black America."[23] Clearly, no Torch of Liberty welcomed these "huddled masses." Instead, the opposite was true. Though innocent of any crime and given no say in the matter, they found themselves sentenced for life to confinement within a growing system of privatized, for-profit slave-labor camps.[24]

Since Philip Curtin's pioneering book about the Atlantic slave trade in 1969, several generations of innovative scholars have greatly expanded and deepened our knowledge.[25] (Usually, they include at least a tip of the hat to the Wellesley College economist Elizabeth Donnan, whose four-volume set of edited documents for the Carnegie Institution in the 1930s showed the possibility for sustained research in this field.[26]) Most importantly, the monumental website www.SlaveVoyages.com has compiled records on more than 36,000 slave-trading voyages from Africa to the Americas into a huge and accessible database. Thanks to this transforming work by David Eltis and his digital humanities collaborators, we are able to learn much more about specific voyages.

Naturally, the database remains incomplete.[27] But in recent years it has already served to encourage a new genre in Atlantic history where authors undertake to write a whole book about a single slaving voyage.[28]

Significantly, the new knowledge about slave ships that sailed into North American ports is not all quantitative. Visceral reports survive for those willing to look. In a recent article about Charleston's slave trade, for example, historian Gregory O'Malley reports that in the spring of 1769, "residents of Charleston complained . . . that slave ships in the harbor had pitched so many carcasses of dead captives overboard that it was a danger to public health." The governor responded in June with a public notice, confirming "that a large number of dead negroes, whose bodies have been thrown into the river, are driven upon the marsh opposite of Charles-Town, and the noisome smell arising from their putrification may become dangerous to the health of the inhabitants of this province." The governor demanded an end to this "inhuman and unchristian practice," but he did not forbid the slave trade itself.[29]

As a result, such noxious scenes continued on Charleston's docks more than a generation later, as slave merchants pushed to import more Africans in anticipation of the federal ban on this perverse Atlantic commerce. On November 22, 1805, the *Charleston Courier* protested that as a result of conditions created by "the importation of slaves from Africa, several incidents have occurred of dead human bodies having been thrown into the waters of the harbor of Charleston." Six days later, the newspaper complained that in order to avoid the cost of burying deceased Africans, some traders were leaving bodies "to be devoured by the turkey buzzards," the large black vultures that scavenged around Market Street so frequently that they earned the sobriquet "Charleston eagles." Other traders simply pushed corpses into the water—so many, according to the editor, that residents were advised not to eat fish from the Cooper River for several months.[30]

James McMillin, who unearthed these details in his impressive book on the final decades of the legal American slave trade, went on to recount an equally grim situation observed twenty-six months later, in mid-January 1808, among several thousand African captives huddled on Gadsden's Wharf. The federal prohibition on further slave imports had taken effect on January 1, and slave merchants had been holding back on sales for months, anticipating that prices would rise. McMillin used the account of John Lambert to recapture the situation. The English visitor testified that "close confinement, scanty clothing, sharp weather, and improper food created a variety of disorders; which, together with dysentery and some contagious diseases to which the Negroes are subject, considerably increased the mortality. Upwards of 700 died in less than three months and carpenters were daily employed in making shells for the dead bodies."[31]

Standing beside the Remembrance Bench on Sullivan's Island, I shared some of these reports with the Colorado visitors. Far from being shocked, the well-prepared teachers from the Boulder Valley School District heard them as confirmation of work that was already under way in their classrooms. Their willingness to look back into this dark place in the American past had been empowering them to look ahead as teachers. They had been moving forward with lesson plans for a full year, ever since this small band of innovators came together and decided to name themselves AT LAST: Alliance for Teaching the Legacies of the Atlantic Slave Trade. Clearly, they wanted to turn Colorado's "remoteness" from the lived experience of Black enslavement, plus Boulder County's frequent hesitancy to confront the history of American racism, from disadvantages into challenges. And they were already making progress in this unlikely effort.

Even before we reached Charleston, several teachers at Barnard D. Ryan Elementary School in the Colorado town of Lafayette had spent much of their spring term exploring the Middle Passage from Africa to America. Students in two fifth-grade English classes published illustrated books of their essays, and the school ended its semester-long exploration with an impressive open-house presentation for once-skeptical parents.[32] Six months later, two teachers at Boulder's Nevin Platt Middle School must have still had our visit to Charleston Harbor in their heads when they devoted Technology Day to exploring a 3-D virtual slave ship. Divided into small groups, their sixth and eighth graders used HoloLens goggles to enter a world of augmented reality. One group at a time, they went aboard a recreation of the actual slave ship *Charleston* that I had been working on with experts from SketchUp, a company in Boulder's high-tech community.[33]

What difference will such small efforts make? I have no idea, but it seems clear that scholars of slavery have been talking to one another for far too long and ignoring almost everyone else. Working with secondary school students and teachers reminds me that more academics need to break out of the ivory tower and be drawn into wider discussions by the focused energy of Black Lives Matter. Current knowledge must, belatedly, reach the young people who need it most and the millions of American adults who heard little or nothing about such things when they were in school. I sometimes recall the wise words of Ernest A. Finney Jr., who passed away in 2017. He was the first African American chief justice of South Carolina's Supreme Court and the forward-looking father of the distinguished poet Nikky Finney. "The law works, Girl," he used to tell his daughter. "A steady drop of water will wear a hole in a rock."[34]

With this observation, as with so many others, Justice Finney proved correct. History's steady drip eventually cleared space for Morrison's re-membrance bench and brought Mr. Calhoun off his lofty column. Will the

In December 2017, the author, at right, used HoloLens goggles with students at the Nevin Platt Middle School in Boulder County, Colorado. The devices allowed them, using "enhanced reality technology," to move around inside a full-scale model of a 400-ton American ship used in the transatlantic slave trade in the late eighteenth century. Photo by Allyson McDuffie.

removal of one statue, or many, help to weaken the region's lingering white-supremacy ideology? Time will tell, but watching from Colorado's Front Range it appears as though Charleston's veil of denial and historical amnesia is gradually lifting. In an impressive example of the power of public history, one other Deep South city has already done more to lift the veil.

If Charleston dragged the white South into an ill-conceived proslavery secession effort, it may be the city of Montgomery that points the way out from under antiquated neo-Confederate nostalgia. In no small part, this is because of the constructive vision of Black lawyer Bryan Stevenson, author of the inspired memoir *Just Mercy* (part of which became a feature film in 2019 with the same title). Stevenson's impressive Equal Justice Initiative (EJI) has been active in creating a legacy museum that tells how the First Capital of the Confederacy evolved from being a Deep South slave mart to a modern-day participant in the country's notorious Black "pipeline to prison." Nearby, EJI has also overseen the construction of a powerful National Memorial for Peace

In 2013, civil rights lawyer Bryan Stevenson (right), director of the Equal Justice Initiative, joined members of Montgomery's Black Heritage Council at the unveiling of a new historical marker outside EJI's building at 122 Commerce Street. In antebellum Alabama, thousands of enslaved African Americans (including many from South Carolina) were brought to Montgomery's waterfront by boat or rail and then marched up Commerce Street to large warehouses owned by slave traders. (AP file photo by Dave Martin)

and Justice. This monument to thousands of the country's Jim Crow lynching victims opened in May 2018 on a six-acre plot in the heart of Alabama's capital.

These two well-conceived efforts, based on the logical assumption that truth precedes justice and reconciliation, are drawing tens of thousands of new visitors to Montgomery annually, lifting up the city's economy. Unlike the hordes of cruise ship tourists who now regularly overwhelm the streets of Charleston, these visitors to southern Alabama come wanting to learn more about the region's twisted history. Contradictions still abound, but on a recent visit I found it moving to stand beside a lifelike statue of Rosa Parks, at the spot in the Court Square–Dexter Avenue Historic District where she entered a segregated city bus in 1955 and launched the Montgomery bus boycott. She faces the giant fountain that now occupies what was once known as Artesian Basin, the site of the city's slave market. Thanks to EJI and the city's Black Heritage Council, candid updated historical markers dot the downtown area.

Granted, Charleston originated in 1680, many generations before Montgomery gained a city charter in 1819 and then became Alabama's capital in 1846. So Charleston's proslavery roots stretch much further back in time. For too many prominent residents, reflexive denial still lingers like noisome Lowcountry pluff mud, forever sucking in new generations.[35] But in the twenty-first century, the city's glacial slowness and repeated backsliding appear to be giving way to a more full and honest reckoning with its troubled past. For those who live in the city, and those who admire it, this difficult public history journey is still just beginning. But the removal of Calhoun's glowering monument—politically unthinkable until recently—has made the path toward equity and justice appear notably shorter and more clear.

Notes

Introduction

1. Larry Buchanan, Quoctrung Bui, and Jugal K. Patel, "Black Lives Matter May Be the Largest Movement in U.S. History," *New York Times,* July 3, 2020, www.nytimes.com /interactive/2020/07/03/us/george-floyd-protests-crowd-size.html.

2. Southern Poverty Law Center, Intelligence Project, *The Year in Hate and Extremism, 2019* (Montgomery, AL: Southern Poverty Law Center, 2020), 6, www.splcenter.org/sites /default/files/yih_2020_final.pdf.

3. With public historian Mary Battle as the principal organizer, the conference had several College of Charleston partners, including the Race and Social Justice Initiative (RSJI). RSJI—whose mission is to promote awareness and dialogue about race and social justice issues in Charleston, the Lowcountry, and beyond—was formed in 2015 in response to two tragic events in Charleston that year. The police shooting death of an unarmed Black man, Walter Scott, was followed by the racially motivated mass murder of nine African Americans in their church, Emanuel AME. The Transforming Public History conference was part of a larger effort, then, to address the city's historical and present-day white violence committed against Black people.

4. Ethan Kytle and Blain Robert's *Denmark Vesey's Garden: Slavery and Memory in the Cradle of the Confederacy* (New York: New Press, 2018) and Stephanie Yuhl's *A Golden Haze of Memory: The Making of Historic Charleston* (Chapel Hill: University of North Carolina Press, 2006) explore how whites created racially exclusionary public history in Charleston, the Lowcountry region, and beyond. Focusing on North Carolina, Adam Domby's *The False Cause: Fraud, Fabrication, and White Supremacy in Confederate Memory* (Charlottesville: University of Virginia Press, 2020) explores how whites' Lost Cause narrative littered the landscape with Confederate monuments that were built on lies.

5. Lisa Respers France, "Ryan Reynolds and Blake Lively 'Deeply and Unreservedly Sorry' for Plantation Wedding," CNN, August 4, 2020, www.cnn.com/2020/08/04/entertain ment/ryan-reynolds-blake-lively-plantation-wedding/index.html.

6. Heather Murphy, "Pinterest and The Knot Pledge to Stop Promoting Plantation Weddings," *New York Times,* December 5, 2019, www.nytimes.com/2019/12/05/style/plantation -weddings-pinterest-knot-zola.html.

7. Julie Rose, *Interpreting Difficult History at Museums and Historic Sites* (London: Rowan & Littlefield, 2016), 18.

8. Kevin Liptak, "Trump Says Department of Education Will Investigate Use of 1619 Project in Schools," CNN, September 6, 2020, www.cnn.com/2020/09/06/politics/trump -education-department-1619-project/index.html.

9. Noreen Nasir and Corey Williams, "AP-NORC Poll: Most Americans Oppose Reparations for Slavery," *AP News,* October 25, 2019, https://apnews.com/76de76e9870b45d38390cc4 0e25e8f03.

10. See also James Oliver Horton and Lois E. Horton, eds., *Slavery and Public History: The Tough Stuff of American Memory* (New York: New Press, 2006); and Roy Rosenzweig and David Thelen, *The Presence of the Past: Popular Uses of History in American Life* (New York: Columbia University Press, 1998).

11. The discussions noted here refer to those that took place among the interpretive staff at McLeod Plantation Historic Site (MPHS) when Leah Worthington worked there as an interpretative aide and then lead interpreter from 2015 to 2016. Worthington's continued conversations with current interpreters at MPHS and other Charleston-area historic sites of slavery reinforce the continued occurrences of these comments from visitors.

12. Amy M. Tyson and Azie Mira Dungey, "'Ask a Slave' and Interpreting Race on Public History's Front Line: Interview with Azie Mira Dungey," *Public Historian* 36, no. 1 (2014): 38.

13. *Ask a Slave*, accessed November 1, 2019, www.askaslave.com/home.html.

14. Sharon Macdonald, *Difficult Heritage: Negotiating the Nazi Past in Nuremburg and Beyond* (New York: Routledge, 2009), 2.

15. "McLeod Plantation Historic Site," Tripadvisor, accessed October 29, 2019, www .tripadvisor.com/Attraction_Review-g54171-d8036493-Reviews-McLeod_Plantation_Historic _Site-Charleston_South_Carolina.html.

16. "Magnolia Plantation and Gardens," Tripadvisor, accessed October 29, 2019, www .tripadvisor.com/Attraction_Review-g54171-d104636-Reviews-Magnolia_Plantation_Gardens -Charleston_South_Carolina.html.

17. Ritu Prasad, "The Awkward Questions about Slavery from Tourists in the US South," *BBC News*, October 2, 2019, www.bbc.com/news/world-us-canada-49842601.

18. The email and experience referenced here were shared privately by a Charleston-area interpreter with Leah Worthington.

19. Benedict Anderson, *Imagined Communities: Reflections on the Origin and Spread of Nationalism* (New York: Verso, 1983), 51; Laurajane Smith, *Uses of Heritage* (New York: Routledge, 2006); Gregory Hansen, "Cultural Heritage and Public Folklore: Tales of Tradition," in *Cultural Heritage Care and Management: Theory and Practice* (Lanham, MD: Rowman & Littlefield, 2018), 62–63.

20. Avishai Margalit, *The Ethics of Memory* (Cambridge, MA: Harvard University Press, 2004), 83.

21. "How Historians Work," National Council on Public History, accessed December 1, 2019, https://ncph.org/what-is-public-history/how-historians-work.

22. Rachel Donaldson, Kieran Taylor, and Leah Worthington, "Making Labor Visible in Historic Charleston," *Labor: Studies in Working-Class History* 17, no. 1 (March 2020): 45–73.

23. Ibid., 51.

24. "About Us," Slave Dwelling Project, accessed January 5, 2020, https://slavedwelling project.org/about-the-slave-dwelling-project.

25. Darcie Goodwin, "CofC to Recognize Birthplace of Civil Rights Activist, Educator Septima Clark," *The College Today*, College of Charleston, May 1, 2018, https://today.cofc .edu/2018/05/01/septima-clark-historical-marker.

26. Jon Hale, *A History of Burke High School in Charleston, South Carolina since 1894*, Lowcountry Digital Library, July 2013, http://ldhi.library.cofc.edu/exhibits/show/history _burke_high_school/introduction.

27. Kytle and Roberts's *Denmark Vesey's Garden* has provided the same type of assistance to public history workers.

28. "John C. Calhoun Monument Statue Taken Down from Its Perch above Charleston's Marion Square," *Post and Courier*, June 24, 2020, www.postandcourier.com/news

/john-c-calhoun-statue-taken-down-from-its-perch-above-charlestons-marion-square/article
_7c428b5c-b58a-11ea-8fcc-6b5a374635da.html.

They Wore White and Prayed to the East

The author would like to express her appreciation to the Smithsonian National Museum of African American History and Culture for its support, especially William Pretzer, Nancy Bercaw, and Mary Elliott. Deepest thanks to Kym Rice, Carlos Bustamante, and Patrick Giamario for their insightful comments and encouragement.

1. Ala Alryyes, *A Muslim American Slave: The Life of Omar ibn Said* (Madison: University of Wisconsin Press, 2011), 63; Folio 15. Omar ibn Said. *The life of Omar ben Saeed, called Morro, a Fullah Slave in Fayetteville, N.C. Owned by Governor Owen.* Manuscript. 1831. From Library of Congress, Theodore Dwight, Henry Cotheal, Lamine Kebe, and Omar Ibn Said Collection, https://www.loc.gov/item/2018371864/ (accessed February 28, 2020).

2. Gregory Townshend Bedell, "Prince Moro," *Christian Advocate* (Philadelphia), July 1825, 306. An 1854 article in the *North Carolina University Magazine* notes that Sayyid "filled the walls of his room with piteous petitions to be released, all written in the Arabic language." See "Uncle Moreau," *North Carolina University Magazine* 3, no. 1 (September 1854): 307. Given that Arabic was not read by any of his jailers or witnesses, the description as "petitions for release" seems to be pure speculation on the writer's part. More recent articles also repeat this fallacy. See Akel Kahera, "God's Dominion: Omar ibn Said's Use of Arabic Literacy as Opposition to Slavery," *South Carolina Review* 46, no. 2 (2014): 128; Ghada Osman and Camille F. Forbes, "Representing the West in the Arabic Language: The Slave Narrative of Oman ibn Said," *Journal of Islamic Studies* 15, no. 3 (2004): 333. Given other extant pieces of writing by Sayyid, what he wrote were most likely Qur'anic *suwar* (verses).

3. "Prince Omeroh," *Farmer and Mechanic,* June 25, 1884.

4. In extant documents, Sayyid signs his name "S-y-d" (*sīn-yā'-dāl*), which would likely be read as "Sayyid" rather than the frequently used "Said." In western Africa, "Sayyid" was rarely used as a personal name; rather, it was an honorific, especially for a religious scholar. See John Hunwick, "'I Wish to Be Seen in Our Land Called Afrika': Umar b. Sayyid's Appeal to Be Released from Slavery (1819)," *Journal of Arabic and Islamic Studies* 5 (2003–2004): 62.

5. Charles Ball, *Slavery in the United States: A Narrative of the Life and Adventures of Charles Ball, a Black Man* (New York: John S. Taylor, 1837), 165. Throughout eighteenth- and nineteenth-century sources, practitioners of Islam are given numerous appellations, some of the most common including "Mussulman," "Mohammedan," "Moslem," and "Turk," along with all their possible spelling variations. They were also at times simply referred to as "pagans" or "barbarians." I have left these terms as they appear in the given sources.

6. Allan Austin, *African Muslims in Antebellum America: Transatlantic Stories and Spiritual Struggles* (New York: Routledge, 2011), 34, 37–39; Michael Gomez, *Black Crescent: The Experience and Legacy of African Muslims in the Americas* (New York: Cambridge University Press, 2005), 148, 173–74; David Hunter Strother, "The Dismal Swamp," *Harper's New Monthly Magazine* 13, no. 76 (September 1856): 452–53.

7. Joseph LeConte, *The Autobiography of Joseph Le Conte,* ed. William Dallam Armes (New York: D. Appleton, 1903), 29–30.

8. William Caruthers, *The Kentuckian in New-York. Or, the Adventures of Three Southerns. By a Virginian* (New York: Harper & Brothers, 1834), 1:146–47.

9. See, for example, William Brown Hodgson, "The Gospels, Written in the Negro Patois of English, with Arabic Characters, by a Mandingo Slave in Georgia" (paper presented at the Ethnological Society of New York, New York, October 13, 1857, 15–16).

10. The concept of Africans as tabula rasa—empty vessels that were indoctrinated with European and American cultural values through a concurrent removal of their own heritage —was strongly perpetuated by the Europeans and Americans involved in the slave trade —and resulted in blanket assumptions about enslaved persons that echoed through academia and in popular discourse for decades thereafter. Scholars have recently made great strides to correct for this earlier dismissal, but a lack of available information about enslaved persons and the spaces from which they came has often challenged even modern researchers to write full religio-cultural histories of the enslaved and has, ironically, created new spaces for projection in the wake of removing denigrating narratives. Even in the interest of fuller historical narratives, Islam and other traditional African religions practiced among the enslaved remain far under-studied as compared to Christianity, and they are far less recognized among public audiences. For the strong and over-prevalent scholastic focus on Christianity among enslaved persons, see note 61.

11. For a history of Islam in western Africa, see Michael Gomez, "Muslims in Early America," *Journal of Southern History* 60, no. 4 (November 1994): 671–710; John Hunwick, "Toward a History of the Islamic Intellectual Tradition in West Africa Down to the Nineteenth Century" (paper presented at the International Symposium on Islamic Civilization in West Africa, Dakar, Senegal, December 1996); Nehemia Levtzion, *Muslims and Chiefs in West Africa: A Study of Islam in the Middle Volta Basin in the Pre-colonial Period* (New York: Oxford University Press, 1969); Nehemia Levtzion, "Islam in the Bilad al-Sudan to 1800," in *The History of Islam in Africa*, ed. Nehemia Levtzion and Randall Pouwels (Athens, OH: Ohio University Press, 2000), 63–92; Paul Lovejoy, "Muslim Freedmen in the Atlantic World: Images of Manumission and Self-Redemption," in *Slavery on the Frontiers of Islam*, ed. Paul Lovejoy (Princeton, NJ: Markus Wiener, 2003), 233–62; Osmane Oumar Kane, *Beyond Timbuktu: An Intellectual History of Muslim West Africa* (Cambridge, MA: Harvard University Press, 2016); and Stefan Reichmuth, "Islamic Education and Scholarship in Sub-Saharan Africa," in *The History of Islam in Africa*, ed. Nehemia Levtzion and Randall Pouwels (Athens: Ohio University Press, 2000), 419–40.

12. As this chapter explores, there is no concrete way to assign a definite numerical value to the number of enslaved persons who were Muslim. Given available historical data regarding the proportion of Muslims in the regions plundered by the slave trade, most scholars agree on figures between 10 and 20 percent, although the vast spread of Islam in western Africa suggests that the number of people familiar with the traditions of Islam and those who incorporated aspects of it into their lives and practices was much larger. See Austin, *African Muslims in Antebellum America: Transatlantic Stories and Spiritual Struggles,* 22–23; Sylviane Diouf, *Servants of Allah: African Muslims Enslaved in the Americas* (New York: New York University Press, 1998), 45–48; David Eltis and David Richardson, *Atlas of the Transatlantic Slave Trade* (New Haven, CT: Yale University Press, 2010), map 7; Gomez, "Muslims in Early America," 682; Lovejoy, "Muslim Freedmen in the Atlantic World," 241.

13. C. B. Wadstrom, *An Essay on Colonization, Particularly Applied to the Western Coast of Africa, with Some Free Thoughts on Cultivation and Commerce* (London: Darton and Harvey, 1794), 185.

14. Ibid., 83.

15. Although faith was not a necessary divulgement before immigration or naturalization in America—the Naturalization Act of 1790 specifies only a waiting period before citizenship is open to "free white person[s]"—the categorization of "white person" as well as a distinct prejudice against non-Christian religions and Catholics would have made it very difficult for a non-Christian family to settle and practice openly in America. Of course, this

did not apply to forcibly migrated enslaved persons who were not eligible for citizenship. An interesting challenge to this is a "Moorish" (Moroccan) community in South Carolina, which in 1790 successfully petitioned the courts to be seen as white under the law (see the Moors Sundry Act of 1790).

16. Voltaire's original reads "Le glaive & l'Alcoran dans mes sanglantes mains, / Imposeroient silence au reste des humains." Voltaire, *Le Fanatisme, ou Mahomet le Prophète* (Amsterdam: Chez Jacques Desbordes, 1743), 2.5.19–20, translation mine.

17. Kevin Hayes, "How Thomas Jefferson Read the Qur'an," *Early American Literature* 39, no. 2 (2004): 249–51; D. A. Spellberg, "Islam on the Eighteenth-Century Stage: Voltaire's *Mahomet* Crosses the Atlantic," in *Views from the Edge: Essays in Honor of Richard W. Bulliet*, ed. Naguin Yavari et al. (New York: Columbia University Press, 2004), 297–301; Denise Spellberg, *Thomas Jefferson's Qur'an: Islam and the Founders* (New York: Vintage, 2013), 28–33.

18. Denise Spellberg, "Islam in America: Adventures in Neo-Orientalism," *Review of Middle East Studies* 43, no. 1 (Summer 2009): 28–31.

19. Thomas Jefferson, "Feb. 6," *Autobiography Draft Fragment, January 6 through July 27, 1821* (Library of Congress, Series 1: General Correspondence. 1651–1827, reel 052), 1821, folio 22.

20. Thomas Jefferson, *The Papers of Thomas Jefferson*, ed. Julian P. Boyd, vol. 2, 1777–18 June 1779 (Princeton, NJ: Princeton University Press, 1950), 545–53.

21. James Madison, *The Papers of James Madison*, ed. Robert A. Rutland and William M. E. Rachal, vol. 8, 10 March 1784–28 March 1786 (Chicago: University of Chicago Press, 1973), 149–52.

22. Ayla Amon, "African Muslims in Early America," *Collection Stories* (blog), Smithsonian National Museum of African American History and Culture, February 22, 2017, https://nmaahc.si.edu/explore/stories/collection/african-muslims-early-america; Andrew Lawler, "Muslims Were Banned from the Americas as Early as the 16th Century," Smithsonian.com, February 7, 2017; João José Reis, *Slave Rebellion in Brazil: The Muslim Uprising of 1835 in Bahia* (London: Johns Hopkins University Press, 1993), 73–111; Gaye Wilson, "Dealings with Mellimelli, Colorful Envoy from Tunis," *Monticello Newsletter* 14, no. 2 (Winter 2003).

23. It should be noted that naming conventions were complicated in western Africa. In Senegambia, for example, the widespread use of Islamic names began with the Almoravid dynasty, which extended through modern Morocco, Algeria, the Western Sahara, and Mauritania, in the eleventh century. Frequent sub-Saharan trade, combined with pseudo-conversions to Islam to facilitate financial and imperial gain, also contributed to the widespread use of Islamic names. Some names are also common to all religions of the book, including Judaism and Christianity, so it is impossible to be certain of the faith of a person with such a name. See Diouf, *Servants of Allah* (1998), 82–87; Lorenzo Dow Turner, *Africanisms in the Gullah Dialect* (Columbia: University of South Carolina Press, 2002); Gwendolyn Midlo Hall, *Africans in Colonial Louisiana: The Development of Afro-Creole Culture in the Eighteenth Century* (Baton Rouge: Louisiana State University Press, 1992), 408; and Peter H. Wood, *Black Majority: Negroes in Colonial South Carolina from 1670 through the Stono Rebellion* (New York: Alfred A. Knopf, 1975), 181–86.

24. George Washington, "List of Slaves at Mount Vernon, 18 February 1786," in *The Diaries of George Washington*, ed. Dorothy Twohig and Donald Jackson (Charlottesville: University Press of Virginia, 1978), 4:277, 4:282–83; George Washington, *The Papers of George Washington*, ed. W. W. Abbot and Dorothy Twohig, Colonial Series, vol. 10, *21 March 1774–15 June 1775* (Charlottesville: University Press of Virginia, 1995), 137–38; see also *Charleston Courier*, June 19, 1808.

25. Gomez, *Black Crescent*, 24, 147; see also Turner, *Africanisms in the Gullah Dialect*, 31-43, for a discussion of naming conventions in western Africa and how they translated in an American context.

26. Michael Gomez, "Africans and Islam in the Lowcountry," in *African American Life in the Georgia Lowcountry: The Atlantic World and the Gullah Geechee*, ed. Philip Morgan (Athens: University of Georgia Press, 2010), 103-5; John Stapleton, *Plantation Journal, 1813-1816* (John Stapleton Papers, South Caroliniana Library, University of South Carolina), microfilm roll R1069-f.

27. *Georgia Gazette*, June 7, 1792.

28. Hall, *Africans in Colonial Louisiana*, 408-12. The Tijaniyyah Sufi order was prominent and influential in western Africa beginning in the eighteenth century. For an exploration of its social significance in the region, see Patrick Ryan, "The Mystical Theology of Tijani Sufism and Its Social Significance in West Africa," *Journal of Religion in Africa* 30, fasc. 2 (May 2000): 208-24.

29. See Lathan Windley, comp., *Runaway Slave Advertisements: A Documentary History from the 1730s to 1790*, 4 vols. (Westport, CT: Greenwood, 1983), especially vol. 3, South Carolina, and vol. 4, Georgia, for numerous runaway notices that showcase these names.

30. Sylviane Diouf, *Servants of Allah: African Muslims Enslaved in the Americas*, 15th anniversary ed. (New York: New York University Press, 2013), 14-15; Theodore Dwight, "Condition and Character of Negroes in Africa," in *The People of Africa: A Series of Papers on Their Character, Condition, and Future Prospects* (New York: Anson D. F. Randolph, 1871), 48; William B. Hodgson, *Notes on Northern Africa: The Sahara and Soudan* (New York: Wiley and Putnam, 1844), 68-75; *Savannah Gazette of the State of Georgia*, December 8, 1791.

31. Wood, *Black Majority*, 181-86.

32. Diouf, *Servants of Allah* (1998), 81; Sylviane Anne Diouf, "Devils or Sorcerers, Muslims or Studs: Manding in the Americas," in *Trans-Atlantic Dimensions of Ethnicity in the African Diaspora*, ed. Paul Lovejoy and David Trotman (London: Continuum, 2003), 139-41; Lovejoy, "Muslim Freedmen in the Atlantic World," 241-42.

33. *Charleston Royal Gazette*, January 9-12, 1782; *Charleston South-Carolina Gazette and Country Journal*, July 29, 1766.

34. John Stewart, *View of the Past and Present State of the Island of Jamaica; with Remarks on the Moral and Physical Condition of the Slaves, and on the Abolition of Slavery in the Colonies* (Edinburgh: Oliver & Boyd, 1823), 251.

35. Diouf, "Devils or Sorcerers, Muslims or Studs," 150.

36. Some were referred to as "Turks," associated with Morocco, Persia, and Arabia, or even noted as "nobles of the Delhi courts." See Austin, *African Muslims in Antebellum America: Transatlantic Stories and Spiritual Struggles*, 72; Diouf, *Servants of Allah* (1998), 99.

37. Austin, *African Muslims in Antebellum America: Transatlantic Stories and Spiritual Struggles*, 66-67; Gomez, *Black Crescent*, 148-49, 181-82; Cyrus Griffin, "The African Homeland of Abdul Rahman Ibrahima," *Natchez Southern Galaxy*, May 29, June 5, June 12, and July 5, 1828; *Savannah Georgia Gazette*, May 24, 1775.

38. Quoted in Paul B. Barringer, *The Natural Bent: The Memoirs of Dr. Paul D. Barringer* (Chapel Hill, University of North Carolina Press, 1949), 3-13, italics mine; Gomez, *Black Crescent*, 148.

39. Alryyes, *A Muslim American Slave*, 14; Diouf, *Servants of Allah* (1998), 98-100; Michael Gomez, *Exchanging Our Country Marks: The Transformation of African Identities in the Colonial and Antebellum South* (Chapel Hill: University of North Carolina Press, 1998), 82-87; Muska Kamran, "'A Negro Who Could Read and Write the Arabic Language': African

Muslim Slaves as Intermediaries in North American Plantations and African Colonies" (master's thesis, Johns Hopkins University, 2015), 9–14; Lovejoy, "Muslim Freedmen in the Atlantic World," 243–45.

40. Gomez, "Muslims in Early America," 686; Gomez, *Black Crescent*, 149–150.

41. Omar ibn Sayyid, "Letter to Major John Owen," 1819 (James Weldon Johnson Collection in the Yale Collection of American Literature, Beinecke Rare Book and Manuscript Library), JWJ MSS 185. For a discussion of Sayyid's phrase "*fī makān al-bahr yusammā K-bā/K-bya*" ("in a place of the sea/river called K-bā/K-bya") and interpretation of *K-bā/K-bya* as "Gambia," see Hunwick, "'I Wish to Be Seen in Our Land Called Afrika,'" 66–68. Sayyid refers to his place of birth as "Fut Tur" (Futa Toro, located between the Senegal and Gambia Rivers) in his 1831 autobiography (Alryyes, *A Muslim American Slave*, 61; Gomez, "Muslims in Early America," 677; Sayyid, *The Life of Omar ben Saeed*, folio 14).

42. Omar ibn Sayyid, "The Lord's Prayer" (North Carolina Department of Cultural Resources/State Archives of North Carolina, Raleigh, NC), PC.812; see also Ayla Amon, "The Written Word: Omar ibn Sayyid's Slave Experience" (paper presented at the annual conference of the Midwest Popular Culture Association/American Culture Association, Cincinnati, OH, October 2015, 3–4); and Austin, *African Muslims in Antebellum America: Transatlantic Stories and Spiritual Struggles*, 128–56.

43. Allan Austin, *African Muslims in Antebellum America: A Sourcebook* (New York: Garland, 1984), 447; Austin, *African Muslims in Antebellum America: Transatlantic Stories and Spiritual Struggles*, 135–36; Gomez, "Muslims in Early America," 695; Gomez, *Black Crescent*, 53.

44. Amon, "The Written Word," 8; Ronald A. T. Judy, *(Dis)forming the American Canon: African-Arabic Slave Narratives and the Vernacular* (Minneapolis: University of Minnesota Press, 1993); Mauro Nobili, "Arabic Scripts in West African Manuscripts: A Tentative Classification from the De Gironcourt Collection," *Islamic Africa* 2, no. 1 (Spring 2011): 109–10.

45. Works Progress Administration (WPA), Savannah Unit, Georgia Writer's Project, *Drums and Shadows: Survival Studies among the Georgia Coastal Negroes* (1940; repr., Athens, GA: University of Georgia Press, 1986), 154.

46. *Gettysburg Compiler*, February 12, 1823.

47. Hodgson, "The Gospels," 8; Cornelia Walker Bailey, *God, Dr. Buzzard, and the Bolito Man* (New York: Doubleday, 2000), 134.

48. Diouf, *Servants of Allah* (1998), 113–18; Ralph R. Gurley, "Secretary's Report," *African Repository and Colonial Journal* 13, no. 7 (July 1837): 203; Hodgson, *Notes on Northern Africa*, 69; Rev. William S. Plumer, "Meroh, a Native African," *New York Observer*, January 8, 1863: 1; WPA, *Drums and Shadows*, 179.

49. Allen, *African Muslims in Antebellum America: Transatlantic Stories and Spiritual Struggles*, 33, 41; Diouf, "Devils or Sorcerers, Muslims or Studs," 149. The manuscript penned by the enslaved man owned by Captain David Anderson can be found at the American Philosophical Society, Mss.B.V462.

50. Max Radiguet, *Souvenirs de l'Amérique espagnole: Chili, Pérou, Brésil* (Paris: M. Levy, 1874), 138. Radiguet's original reads in full: "Le savant Mandingue, voyageur, l'homme caucasique de l'Afrique, par exemple, vous révélera des versions oubliées ou inédites du Coran ou de la Bible" (translation mine).

51. Diouf, *Servants of Allah* (1998), 80, 128–34; Diouf, "Devils or Sorcerers, Muslims or Studs," 146–48.

52. Diouf, *Servants of Allah* (1998), 130–31.

53. Jonathan Burns, Andrew Dudash, and Ryan Mathur, "Fort Shirley's Copper Charm:

Investigating Muslim Ethnicity on Pennsylvania's Colonial Frontier," in "Immigration and Ethnicity in Pennsylvania History," special issue, *Pennsylvania Magazine of History and Biography* 140, no. 3 (October 2016): 2016, 413–16; Christina Rouvalis, "Commerce and Conflict on the 18th-Century Frontier," *American Archaeology* 17, no. 3 (Fall 2013): 35–36. The amulet from Saint-Domingue can be found at the Library Company of Philadelphia (Print Department, Box 10, Folder 4, 961.F.5d, Pierre Eugène du Simitière Collection, 1492–1784); the small metal amulet is currently on display at the Museum of the American Revolution in Philadelphia.

54. George Callcott, "Omar ibn Seid: A Slave Who Wrote an Autobiography in Arabic," *Journal of Negro History* 39, no. 1 (January 1954): 62; Diouf, *Servants of Allah* (1998), 72–82; Diouf, "Devils or Sorcerers, Muslims or Studs," 150–51; Harrison Hough, "Grégoire's Sketch of Angelo Solimann," *Journal of Negro History* 4, no. 3 (July 1919): 289; WPA, *Drums and Shadows,* 162, 179–81. Given the strict laws surrounding clothing and the scant annual allotments of cloth given to the enslaved to make their clothing (see Madelyn Shaw, "Slave Cloth and Clothing Slaves: Craftsmanship, Commerce, and Industry," *Journal of Early Southern Decorative Arts* 33 [2012]), it is astounding that Muslims were able to reliably and systematically choose white cloth or to create clothing such as turbans, which require large swaths of cloth to produce. As Ben Sullivan remembered of his grandfather, Bilali, "He always tie he head up in a white cloth and seem he keep a lot of cloth on hand, for I remember, you could see them hanging round the stable drying" (quoted in WPA, *Drums and Shadows,* 179). It is also recorded that women were sometimes allotted cloth for "turbans" (Shaw, "Slave Cloth and Clothing Slaves"), although I suspect the term is used in the sense of a head cloth or covering rather than a wrapped turban.

55. Thomas Bluett, *Some Memoirs of the Life of Job, the Son of Solomon the High Priest of Boonda in Africa; Who Was a Slave about Two Years in Maryland; and afterwards Being Brought to England, Was Set Free, and Sent to His Native Land in the Year 1734* (London: Richard Ford, 1734), 50.

56. For Diallo's portrait, see the National Portrait Gallery, London (NPG L245), and a copy in *Gentleman's Magazine,* June 1750 (NPG D45779); for Sayyid, see the North Carolina Department of Natural and Cultural Resources (PC.812.1) and the University of North Carolina at Chapel Hill Wilson Library, Special Collections (P0007); and for Mamout, see the Philadelphia Museum of Art (2011-87-1) and the Peabody Room, Georgetown Branch, District of Columbia Public Library.

57. Diouf, *Servants of Allah* (1998), 77, 81. Outside the scope of this essay lies another source essential to the examination of the enslaved Muslim communities: living traditions. Although the Islam brought to America by enslaved from western Africa did not survive long, many traces are still visible today, including the practice of Ring Shout (*shaw't*), the baking of *saraka* cakes, phoneme extension in blues music, communities praying and burying their dead facing east, and words in the Gullah language. See Amon, "African Muslims in Early America"; Jonathan Curiel, *Al' America: Travels through America's Arab and Islamic Roots* (New York: New Press, 2008), 18–36; Diouf, *Servants of Allah* (1998), 69–69, 182–98; Turner, *Africanisms in the Gullah Dialect;* Nada Elia, "'Kum Buba Yali Kum Buba Tambe, Ameen, Ameen, Ameen': Did Some Flying Africans Bow to Allah?" *Callaloo* 26, no. 1 (Winter 2003): 186–87, 196–200; Gomez, *Black Crescent,* 183; and Peter Onuf and Frank Cogliano, "#0105: Islam and the U.S.," podcast, *Backstory,* December 18, 2015, http://backstoryradio.org/shows/islam-and-the-united-states.

58. Paul Lovejoy, "Review: *Servants of Allah: African Muslims Enslaved in the Americas* by Sylviane A. Diouf," *International History Review* 21, no. 4 (December 1999): 993.

59. There is a growing body of literature considering the substantial presence of enslaved Muslims in Central America, South America, and the Caribbean (including Jamaica, Trinidad, Brazil, Peru, and Bolivia) that far outpaces the work being done in North America (for a discussion of some existing sources, see Diouf, *Servants of Allah*, 12–15). Within this essay I am limiting my comments to the literature concerning enslaved Muslims in the modern United States.

60. Another issue outside the scope of this essay that deserves considerable attention is the status of Islam as an African and African American religious tradition. Primarily, the considerable focus on Christianity among the enslaved has largely obscured the existence of and role played by other religions. The dominance of Christianity in these studies "minimizes or plainly ignores the diversity of the enslaved community's experiences" (Diouf, *Servants of Allah*, 11). Second, Islam is not studied or perceived as an "African religion," meaning that there is no reason to include African Muslims in diaspora discussions. Rather, Islam is often viewed as an Arabization of Africa that belittles the "authentic" African cultures and religions (Diouf, *Servants of Allah*, 11–12; Elia, "'Kum Buba Yali Kum Buba Tambe, Ameen, Ameen, Ameen,'" 193–94; Nobili, "Arabic Scripts in West African Manuscripts," 109–10; Kane, *Beyond Timbuktu*, 6–7). Both of these ideas contribute to the minimization of academic discourse around African Muslims in America.

61. Isaac Bired to Theodore Dwight. Letter, April 1, 1862. Library of Congress, Theodore Dwight, Henry Cotheal, Lamine Kebe, and Omar Ibn Said Collection, https://www.loc.gov/item/2018371864/ (accessed February 28, 2020), italics mine. This lack of knowledge occurred despite the well-known contemporary provision of Charles Thompson that when learning Arabic, one should secure a copy of the Qur'an so that no one was ever found "in error on the subject of its contents." See Charles Thompson, "Study of the Arabic Language," *African Repository* 5, no. 4 (June 1829): 97.

62. Nikolay Dobronravin, "West African Ajami in the New World (Hausa, Fulfude, Mande Languages)," in *The Arabic Script in Africa: Studies in the Use of a Writing System,* ed. Meikal Mumin and Kees Versteegh (Leiden: Brill, 2014), 159–72; Moulaye Hassane, "Ajami in Africa: The Use of Arabic Script in the Transcription of African Languages," in *The Meanings of Timbuktu,* ed. Shamil Jeppie and Souleymane Bachir Diagne (Cape Town, South Africa: Human Sciences Research Council, 2008), 109–22; Marie-Ève Humery, "Fula and the Ajami Writing System in the Haalpulaar Society of Fuuta Toore (Senegal and Mauritania): A Specific 'Restricted Literacy,'" in *The Arabic Script in Africa: Studies in the Use of a Writing System,* ed. Meikal Mumin and Kees Versteegh (Leiden: Brill, 2014), 173–98; Judy, *(Dis)forming the American Canon,* 220–21; Kane, *Beyond Timbuktu,* 54–56. This misunderstanding of grammar and spelling extended well into the twentieth century, as when Nicholas Maselli noted of an 1853 letter by Sayyid that "the person's 'grammar' and 'spelling' are not of good quality. . . . The person's written command of Arabic is poor." Nicholas Maselli to Farouk Tanyeloglu, May 1, 1982, Spartanburg County Historical Association, Acquisition File, 82.10.1. For a discussion of the linguistic errors and omissions Omar ibn Sayyid makes in his 1819 manuscript, see Hunwick, "'I Wish to Be Seen in Our Land Called Afrika,'" 64–66.

63. Hodgson, "The Gospels," 5, 9–10.

64. Alryyes, *A Muslim American Slave,* 63–65; Hunwick, "'I Wish to Be Seen in Our Land Called Afrika,'" 66n9; Sayyid, "Letter to Major John Owen"; Folio 15. Omar ibn Said. Manuscript. 1831. From Library of Congress, Theodore Dwight, Henry Cotheal, Lamine Kebe, and Omar Ibn Said Collection, https://www.loc.gov/item/2018371864/ (accessed February 28, 2020).

65. Diouf, *Servants of Allah* (2013), 17.

66. Pants and jacket, Shadow-on-the-Têche, Site of the National Trust for Historic Preservation, New Iberia, Louisiana (NT59.67.644 (5B)); osnaburg from the plantation of Mr. Mitchell King, South Carolina, Museum of the Confederacy (0985.10.85); "Bill of Sale for Sambo, Molly, Tombo, Mashac, Lydia, and Dick," May 5, 1812, Wilson Library, University of North Carolina Chapel Hill (Mitchell King Papers, Folder 37); beads, Virginia Institute of Marine Science (FS No. 2192.3-.4).

67. Muhammad Fraser-Rahim, *Enslaved and Free African Muslims: Spiritual Wayfarers in the South and Lowcountry,* Lowcountry Digital History Initiative, http://ldhi.library.cofc.edu /exhibits/show/african-muslims-in-the-south/sources-and-credits.

68. Nadirah Rasheed, "Islamic Heritage Museum Opens in D.C.," *Muslim Link* (blog), May 6, 2011; Intisar Seraaj, "Power of Muslim Museum Extends Far beyond Jackson," *Mississippi Today* (blog), August 1, 2017.

69. Recent conferences and lectures have attempted to correct some of the limitations presented by the exhibition medium, including "American and Muslim Worlds, c. 1500-1900" at the Wolf Humanities Center, Philadelphia (March 30-April 1, 2017); and "Muslims in America since 1619" at the Boston Athenaeum, Boston (December 13, 2016). There was also significant public programming and lectures surrounding the recent excavations of Yarrow Mamout's home in Georgetown, Washington, DC (http://yarrowmamoutarchaeology .weebly.com).

70. Mary V. Thompson, "Religious Practice in the Slave Quarters at Mount Vernon," *Colonial Williamsburg Interpreter* 21, no. 1 (Spring 2000): 10-14; Mary V. Thompson, "Islam at Mount Vernon," *George Washington's Mount Vernon* (blog), accessed September 8, 2017, www .mountvernon.org/digital-encyclopedia/article/islam-at-mount-vernon; Whitney Plantation, "Naming Practices," accessed November 20, 2019, www.whitneyplantation.com/education /louisiana-history/slavery-in-louisiana/slave-trade-in-louisiana/naming-practices; Whitney Plantation, "Slave Trade: Louisiana," accessed November 20, 2019, www.whitneyplantation .com/education/louisiana-history/slavery-in-louisiana/slave-trade-in-louisiana.

71. Amon, "African Muslims in Early America."

72. Theodore Dwight, "Preface," galley proofs from unpublished manuscript, 1860, Library of Congress, African and Middle East Division, Omar Ibn Said Collection, https://lccn .loc.gov/2018662627.

More Than Just a Way across the Water

1. Brian Hicks, "Hourly Water Taxi Now Under Way between Charleston, Mount Pleasant," *Post and Courier,* December 28, 2005, and "Revived Alternative to Driving," *Post and Courier,* January 9, 2006.

2. The Grace Memorial Bridge was the only bridge over the Cooper River in Charleston from 1929 until the construction of the Silas N. Pearman Bridge in 1966. In 2005 the South Carolina Department of Transportation completed the Arthur Ravenel Jr. Bridge and removed the two older bridges. Susan King, "Cooper River Bridges," in *South Carolina Encyclopedia,* ed. Walter Edgar (Columbia: University of South Carolina Press, 2006), 225-26.

3. Christer Westerdahl, "The Maritime Cultural Landscape," *International Journal of Nautical Archaeology* 21, no. 1 (1992): 6.

4. Rebecca Conard, "'Once I Built a Railroad': Viewing History from the Depot Platform," *Public Historian* 14, no. 2 (Spring 1992): 33.

5. Andrew Hurley, "Narrating the Urban Waterfront: The Role of Public History in Community Revitalization," *Public Historian* 28, no. 4 (Autumn 2006): 19-50.

6. See Benjamin W. Labaree et al., *America and the Sea: A Maritime History* (Mystic, CT: Mystic Seaport, 1998); and Eloise Engle and Arnold S. Lott, *America's Maritime Heritage* (Annapolis, MD: Naval Institute Press, 1973). These studies do not discuss ferries; however, ferries have been studied in other English-speaking nations. See L. M. W. Weir, "Ferries in Scotland between 1603 and the Advent of Steam" (PhD diss., University of Edinburgh, 1985).

7. Charles F. Kovacik and John J. Winberry, *South Carolina: The Making of a Landscape* (Columbia: University of South Carolina Press, 1987), 81. Kovacik and Winberry is the definitive work on the geography and landscape of South Carolina. The rivers of the state have not been as thoroughly studied as rural landscapes have.

8. Robert M. Weir, *Colonial South Carolina: A History* (Columbia: University of South Carolina Press, 1997), 158.

9. Edward C. Gilmore, "South Carolina River Ferries," *South Carolina History Illustrated* 1, no. 2 (1970): 45–46.

10. Lawrence S. Rowland, Alexander Moore, and George C. Rogers Jr., *The History of Beaufort County, South Carolina,* vol. 1, *1514–1861* (Columbia: University of South Carolina Press, 1996), 123.

11. George C. Rogers Jr., *The History of Georgetown County, South Carolina* (Columbia: University of South Carolina Press, 1970), 44.

12. Gilmore, "South Carolina River Ferries," 48.

13. Robert K. Ackerson, *South Carolina Colonial Land Policies* (Columbia: University of South Carolina Press, 1977), 30; Bradford Botwick, "Underwater Historic Archaeological Sites in South Carolina: A Research Plan" (master's thesis, University of South Carolina, 1989), 10; Moore, "The Ashley and the Cooper Rivers," 10.

14. The Commons House of Assembly was the lower house of South Carolina's legislature and the only elected branch of government in the colony from 1670 to 1776. After 1744 the branch was referred to as the Assembly. See Keith Krawczynski, "Commons House of Assembly," in *South Carolina Encyclopedia,* ed. Walter Edgar (Columbia: University of South Carolina Press, 2006), 212. See also Lawrence S. Rowland, "Eighteenth Century Beaufort: A Study of South Carolina's Southern Parishes to 1800" (PhD diss., University of South Carolina, 1978), 124.

15. Carl Bridenbaugh, *Cities in the Wilderness* (New York: Alfred A. Knopf, 1968), 335; Joseph A. Ernst and H. Roy Merrens, "'Camden's Turrets Pierce the Skies!': The Urban Process in the Southern Colonies during the Eighteenth Century," *William and Mary Quarterly* 30, no. 3 (1973): 558; Rogers, *The History of Georgetown County,* 28.

16. George Lloyd Johnson Jr., *The Frontier in the Colonial South: South Carolina Backcountry, 1736–1800,* Contributions in American History vol. 175 (Westport, CT: Greenwood, 1997).

17. Alexis de Tocqueville, *Democracy in America,* ed. J. P. Mayer, trans. George Lawrence (1969; repr. New York: HarperPerennial, 1988), 384–85.

18. John Jakle, "Landscapes Redesigned for the Automobile," in *The Making of the American Landscape* (New York: Routledge, 1994), 293–310.

19. The institutions that developed along transportation routes are referred to as "travel capitalism." For a discussion of the development of travel capitalism, see Wilma A. Dunaway, *The First American Frontier: Transition to Capitalism in Southern Appalachia, 1700–1860* (Chapel Hill: University of North Carolina Press, 1996).

20. Tyrel G. Moore Jr., "Role of Ferryboat Landings in East Tennessee's Economic Development, 1790–1870," *Studies in the Social Studies* 18 (1979): 1–5; Diana Diz. Rockman and Nan

A. Rothschild, "City Tavern, Country Tavern: An Analysis of Four Colonial Sites," *Historical Archaeology* 18, no. 2 (1984): 112.

21. Hermann Wellenreuther, Fred Siegel, Joseph A. Ernst, and H. Roy Merrens, "Urbanization in the Colonial South: A Critique," *William and Mary Quarterly*, 3rd ser., 31, no. 4 (October 1974): 663.

22. Fred B. Kniffen, "The American Covered Bridge," *Geographical Review* 41 (January 1951): 114.

23. David Beard, "Good Wharves and Other Conveniences: An Archaeological Study of Riverine Adaptation in the South Carolina LLowcountry," in *Carolina's Historical Landscapes: Archaeological Perspectives* (Knoxville: University of Tennessee Press, 1997), 65; Jim Errante, "Waterscape Archaeology: Recognizing the Archaeological Significance of the Plantation Waterscape," in *Carolina's Historical Landscapes: Archaeological Perspectives* (Knoxville: University of Tennessee Press, 1997), 33. Leland Ferguson and David Babson, *Survey of Plantation Sites along the East Branch of Cooper River: A Model for Predicting Archaeological Site Location* (Columbia: South Carolina Institute of Anthropology and Archaeology, 1986), presents a predictive model for the Cooper River and identifies several possible ferry sites.

24. William B. Barr, "Strawberry Ferry and Childsbury Towne: A Socio-Economic Enterprise on the Western Branch of the Cooper River, Saint John's Parish, Berkeley County, South Carolina" (master's thesis, University of South Carolina, 1995), 92–93.

25. Poplin, Eric C., and Elsie I. Eubanks, *Cultural Resources Survey of the Silverman Tract, Charleston County, South Carolina* (Charleston: Southern National Bank of South Carolina, 1993); Ralph Bailey Jr., "Milton's Ferry: Mount Pleasant's First Connector," in *Mount Pleasant's Archaeological Heritage: Proceedings of a Symposium Held at Lynch Hall, Dunes West, Mount Pleasant, September 21, 1996*, ed. Amy Thompson McCandless (Mount Pleasant, SC: City of Mount Pleasant, 1996), 1–4.

26. Barr, "Strawberry Ferry and Childsbury Towne."

27. Michael O. Hartley, *The Ashley River: A Survey of Seventeenth Century Sites*, Research Manuscript Series 192 (Columbia: South Carolina Institute of Anthropology and Archaeology, 1984), 62–63, 84; Barr, "Strawberry Ferry and Childsbury Towne," 99.

28. Barr, "Strawberry Ferry and Childsbury Towne," 99.

29. Beard, "Good Wharves and Other Conveniences," 66.

30. Spirek, James D., Christopher F. Amer, J. Beatty, L. Harris, C. Naylor, and Laura Von Harten. "The Port Royal Sound Survey, Phase One: Preliminary Investigations of Intertidal and Submerged Cultural Resources in Port Royal Sound, Beaufort County, South Carolina." (1999); Joseph L. Tippett and Wayne D. Roberts, "Archaeological Survey of U.S. Route 21 Whale Branch Bridge Replacement, Beaufort County, South Carolina," letter report, 1988, South Carolina Institute of Archaeology and Anthropology, University of South Carolina, Columbia, 11.

31. Kristrina A. Shuler et al., *Intensive Cultural Resources Survey and Archaeological Testing of Site 38BU1216, US Highway 17 Widening Project, Gardens Corner to Jacksonboro, Beaufort and Colleton Counties, South Carolina* (Mount Pleasant, SC: Brockington and Associates, 2007).

32. Lynn Harris, *Database Management Report on the South Carolina Hobby Diver Licensing System and Submerged Site Inventory, 1996 Management Report: Part II*, Research Manuscript Series 223 (Columbia: South Carolina Institute of Archaeology and Anthropology, 1996), 6, 12.

33. Ibid., 12.

34. J. W. Joseph, Theresa M. Hamby, and Catherine S. Long, *Historical Archaeology in Georgia* (Stone Mountain, GA: New South Associates, 2004), 216.

35. Ibid., 172.

36. Ibid., 113.

37. Bruce F. Thompson, *The Martinak Boat (CAR-254, 18CA54), Caroline County, Maryland* (Crownsville: Maryland Historical Trust, Office of Archeology, 2005), 5.

38. Claude Jackson, "The Cape Fear River Comprehensive Survey: Historical and Cartographic Research in Southeastern North Carolina," in *Underwater Archaeology Proceedings from the Society for Historical Archaeology Conference*, ed. Paul Forsythe Johnston (Washington, DC: Society for Historical Archaeology, 1995), 13.

39. Carol D. Schull, "Using the National Register of Historic Places," *CRM* 17 (1994): 1.

40. For a discussion of the online mission of the NRHP, see Beth L. Savage, "Spreading the Word: Fulfilling the National Register's Mission Online," *CRM* 25 (2002): 41–43. As of 2008, SCDAH has digitized all of the NRHP nominations in South Carolina. It has also provided examples of photographs and copies of the maps of districts.

41. Elias B. Bull, "Strawberry Chapel and Site of Town of Childsbury," National Register of Historic Places Nomination Form, 1972.

42. Nancy R. Ruhf, "Village of Rockville Historic District," National Register of Historic Places Nomination Form, 1972.

43. Ibid.

44. W. David Chamberlain, Suzanne Pickens, and John Wells, "Cainhoy Historic District," National Register of Historic Places Nomination Form, 1980.

45. Ian Burrow, William Liebeknecht, Damon Tvaryanas, and Cheryl Hendry, *Archaeological Investigations, Replacement of Woodlands Ferry and Facility Improvements, Woodland, Broad Creek and Seaford Hundreds, Sussex County, Delaware* (Trenton, NJ: Hunter Research, 2008), 4–3.

46. J. Tracy Power, Ian D. Hill, and J. Lee Tippett, "Ashley River Historic District," National Register of Historic Places Nomination Form, 1994, 8–8.

47. Jill Hanson, "Bridge Abutments," National Register of Historic Places Nomination Form, 1996.

48. Suzanne Pickens Wylie and Norman McCorkle, "Ashley River Road National Register of Historic Places Nomination."

49. James B. Jones, Jr., "An Analysis of National Register Listings and Roadside Historic Markers in Tennessee: A Study of Two History Programs," *The Public Historian* 10, no. 3 (Summer 1988): 19–30. Accessed February 9, 2021. doi:10.2307/3378527. James W. Loewen, *Lies across America: What Our Historic Sites Get Wrong* (New York: Simon & Schuster, 1999), 25–28, provides a good survey of the importance of historical markers. It should be noted that almost all of the National Register of Historic Places nominations from the 1970s and 1980s were vague and under-researched. This is not a problem unique to South Carolina, and all state historical preservation offices should reexamine older nominations from the 1970s and 1980s and amend them as necessary to address archaeological sites (including ferry sites) that have been identified since the initial listing.

50. Alexia Jones Helsley, *South Carolina Highway Historical Marker Guide* (Columbia: South Carolina Department of Archives and History, 1992), 75, 124, 193.

51. See Christer Westerdahl, "On Oral Tradition and Place Names," *International Journal of Nautical Archaeology* 9 (1980): 311–29.

52. Jane McIntosh, *The Practical Archaeologist: How We Know What We Know about the Past* (New York: Facts on File, 1999), 40.

53. Rita Folse Elliott, *Georgia's Inland Waters* (Ellerslie, GA: Southern Research, 2003), 69.

54. Other important maps of South Carolina are discussed in Worthington Chauncey Ford, "Early Maps of Carolina," *Geographical Review* 16 (April 1926): 264–73; and William P. Cumming, *The Southeast in Early Maps* (Chapel Hill: University of North Carolina Press, 1998).

55. For a discussion of the use of historic maps in archaeology, see Nancy S. Seasholes, "On the Use of Historical Maps," in *Documentary Archaeology* (Cambridge: Cambridge University Press, 1988), 92–118.

56. http://www.scarchsite.org/, accessed December 24, 2008.

57. Keith Derting, interview, May 2008.

58. Robert Mills, *Mills' Atlas: Atlas of the State of South Carolina, 1825* (Easley, SC: Southern Historical Press, 1980); Robert Mills, *Statistics of South Carolina Including Its Natural, Civil, and Military History, General and Particular* (Charleston, SC: Hurlbut and Lloyd, 1826); Thomas Cooper and David J. McCord, eds., *The Statutes at Large of South Carolina*, vol. 9. (Columbia, SC: A. S. Johnson).

59. This methodology for identifying ferry sites from the water corresponds to the techniques in Lucy B. Wayne, *Burning Brick: A Study of a Lowcountry Industry* (Ann Arbor, MI: UMI, 1993). She identified many brick kiln sites along the rivers of the lowcountry from the water.

60. Tyrel Gilce Moore, "The Role of Ferry Crossings in the Development of the Transportation Network in East Tennessee, 1790–1974" (master's thesis, University of Tennessee, 1975), 1.

61. Botwick, "Underwater Historic Archaeological Sites in South Carolina," 41–42.

62. Barr, "Strawberry Ferry and Childsbury Towne," 92–93.

63. Peter H. Wood, *Black Majority: Negroes in Colonial South Carolina from 1670 through the Stono Rebellion* (New York: Alfred A. Knopf, 1974), 230.

Power, Representation, and Memory in the Great Dismal Swamp

1. William Byrd, "The Earliest Passage through the Dismal Swamp," extract from the *Farmer's Register* 4, no. 10 (February 1, 1837), originally written between 1728 and 1737; Hugo Prosper Leaming, *Hidden Americans: Maroons of Virginia and the Carolinas* (New York: Garland, 1995), 222; Charles Royster, *The Fabulous History of the Dismal Swamp Company* (New York: Alfred A. Knopf, 1999), 82; N. S. Shaler, "General Account of the Fresh-Water Morasses of the United States, with a Description of the Dismal Swamp District of Virginia and North Carolina," in *Tenth Annual Report of the United States Geological Society to the Secretary of the Interior, 1888–1889*, ed. J. W. Powell (Washington, DC: Government Printing Office, 1890), 255–339; Daniel O. Sayers, *A Desolate Place for a Defiant People: The Archaeology of Maroons, Indigenous Americans, and Enslaved Laborers in the Great Dismal Swamp* (Williamsburg, VA: Society for Historical Archaeology, 2014), 105.

2. Leaming, *Hidden Americans*, 222; Sayers, *A Desolate Place for a Defiant People*, 20, 92; Daniel O. Sayers, "Scission Communities and Social Defiance: Marronage in the Diasporic Great Dismal Swamp, 1660–1860," in *The Limits of Tyranny*, ed. James A. Delle (Knoxville: University of Tennessee Press, 2015), 185.

3. Philip D. Morgan, *Slave Counterpoint: Black Culture in the Eighteenth-Century Chesapeake & Lowcountry* (Chapel Hill: University of North Carolina Press, 1998), xvii.

4. Kristin L. Gallas and James DeWolf Perry, eds., *Interpreting Slavery at Museums and Historic Sites* (Lanham, MD: Rowman & Littlefield, 2015); Stephen Small, "Still Back of the Big

House: Slave Cabins and Slavery in Southern Heritage Tourism," *Tourism Geographies* 15, no. 3 (2013): 405–23; Derek Alderman and Joshua Inwood, "Landscapes of Memory and Socially Just Futures," in *The Wiley-Blackwell Companion to Cultural Geography*, ed. Nuala Johnson, R. H. Schein, and J. Winders (New York: Wiley, 2013), 186–97; Robyn Autry, "The Political Economy of Memory: The Challenge of Representing National Conflict at 'Identity-Driven' Museums," *Theory and Society* 42 (2013): 57–80; Ana Lucia Araujo, ed., *Politics of Memory: Making Slavery Visible in the Public Space* (New York: Routledge, 2012); Antoinette Jackson, "Shattering Slave Life Portrayals: Uncovering Subjugated Knowledge in U.S. Plantation Sites in South Carolina and Florida," *American Anthropologist* 113, no. 3 (2011): 448–62; Perry Carter, David Butler, and Owen Dwyer, "Defetishizing the Plantation: African Americans in the Memorialized South," *Historical Geography* 39 (2011): 128–46; James Oliver Horton and Lois E. Horton, eds., *Slavery and Public History: The Tough Stuff on American History* (New York: New Press, 2006); David Blight, ed., *Passages to Freedom: The Underground Railroad in History and Memory* (New York: First Smithsonian Books, 2006); Renee Romano and Leigh Raiford, eds., *The Civil Rights Movement in American Memory* (Athens: University of Georgia Press, 2006).

5. W. Fitzhugh Brundage, *Where These Memories Grow: History, Memory, and Southern Identity* (Chapel Hill: University of North Carolina Press: 2000), 11.

6. Michael Omi and Howard Winant, *Racial Formation in the United States: From the 1960s to the 1990s* (New York: Routledge, 1994), 83; Jennifer Eichstedt and Stephen Small, *Representations of Slavery: Race and Ideology in Southern Plantation Museums* (Washington, DC: Smithsonian Books, 2002), 8.

7. Manning Marable, *Living Black History: How Reimagining the African-American Future Can Remake America's Racial Future* (Cambridge, MA: Basic Civitas Books, 2006), 20–21.

8. Paul Shackel, *Memory in Black and White: Race, Commemoration, and the Post-Bellum Landscape* (Walnut Creek, CA: AltaMira, 2003), 13.

9. Richard Price, ed., *Maroon Societies: Rebel Slave Communities in the Americas* (Baltimore: John Hopkins University Press, 1973). For studies on revolt and marronage in Africa and throughout the transatlantic slave trade, see Sylviane A. Diouf, ed., *Fighting the Slave Trade: West African Strategies* (Athens: Ohio University Press, 2003). See also Gad Heuman, ed., *Out of the House of Bondage: Runaways, Resistance and Marronage in Africa and the New World* (London: Frank Cass, 1986).

10. Alvin O. Thompson, *Flight to Freedom: African Runaways and Maroons in the Americas* (Kingston, Jamaica: University of the West Indies, 2006), 9.

11. Herbert Aptheker, "Maroons within the Present Limits of the United States," *Journal of Negro History* 24 (1939): 167.

12. Price, *Maroon Societies*, 3, 24, 107; Thompson, *Flight to Freedom*, 56–57.

13. Sylviane A. Diouf, *Slavery's Exiles: The Story of the American Maroons* (New York: New York University Press, 2014).

14. Ibid., 212–16; Sayers, *A Desolate Place for a Defiant People*, 89–105; Michael Mullin, *Flight and Rebellion: Slave Resistance in Eighteenth Century Virginia* (New York: Oxford University Press, 1972), 131; Brent Morris, "'Running Servants and All Others': The Diverse and Elusive Maroons of the Great Dismal Swamp," in *Voices from within the Veil: African Americans and the Experience of Democracy*, eds. William H. Alexander, Cassandra Newby-Alexander, and Charles H. Ford (Newcastle upon Tyne, United Kingdom: Cambridge Scholars Publishing, 2008), 85–105.

15. Diouf estimates that hundreds of maroons lived in the swamp, with "certainty." See Diouf, *Slavery's Exiles*, 210–12. Leaming states that "some two thousand" lived in the swamp

over the centuries in question. See Leaming, *Hidden Americans,* 221. Sayers assures us that "it makes perfect sense that thousands of maroons inhabited the swamp." See Sayers, *A Desolate Place for a Defiant People,* 88. Aptheker also estimates about two thousand maroons. See Aptheker, "Maroons Within the Present Limits," 168. The abolitionist Edmund Jackson received reports from a reputable Norfolk merchant that "the value of slave property lost in the swamp, at one and a half million dollars . . . would give near forty thousand as the population of the swamp—an estimate, I apprehend, quite too large." See Edmund Jackson, "The Virginia Maroons," *Liberty Bell,* January 1, 1852, 149.

16. Tommy Bogger, "Maroons and Laborers in the Great Dismal Swamp," in *Readings in Black and White: Lower Tidewater Virginia,* ed. J. H. Kobelski (Portsmouth, VA: Portsmouth Public Library, 1982), 1–8; "Insurrection in N Carolina," *Norfolk Herald,* May 13, 1802; *Norfolk Herald,* June 23, 1818; Herbert Aptheker, *American Negro Slave Revolts* (New York: Columbia University Press, 1943), 231; Thomas C. Parramore, *Cradle of the Colony: The History of Chowan County and Edenton, North Carolina* (Edenton, NC: Chamber of Commerce, 1967), 51; F. Roy Johnson, *Tales from Old Carolina: Traditional and Historical Sketches* (Murfreesboro, NC: Johnson, 1965), 155–56.

17. Sayers, *A Desolate Place for a Defiant People,* 105; Morris, "'Running Servants and All Others,'" 85–105; Leaming, *Hidden Americans,* 278–80.

18. David Hunter Strother, "The Dismal Swamp," *Harper's Monthly* 13 (1856): 452–53.

19. "Petition of Princess Anne County Citizens," December 1–11, 1818. Related materials are in Virginia Executive Papers, Letters Received, Library of Virginia.

20. "Letter to the Sheriff," December 7, 1818. Oversize file on the trial of Mingo, Princess Anne County, Condemned Slaves, Library of Virginia.

21. Sayers, *A Desolate Place for a Defiant People,* 22, 129–53.

22. Kathryn Benjamin Golden, "'Armed in the Great Swamp': Fear, Maroon Insurrection, and the Insurgent Ecology of the Great Dismal Swamp," *The Journal of African American History* 106, no. 1, (Winter 2021). Marcus P. Nevius, *City of Refuge: Slavery and Petit Marronage in the Great Dismal Swamp, 1763–1856* (Athens: University of Georgia Press, 2020); Brent Morris, "'Mingled Fear and Ferocity': A Brief Glimpse into the Maroon Communities of the Great Dismal Swamp," in *Maroons and the Marooned: Runaways and Castaways in the Americas,* ed. Richard Bodek and Joseph P. Kelly (Jackson: University of Mississippi Press, 2020).

23. The Hampton Roads MSA includes the Elizabeth City, North Carolina, Micropolitan Statistical Area, comprising Pasquotank, Perquimans, Gates, Currituck, and Camden Counties. "Current Statistical Area Lists and Delineations," Office of Management and Budget (OMB) Bulletins, US Census Bureau, February 2013.

24. Unfortunately, it has required the stasis of the COVID-19 quarantine and the continued killings of Black people to bring about a national reconsideration of Confederate monuments and memorials and a popularized move to dismantle them. Recorded footage of ongoing anti-Black violence has pushed many to reevaluate the history of slavery and its legacies. Even still, the removal, destruction, and defacement of Confederate monuments do not erect new narratives commemorating historical Black actors and their contributions. However, the efforts of social justice activist Bryan Stevenson's Equal Justice Initiative to establish the National Memorial for Peace and Justice are one example of counternarration against silences about historical anti-Black violence, Black suffering, Black death, and white culpability. The memorial, opened in Montgomery, Alabama, in April 2018, is the nation's first national museum and memorial dedicated to difficult histories of slavery, lynching, and segregation. It demonstrates possibilities for social transformation and national healing

through honest recognition, confrontation of ongoing racial injustice, reflection, and commemoration. Opened to the public in 2014, the Whitney Plantation Museum in Edgar, Louisiana, is another example of recent efforts to commemorate the lives of enslaved people and confront the history of slavery.

25. *Django Unchained* (2012); *12 Years a Slave* (2013); WGN America's new TV series "Underground," (2016); the History Channel's *Roots* TV mini-series (May 2016); *The Birth of a Nation* (October 2016); and *Harriet* (2019) are some examples of recent popular interest in slavery.

26. Eichstedt and Small, *Representations of Slavery,* 108, emphasis in original.

27. Ibid., 4.

28. Amy E. Potter, "'She Goes into Character as the Lady of the House': Tour Guides, Performance, and the Southern Plantation," *Journal of Heritage Tourism* 11, no. 3 (2015): 250; David L. Butler, "Whitewashing Plantations: The Commodification of a Slave-Free Antebellum South," *International Journal of Hospitality & Tourism Administration* 2 (2001): 163–75.

29. Eddie Modlin, "Representing Slavery at Plantation-House Museums in the U.S. South: A Dynamic Spatial Process," *Historical Geography* 39 (2011): 147–73; E. Arnold Modlin, Jr., "Tales Told on the Tour: Mythic Representations of Slavery by Docents at North Carolina Plantation Museums," *Southeastern Geographer* 48 (2008): 265–87.

30. Ibid., 281.

31. Meredith Stone et al., "Searching for the Enslaved in the 'Cradle of Democracy': Virginia's James River Plantation Websites and the Reproduction of Local Social Memories," *Southeastern Geographer* 56, no. 2 (2016): 204.

32. Eichstedt and Small, *Representations of Slavery,* 6, 144–45.

33. Derek Alderman, David Butler, and Stephen Hanna, "Memory, Slavery, and Plantation Museums: The River Road Project," *Journal of Heritage Tourism* 11, no. 3 (2016): 209.

34. For an elaboration of these findings, see Kathryn Benjamin Golden, "Through the Muck and Mire: Marronage, Representation, and Memory in the Great Dismal Swamp" (PhD diss., University of California, Berkeley, 2018).

35. Other plantation tourist options are available to the public outside of the Hampton Roads counties and farther away from Dismal Swamp communities. Carter's Grove Plantation in Williamsburg, which was open to the public for most of the years between 1969 and 2007 and was locally famous for its historical reenactments and slave quarter tours, is now privately owned and no longer open to the public. See Susan Svrluga, "Colonial Williamsburg Sells Carter's Grove Plantation after Bankruptcy," *Washington Post,* September 19, 2014.

36. Site visit, Museum of the Albemarle, Elizabeth City, NC, May 2013 and July 29, 2015.

37. See Raymond Parker Fouts, ed., *Registration of Slaves to Work in the Great Dismal Swamp: Gates County, North Carolina, 1847–1861* (Cocoa, FL: GenRec, 1995), which offers detailed descriptions of the enslaved men hired out to dig canals in Gates County, North Carolina.

38. William L. Andrews, ed., *North Carolina Slave Narratives: The Lives of Moses Roper, Lunsford Lane, Moses Grandy, & Thomas H. Jones Moses Grandy* (Chapel Hill: University of North Carolina Press, 2003), 169.

39. Untitled document compiled by Gerald Rogers, City of Chesapeake, retrieved April 8, 2015.

40. Interview with the City of Chesapeake parks manager, Chesapeake, VA, April 8, 2015.

41. Byrd, "The Earliest Passage"; Leaming, *Hidden Americans,* 222; Royster, *The Fabulous History of the Dismal Swamp Company,* 82.

42. US Fish and Wildlife Service, "Great Dismal Swamp National Wildlife Refuge: The Great Dismal Swamp and the Underground Railroad," July 2001, www.fws.gov.

43. Diane Miller, "The Places and Communities of the Underground Railroad: The National Park Service Network to Freedom," in *Passages to Freedom: The Underground Railroad in History and Memory,* ed. David W. Blight (New York: First Smithsonian Books, 2006), 279–80.

44. National Park Service, US Department of the Interior, National Underground Railroad Network to Freedom Program, "Network to Freedom," retrieved July 2015, www.cr.nps.gov/ugrr.

45. Ibid.

46. Site visit, Dismal Swamp State Park, South Mills, NC, May 2013, January 2014, and March–April 2015.

47. Ibid.

48. Dismal Swamp Canal Welcome Center, "Underground Railroad Network to Freedom," Dismal Swamp State Park, South Mills, NC, retrieved July 2015.

49. Interview with the former park superintendent, Dismal Swamp State Park, South Mills, NC, January 15, 2014.

50. "Park Purpose: State Parks System Mission Statement," Dismal Swamp State Park, November 1, 1994, retrieved April 24, 2015.

51. Interview with the former park superintendent, Dismal Swamp State Park, January 15, 2014.

52. Ibid.

53. Interview with the present park superintendent, Dismal Swamp State Park, South Mills, NC, April 13, 2015.

54. Interview with Dismal Swamp State Park staff member, Dismal Swamp State Park, South Mills, NC, April 24, 2015.

55. Interview with Eric Sheppard, president of Diversity Restoration Solutions, June 20, 2015.

56. Site visit, Great Dismal Swamp Fish and Wildlife Refuge, May 2013–July 2015.

57. US Fish and Wildlife Service, "The Great Dismal Swamp and the Underground Railroad," retrieved May 2013 and March 2015.

58. This is evidenced through ethnography I conducted in 2015 with local Tidewater communities.

59. Dismal Swamp Canal Welcome Center, "Underground Railroad Network to Freedom," Dismal Swamp State Park, South Mills, NC, retrieved July 2015. This information is also reflected in the City of Norfolk's walking tour guide: Cassandra Newby-Alexander, "Waterways to Freedom: The Underground Journey from Hampton Roads," retrieved June 2015.

60. Dismal Swamp Canal Welcome Center, "Underground Railroad Network to Freedom."

61. Newby-Alexander, "Waterways to Freedom."

62. John Michael Vlach, "Above Ground on the Underground Railroad: Places of Flight and Refuge," in *Passages to Freedom: The Underground Railroad in History and Memory,* ed. David W. Blight (New York: First Smithsonian Books, 2006), 98.

63. US Fish and Wildlife Service, "Great Dismal Swamp: National Wildlife Refuge," Great Dismal Swamp Fish and Wildlife Refuge, Suffolk, VA, retrieved May 2013 and March 2015.

64. Interview with the Great Dismal Swamp Fish and Wildlife Refuge visitors services specialist, March 25, 2015.

65. National Park Service, "Network to Freedom."

66. Sayers, *A Desolate Place for a Defiant People;* Benjamin Golden, "Through the Muck and Mire." Congressman McEachin, the GDSSC, and the Wilderness Society consulted these scholars and their research to craft an argument substantiating the need for introducing the GDS National Heritage Act.

67. Brundage, *Where These Memories Grow,* 12.

68. Byrd, "Proposal to Drain the Dismal Swamp."

Hidden in Plain Sight

1. John Hebron Moore, *The Emergence of the Cotton Kingdom in the Old Southwest: Mississippi, 1770–1860* (Baton Rouge: Louisiana State University Press, 1988), 177.

2. Hubert H. McAlexander, *A Southern Tapestry: Marshall County, Mississippi, 1835–2000* (Virginia Beach, VA: Donning, 2000), 32. For census data, see "Population of Such Cities, Towns, Townships, Hundreds, &c, in the United States Census as Have Been Entertained in the Census Office," 1850 Census: Compendium of the Seventh Census, www2.census.gov /library/publications/decennial/1850/1850c/1850c-12.pdf?#; and the Seventh Census of the United States: 1850—Mississippi.

3. Derek H. Alderman and E. Arnold Modlin, "On the Political Utterances of Plantation Tourists: Vocalizing the Memory of Slavery on River Road," *Journal of Heritage Tourism* 11, no. 3 (2016), http://doi.org/10.1080/1743873X.2015.1100623; Christine N. Buzinde and Carla Almeida Santos, "Interpreting Slavery Tourism," *Annals of Tourism Research* 36, no. 3 (2009): 439–58; Jennifer L. Eichstedt and Stephen Small, *Representations of Slavery: Race and Ideology in Southern Plantation Museums* (Washington, DC: Smithsonian Institution Press, 2002); Antoinette T. Jackson, *Speaking for the Enslaved: Heritage Interpretation at Antebellum Plantation Sites* (Walnut Creek, CA: Left Coast, 2012); Tiya Miles, *Tales from the Haunted South: Dark Tourism and the Civil War Legacy of Slavery and Memory* (Chapel Hill: University of North Carolina Press, 2015). Exceptions include Kevin Fox Gotham, *Authentic New Orleans: Tourism, Culture, and Race in the Big Easy* (New York: NYU Press, 2007); Stephen W. Litvin and Joshua David Brewer, "Charleston, South Carolina Tourism and the Presentation of Urban Slavery in an Historic Southern City," *International Journal of Hospitality and Tourism Administration* 9, no. 1 (2008): 71–84.

4. Kristin L. Gallas and James DeWolf Perry, eds., *Interpreting Slavery at Museums and Historic Sites* (New York: Rowman & Littlefield, 2015).

5. Jack E. Davis, "A Struggle for Public History: Black and White Claims to Natchez's Past," *Public Historian* 22, no. 1 (2000): 52.

6. McAlexander, *A Southern Tapestry,* 32.

7. Antoinette Jackson, "Changing Ideas about Heritage and Heritage Resource Management in Historically Segregated Communities," *Transforming Anthropology* 18, no. 1 (2010): 80.

8. Jodi Skipper, "Community Development through Reconciliation Tourism: The Behind the Big House Program in Holly Springs, Mississippi," *Community Development* 47, no. 4 (2016): 514–29.

9. Bernard L. Herman, "Slave and Servant Housing in Charleston, 1770–1820," *Historical Archaeology* 33, no. 3 (1999): 88–101; Leslie C. Stewart-Abernathy, "Separate Kitchens and Intimate Archaeology: Constructing Urban Slavery on the Antebellum Cotton Frontier in Washington, Arkansas," in *Household Chores and Household Choices: Theorizing the Domestic Sphere in Historical Archaeology,* ed. Kerri S. Barile and Jamie C. Brandon (Tuscaloosa: University of Alabama Press, 2004); John Michael Vlach, "'Without Recourse to Owners': the Architecture of Urban Slavery in the Antebellum South," in *Shaping Communities:*

Perspectives in Vernacular Architecture, eds. Carter L. Hudgins and Elizabeth Collins Cromley (Knoxville: University of Tennessee Press, 1997), 6:151.

10. See, for example, Stewart-Abernathy, "Separate Kitchens and Intimate Archaeology." There have been more recent forays into slavery in northern cities, yet these are still partial to what we consider large cities. For examples, see Leslie M. Harris, *In the Shadow of Slavery: African Americans in New York City, 1626–1863* (Chicago: University of Chicago Press, 2004); and Tiya Miles, *Dawn of Detroit: A Chronicle of Slavery and Freedom in the City of the Straits* (New York: New Press, 2019).

11. Gallas and Perry, eds., *Interpreting Slavery,* 11. See also Jodi Skipper and James M. Thomas, "Plantation Tours," *Contexts: Sociology for the Public* 19, no. 2 (2020): 64–67.

12. McAlexander, *A Southern Tapestry,* 33.

13. Ibid., 65–67.

14. Joseph McGill, "Jenifer Eggleston's Reflections," *Lowcountry Africana* (blog), April 30, 2012, www.Lowcountryafricana.com/back-of-the-big-house-slave-dwelling-project-a -stop-on-holly-springs-ms-pilgrimage-tour-tour.

15. Bernard L. Herman, "Slave and Servant Housing in Charleston, 1770–1820," *Historical Archaeology* 33, no. 31 (1999): 98.

16. Edward Chappell, "Building Notes," unpublished manuscript, in author's possession.

17. Chesley Thorne Smith, *Childhood in Holly Springs: A Memoir* (Lafayette, CA: Berryhill, 1996), 74.

18. "Mississippi, Compiled Marriage Index, 1776–1935," Ancestry.com, 2004.

19. Herman, "Slave and Servant Housing in Charleston," 90.

20. Stephanie M. H. Camp, *Closer to Freedom: Enslaved Women & Everyday Resistance in the Plantation South* (Chapel Hill: University of North Carolina Press, 2004).

21. Joseph McGill Jr. was a program coordinator in the National Trust for Historic Preservation Charleston office when he decided to start his Slave Cabin Project in 2010. McGill started the project to bring attention to some of the engendered slave dwelling sites he saw on his travels throughout the southeastern United States.

22. Stewart-Abernathy, "Separate Kitchens and Intimate Archaeology."

23. Candace Forbes Bright, Derek H. Alderman, and David L. Butler, "Tourist Plantation Owners and Slavery: A Complex Relationship," *Current Issues in Tourism* 21, no. 15 (2018): 3, https://doi.org/10.1080/13683500.2016.1190692.

24. Vlach, "'Without Recourse to Owners,'" 151.

25. The Aiken-Rhett House is a townhouse complex once occupied by South Carolina governor William Aiken. It was built in 1820 and spent 142 years in the Aiken family before being sold and opened as a house museum in 1975. The complex includes the original slave quarters.

26. Vlach, "'Without Recourse to Owners,'" 155.

27. Barbara H. Combs et al., "The Symbolic Lynching of James Meredith: A Visual Analysis and Collective Counter Narrative to Racial Domination," *Sociology of Race and Ethnicity* 2, no. 3 (2016): 338–53.

28. The ticket location changed in 2019 and is no longer at the public library. Even with the disconnect between Behind the Big House and the Pilgrimage headquarters, some Pilgrimage hosts directed their guests to Behind the Big House sites. The impact of this change is unclear, for program attendance was heavily affected by rain in 2019. The 2020 program had not yet taken place when this was written.

29. Saidiya V. Hartman, *Scenes of Subjection: Terror, Slavery, and Self-Making in Nineteenth-Century America* (New York: Oxford University Press, 1997).

30. Gallas and Perry, eds., *Interpreting Slavery at Museums and Historic Sites.*

31. "State of Mississippi," 1860 Census: Population of the United States, www.census .gov/library/publications/1864/dec/1860a.html; Clifton Ellis and Rebecca Ginsburg, eds., *Slavery in the City: Architecture and Landscapes of Urban Slavery in North America* (Charlottesville: University of Virginia Press, 2017), 14.

32. Ellis and Ginsburg, *Slavery in the City.*

33. Buzinde and Santos, "Interpreting Slavery Tourism," 439–58.

34. Gallas and Perry, eds., *Interpreting Slavery at Museums and Historic Sites,* 17.

35. Kristin L. Gallas and James DeWolf Perry, "Comprehensive Content and Contested Historical Narratives," in *Interpreting Slavery at Museums and Historic Sites,* ed. Kristin L. Gallas and James DeWolf Perry (New York: Rowman & Littlefield, 2015), 12.

36. Jason Phillips, "Reconstruction," in *Mississippi Encyclopedia,* April 15, 2018, accessed November 23, 2019, http://mississippiencyclopedia.org/entries/reconstruction.

37. Suzanne R. Davidson, "African American Roots Tourism at 'Home': History, Memory, and Heritage in Holly Springs, Mississippi" (master's thesis, University of Mississippi, 2018).

38. Behind the Big House Tour student evaluation, March 10, 2016, in author's possession.

39. Behind the Big House Tour student evaluation, May 9, 2017, in author's possession.

40. Behind the Big House Tour student evaluation, March 10, 2016, in author's possession.

41. Gallas and Perry, eds., *Interpreting Slavery at Museums and Historic Sites.*

42. McGill, "Jenifer Eggleston's Reflections."

43. Salamishah Tillet, *Sites of Slavery: Citizenship and Racial Democracy in the Post–Civil Rights Imagination* (Durham, NC: Duke University Press, 2012).

44. Elizabeth Fox-Genovese, *Within the Plantation Household: Black and White Women of the Old South* (Chapel Hill: University of North Carolina Press, 1988), 75.

45. Anthony E. Kaye, *Joining Places: Slave Neighborhoods in the Old South* (Chapel Hill: University of North Carolina Press, 2007).

46. Juliet Crutchfield, "Juliet's Genealogical Gems Gleaning Information from Slave Schedules," African American Genealogical Society of Northern California, October 1999, accessed November 24, 2019, www.aagsnc.org/columns/oct99gems.htm.

47. Kaye, *Joining Places,* 4.

48. Max Grivno, "Slavery and Freedom in Northern Mississippi," lecture, University of Mississippi, Oxford, April 2, 2019. Grivno is currently writing *From Bondage to Freedom: Slavery in Mississippi, 1690–1865.*

49. Stewart-Abernathy, "Separate Kitchens and Intimate Archaeology," 54. See also Fox-Genovese, *Within the Plantation Household.*

50. See Thavolia Glymph, *Out of the House of Bondage: The Transformation of the Plantation Household* (Cambridge: Cambridge University Press, 2008); and Stephanie E. Jones-Rogers, *They Were Her Property: White Women as Slave Owners in the American South* (New Haven, CT: Yale University Press, 2019).

51. Stewart-Abernathy, "Separate Kitchens and Intimate Archaeology," 53.

52. Behind the Big House Tour student evaluation, March 9, 2015, in author's possession.

53. Kaye, *Joining Places.*

54. Richard C. Wade, *Slavery in the Cities: The South 1820–1860* (New York: Oxford University Press, 1964), quoted in Stewart-Abernathy, "Separate Kitchens and Intimate Archaeology," 55.

55. For more information, see Davidson, "African American Roots Tourism at 'Home.'"

56. Ibid.

57. Although other Mississippi cities have not adopted the model, a sister program in Arkansas developed from this model. See behindthebighouse.org for contexts.

58. Mary Pinckney Battle, "Confronting Slavery in Historic Charleston: Changing Tourism Narratives in the Twenty-First Century" (PhD diss., Emory University, 2013), 20–21.

59. African American families in the United States South were faced with a lack of state and local funding to support public schools for their children. To help provide Black children access to education, Booker T. Washington and Julius Rosenwald worked with African American communities to build and fund nearly 5,000 schools. Black communities donated their land and held fundraisers. Their efforts were combined with funding from the Julius Rosenwald Foundation to build the schools that became known as the Rosenwald Schools.

Creating and Maintaining Digital Public History

1. Ed Pilkington, "'Secession Ball' Marks Start of American Civil War with Champagne and Dancing," *Guardian,* December 21, 2010, www.theguardian.com/world/2010/dec/21/secession-ball-civil-war; Blain Roberts and Ethan Kytle, "Dancing Around History," *New York Times,* December 21, 2010, https://opinionator.blogs.nytimes.com/2010/12/21/dancing-around-history.

2. The LCDL team that worked to create the Lowcountry Digital History Initiative included John White, Heather Gilbert, Tyler Mobley, and Mary Battle.

3. *African Passages, Lowcountry Adaptations,* Lowcountry Digital History Initiative, 2013, http://ldhi.library.cofc.edu/exhibits/show/africanpassagesLowcountryadapt; John Harris, *Voyages of the* Echo: *The Trials of an Illegal Trans-Atlantic Slave Ship,* Lowcountry Digital History Initiative, May 2014, http://ldhi.library.cofc.edu/exhibits/show/voyage-of-the-echo-the-trials; Christopher Williams et al., *Liverpool's Abercromby Square and the Confederacy during the U.S. Civil War,* Lowcountry Digital History Initiative, December 2015, http://ldhi.library.cofc.edu/exhibits/show/liverpools-abercromby-square.

4. Muhammad Fraser-Rahim, *Enslaved and Freed African Muslims: Spiritual Wayfarers in the South and Lowcountry,* Lowcountry Digital History Initiative, October 2018, http://ldhi.library.cofc.edu/exhibits/show/african-muslims-in-the-south; Marina López and Kieran Taylor, *Las Voces del Lowcountry,* Lowcountry Digital History Initiative, November 2017, http://ldhi.library.cofc.edu/exhibits/show/las-voces.

5. "Exploring *Omar:* A Spoleto ETC Discussion Series," Spoleto Festival USA, accessed February 20, 2020, https://spoletousa.org/events/exploring-omar/?utm_source=wordfly&utm_medium=email&utm_campaign=FY20ExploringOmarAnnouncement&utm_content=version_A.

6. An internet search for the exhibit reveals more than a dozen references to Fraser-Rahim's LDHI exhibit on enslaved and freed Muslims; see "Slavery and Abolition: Primary Source Collection Online," *US History: Primary Source Collections Online,* Sam Houston State University, accessed February 1, 2020, https://shsulibraryguides.org/c.php?g=86715&p=558455.

7. For details and rationales regarding the work-flow process, the use of Omeka as a publishing platform, and the technical setup and maintenance of Omeka for LDHI, see Mary Battle, Tyler Mobley, and Heather Gilbert, "Digital Public History in the Library: Developing the Lowcountry Digital History Initiative at the College of Charleston," in *Laying the Foundation: Digital Humanities in Academic Libraries* (Purdue University Press, 2016): 35–58.

8. Mary Battle, "Confronting Slavery in Historic Charleston: Changing Tourism Narratives in the Twenty-First Century," Emory University, 2013, http://nuncio.cofc.edu/login?url=https://search-proquest-com.nuncio.cofc.edu/docview/1467753203?accountid=9959.

9. Ethan Kytle and Blain Roberts, *Denmark Vesey's Garden: Slavery and Memory in the Cradle of the Confederacy* (New York: New Press, 2018); Dan Vivian, *A New Plantation World: Sporting Estates in the South Carolina Lowcountry, 1910–1940* (New York: Cambridge University Press, 2018); Stephanie Yuhl, *A Golden Haze of Memory: The Making of Historic Charleston* (Chapel Hill: University of North Carolina Press, 2006), 6.

10. Kytle and Roberts, *Denmark Vesey's Garden,* chapter 6, "America's Most Historic City"; Yuhl, *A Golden Haze of Memory,* 11.

11. Adam Domby, *The False Cause: Fraud, Fabrication, and White Supremacy in Confederate Memory* (Charlottesville: University of Virginia Press, 2020); Mary Battle, "Changing Representations of African American History at Drayton Hall," Drayton Hall, accessed September 17, 2018, www.draytonhall.org/changing-representations-of-african-american -history-at-drayton-hall.

12. Kytle and Roberts's *Denmark Vesey's Garden* thoroughly highlights Black remembrance and commemoration of the past, starting with Emancipation in chapter 1, "The Year of Jubilee."

13. Battle, "Confronting Slavery in Historic Charleston," 15–16.

14. Battle, Mary. "Confronting Slavery in Historic Charleston: Changing Tourism Narratives in the Twenty-First Century." (PhD diss., Emory University, 2013), 2.

15. School of Business, *Office of Tourism Analysis: Annual Report,* 8, accessed December 3, 2019, http://sb.cofc.edu/centers/tourismanalysis/annualreports/OTAAnnualReport20172018 .pdf.

16. "Charleston-North Charleston Area among the Fastest Growing Cities in America," *Holy Sinner City,* April 22, 2019, www.holycitysinner.com/2019/04/22/charleston-north-charleston -area-among-the-fastest-growing-cities-in-america.

The Ansonborough Project

1. "Boston Chamber of Commerce Lauds Preservation Efforts in Charleston," *News and Courier,* November 25, 1962; "Progress in Ansonborough Is Termed 'Encouraging,'" *Evening Post,* February 28, 1964; "N.O. Landmarks to Be Discussed," *Times-Picayune,* October 26, 1961; United States Conference of Mayors, Special Committee on Historic Preservation, *With Heritage So Rice* (New York: Random House, 1966).

2. There is a plethora of scholarship available on Charleston's interwar preservation movement. See Stephanie Yuhl, *A Golden Haze of Memory: The Making of Historic Charleston* (Chapel Hill: University of North Carolina Press, 2006); Sidney Bland, *Preserving Charleston's Past, Shaping Its Future: The Life and Times of Susan Pringle Front* (Columbia: University of South Carolina Press, 1999); Robert R. Weyeneth, "Ancestral Architecture: The Early Preservation Movement in Charleston," in *Historic Preservation for a Living City: Historic Charleston Foundation, 1947–1997* (Columbia: University of South Carolina Press, 2000).

3. Harold Pinter, quoted in W. Fitzhugh Brundage, *The Southern Past: A Clash of Memory and Race* (Cambridge, MA: Harvard University Press, 2005), 5.

4. Brundage, *The Southern Past,* 5.

5. Michel-Rolph Trouillot, *Silencing the Past: Power and the Production of History* (Boston: Beacon, 1995), xxiii.

6. Daniel Bluestone, *Buildings, Landscapes, and Memory: Case Studies in Historic Preservation* (New York: W.W. Norton, 2011), 40.

7. Diane Lea, "America's Preservation Ethos: A Tribute to Enduring Ideals," in *A Richer Heritage: Historic Preservation in the Twenty-First Century,* ed. Robert E. Stipe (Chapel Hill: University of North Carolina Press, 2003), 7.

8. David Hamer, *History in Urban Places: The Historic Districts of the United States* (Columbus: Ohio State University Press, 1998), 85.

9. Mike Wallace, *Mickey Mouse History: And Other Essays on American Memory* (Philadelphia: Temple University Press, 1996), 182.

10. See Yuhl, *A Golden Haze of Memory,* and Ethan J. Kytle and Blaine Roberts, *Denmark Vesey's Garden: Slavery and Memory in the Cradle of the Confederacy* (New York: New Press, 2018), for additional information.

11. Yuhl's discussion of the creation of a "useable past" in the South following the Civil War is common in historiography. For further reading, see David Blight, *Race and Reunion: The Civil War in American Memory* (Cambridge, MA: Harvard University Press, 2009); Brundage, *The Southern Past;* and Kytle and Roberts, *Denmark Vesey's Garden.*

12. Susan V. Donaldson, "Charleston's Racial Politics of Historic Preservation: The Case of Edwin A. Harleston," in *Renaissance in Charleston: Art and Life in the Carolina Low Country, 1900–1940* (Athens: University of Georgia Press, 2003), 177.

13. Sarah Platt, "Urban Dialectics, Misrememberings, and Memory-Work: The Halsey Map of Charleston, South Carolina," *International Journal of Historical Archaeology* (2020): 7.

14. Ned Kaufman, *Place, Race and Story: Essays on the Past and Future of Historic Preservation* (New York: Routledge, 2009), 8.

15. Ibid. Additionally, it is for this reason that many scholars, such as Kaufman and Jennifer J. Babiarz, have written on the need for diversity among practitioners in the field.

16. Emily Williams, "Visitors to Charleston Broke Records Again, Exceeding 7.2 Million Last Year," *Post and Courier,* April 5, 2019, www.postandcourier.com/business/visitors -to-charleston-broke-records-again-exceeding-million-last-year/article_7e0c7d14-57b0-11e9 -a912-671dd61d9f4a.html.

17. "Charleston Tourism Is Built on Southern Charm. Locals Say It's Time to Change," *New York Times,* August 12, 2020, www.nytimes.com/2020/08/12/travel/charleston-tourism -black-lives-matter.html.

18. *The State of Racial Disparities in Charleston, South Carolina 2000–2015,* https://rsji.cofc .edu/wp-content/uploads/2017/01/The-State-of-Racial-Disparities-in-Charleston-County-SC -Rev.-11-14.pdf.

19. Platt, "Urban Dialectics," 10.

20. R. S. Hautaniemi Paynter and N. Muller, quoted in Jennifer J. Babiarz, "White Privilege and Silencing within the Heritage Landscape: Race and the Practice of Cultural Resource Management," in *Materiality of Freedom: Archaeologies of Postemancipation Life,* ed. Jodi A. Barnes (Columbia: University of South Carolina Press, 2011), 49.

21. Platt, "Urban Dialectics," 21.

22. Robert Weyeneth, *Historic Preservation for a Living City: Historic Charleston Foundation* (Columbia: University of South Carolina Press, 2000), 55–56.

23. "Restrictive Covenants," Ansonborough Rehabilitation Project, Margaretta Childs Archives at Historic Charleston Foundation, Lowcountry Digital Library, accessed January 4, 2020, http://lcdl.library.cofc.edu/lcdl/catalog/lcdl:93607; "Protective Covenants," Ansonborough Rehabilitation Project, Margaretta Childs Archives at Historic Charleston Foundation, Lowcountry Digital Library, accessed January 4, 2020, http://lcdl.library.cofc.edu/lcdl /catalog/lcdl:93609.

24. Mrs. S. Henry Edmunds to Mr. Alan B. Anson, May 15, 1962, Ansonborough Rehabilitation Project, Margaretta Childs Archives at Historic Charleston Foundation, Lowcountry Digital Library, accessed January 21, 2018, http://lcdl.library.cofc.edu/lcdl/catalog/lcdl:93562.

25. "Ansonborough: An Historical Residential Area in Old Charleston," brochure, 1967,

Margaretta Childs Archives at Historic Charleston Foundation, Lowcountry Digital Library, accessed February 1, 2020, http://lcdl.library.cofc.edu/lcdl/catalog/lcdl:93704.

26. Meeting Minutes for the Board of Trustees at the Historic Charleston Foundation, July 11, 1961.

27. Herb Frazier, interview by Erin Dickey, South Carolina Public Radio, 2012, accessed January 25, 2020, http://southcarolinapublicradio.org/post/narrative-memories-childhood-ansonborough.

28. Herb Frazier, Bernhard Edward Powers Jr., and Marjory Wentworth, *We Are Charleston: Tragedy and Triumph at Mother Emanuel* (Nashville: W. Publishing, 2016), 109; Frazier interview.

29. Frances McCormack, "Art, Film to Help Recapture Memories of Ansonborough," *Post and Courier,* April 4, 2002.

30. US Census Bureau, Census Records of 1940, National Archives, accessed January 10, 2020, https://1940census.archives.gov.

31. Diane Petro, "Brother, Can You Spare a Dime? The 1940 Census: Employment and Income," *National Archives* 44 (2012), www.archives.gov/publications/prologue/2012/spring/1940.html.

32. To read more about the racial rhetoric of the Historic Charleston Foundation during the Ansonborough Project, see Matthew Klein's master's thesis, "Ansonborough: Historic Preservation in Charleston, Post–World War II" (College of Charleston, 2018), http://hdl.handle.net/123456789/3579.

33. "Properties Owned," Ansonborough Rehabilitation Project, Margaretta Childs Archives at Historic Charleston Foundation, Lowcountry Digital Library, accessed February 18, 2018, http://lcdl.library.cofc.edu/lcdl/catalog/lcdl:93729.

34. "Saving a Neighborhood through Historic Preservation," April 1967, Ansonborough Rehabilitation Project, Margaretta Childs Archives at Historic Charleston Foundation, Lowcountry Digital Library, accessed February 1, 2020, http://lcl/library.cofc.edu/lcdl/catalog/lcdl:93694.

35. Sarah Platt, "Urban Dialectics, Misrememberings, and Memory-Work: The Halsey Map of Charleston, South Carolina," International Journal of Historical Archaeology (2020).

36. Platt, "Urban Dialectics."

37. Frazier, Powers, and Wentworth, *We Are Charleston,* 109.

38. "Statement from Mayor Gaillard," Ansonborough Rehabilitation Project, Margaretta Childs Archives at Historic Charleston Foundation, Lowcountry Digital Library, accessed January 23, 2018, http://lcdl.library.cofc.edu/lcdl/catalog/lcdl:93617.

39. "Tally Sheet—Progress Report on Ansonborough," June 5, 1969, Ansonborough Rehabilitation Project, Margaretta Childs Archives at Historic Charleston Foundation, accessed March 23, 2018, http://lcdl.library.cofc.edu/lcdl/catalog/lcdl:93733.

40. Weyeneth, *Historic Preservation for a Living City,* 65.

41. Kytle and Roberts, *Denmark Vesey's Garden,* 307.

42. Richard Rabinowitz, *Curating America: Journeys through Storyscapes of the American Past* (Chapel Hill: University of North Carolina Press, 2016), 173.

43. Kaufman, *Place, Race and Story,* 38.

44. Richard Rabinowitz was one of the first scholars to use the phrase "storyscape" to describe landscapes.

45. Rabinowitz, *Curating America,* 153, 172.

46. Kaufman, *Place, Race and Story,* 401. During investigations in the enslaved quarter of the Nathaniel Russell House Kitchen, staff at the Historic Charleston Foundation discovered

a folded fragment of an 1830s reading primer. The joy and feelings of independence that come with learning to read is a childhood experience that transcends time.

47. Ibid., 402.

48. Ibid., 49, 50.

49. Kytle and Roberts, *Denmark Vesey's Garden,* 642.

50. Platt, "Urban Dialectics," 9.

51. Michael Frisch, *A Shared Authority: Essays on the Craft and Meaning of Oral and Public History* (New York: State University of New York Press, 1990), xvi.

52. Katrina Andry, *Over There and Here Is Me and Me,* Halsey Institute of Contemporary Art at the College of Charleston, accessed January 5, 2020, http://halsey.cofc.edu/main -exhibitions/katrina-andry.

53. "About," International African American Museum, accessed September 5, 2020, https://iaamuseum.org/about-museum.

54. Historic Charleston Foundation, Instagram post, February 2, 2018.

55. National Register of Historic Places Nomination: Mosquito Beach Historic District, James Island, South Carolina, 2018, accessed August 26, 2020, www.historicmosquitobeach .com/wp-content/uploads/2019/12/Mosquito-Beach-NPS-Nomination.pdf.

56. "NPS Grants," Historic Charleston Foundation, accessed August 25, 2020, www .historicmosquitobeach.com/home/history/the-black-beach.

57. "The Black Beach," Historic Charleston Foundation, accessed August 25, 2020, www .historicmosquitobeach.com/home/history/the-black-beach.

58. National Register of Historic Places Nomination: Mosquito Beach Historic District.

59. Platt, "Urban Dialectics."

60. Rabinowitz, *Curating America,* 9.

"A Thin Neck in the Hourglass"

1. Shawn Halifax is the experienced and innovative director of McLeod Plantation, a site owned by the Charleston County Park and Recreation Commission. This site was once the center of a Sea Island cotton plantation covering nearly 1,700 acres. See Shawn Halifax, "McLeod Plantation Historic Site: Sowing Truth and Change," *Public Historian* 40, no. 3 (August 2018): 252–77.

2. See the Historical Marker Database, "Bite-Size Bits of Local, National, and Global History," accessed December 27, 2017, www.hmdb.org/marker.asp?marker=14855.

3. Marcia M. Greenlee, *Black Americans in United States History: Historic Property Studies of Afro-American Bicentennial Corporation under Contract to the National Park Service* (Washington, DC: National Survey of Historic Sites and Buildings, Office of Archaeology and Historic Preservation, National Park Service, US Department of Interior, 1974); "The Stono River Slave Rebellion," National Register Nomination Form (1974), accessed December 27, 2017, www.nationalregister.sc.gov/charleston/S10817710075/S10817710075.pdf.

4. Brian Graves, "'Return and Get It': Developing McLeod Plantation as a Shared Space of Historical Memory," *Southern Cultures* 23, no. 2 (Summer 2017): 75–96.

5. Peter H. Wood, *Black Majority: Negroes in Colonial South Carolina from 1670 through the Stono Rebellion* (New York: Alfred A. Knopf, 1974), xiv.

6. See, for example, Jack P. Greene, Rosemary Brana-Shute, and Randy J. Sparks, eds., *Money, Trade, and Power: The Evolution of Colonial South Carolina's Plantation Society* (Columbia: University of South Carolina Press, 2001); and Martha A. Zierden and Elizabeth J. Reitz, *Charleston: An Archaeology of Life in a Coastal Community* (Gainesville: University Press of Florida, 2016).

7. In 1975 Charles E. Lee, South Carolina's state historic preservation officer, argued successfully that the edifice, one of the few surviving slave auction buildings in the entire region, deserved a place on the National Register of Historic Sites. Nomination for recognition by the National Park Service, submitted February 27, 1975, accessed September 22, 2017, www.nationalregister.sc.gov/charleston/S10817710090/S10817710090.pdf.

8. Judith Wragg Chase, *Afro-American Art and Craft* (New York: Van Nostrand Reinhold, 1971); "Fate of Museum in Doubt," *New York Times*, July 6, 1987. On Wilson, see Judith Wragg Chase, "Miriam Ballangee Wilson—Founder, Old Slave Mart Museum," *Preservation Progress* 8, no. 4 (November 1963): 7–10.

9. Daniel C. Littlefield, *Rice and Slaves: Ethnicity and the Slave Trade in Colonial South Carolina* (Baton Rouge: Louisiana State University Press, 1981); Charles Joyner, *Down by the Riverside: A South Carolina Community* (Urbana: University of Illinois Press, 1984); Margaret Washington Creel, *"A Peculiar People": Slave Religion and Community-Culture among the Gullahs* (New York: New York University Press, 1988). Other key books would follow: Philip D. Morgan, *Slave Counterpoint: Black Culture in the Eighteenth-Century Chesapeake and Lowcountry* (Chapel Hill: University of North Carolina Press, 1998); Judith A. Carney, *The African Origins of Rice Cultivation in the Americas* (Cambridge, MA: Harvard University Press, 2002); and Edda L. Fields-Black, *Deep Roots: Rice Farmers in West Africa and the African Diaspora* (Bloomington: Indiana University Press, 2008).

10. Alphonso Brown, *A Gullah Guide to Charleston: Walking Through Black History* (Charleston: History Press, 2008), 45. In 1769 South Carolina's colonial legislature moved Charleston's north edge to the fortified spot where visitors approached town along the Broad Path, also known as King Street. An east-west road constructed along the new border had the obvious name of Boundary Street until renamed for Calhoun in the next century. Nic Butler, "A Brief History of Marion Square, Part 1," *Charleston Time Machine*, May 26, 2017, accessed July 29, 2017, https://charlestontimemachine.org/2017/05/26/a-brief-history-of-marion-square-part-1.

11. When Americans worried that British manufacturers might obtain cheap cotton from India and Egypt, Calhoun assured the Senate that the United States had ingeniously fostered the world's most "cheap and efficient body of laborers . . . of any . . . cotton-growing region" in the world. For generations, enslaved Negroes had received no wages at all, for, as Calhoun implausibly argued, "we have paid in advance" for their labor. Beyond the price of minimal subsistence, therefore, labor costs on Southern cotton plantations stood at zero. What could be more cheap and efficient? "With these advantages," Calhoun boasted, "we may bid defiance to Hindoo or Egyptian labor, at its two or three cents a day." Speech, March 16, 1842, quoted in Matthew Karp, *This Vast Southern Empire: Slaveholders at the Helm of American Foreign Policy* (Cambridge, MA: Harvard University Press, 2016), 30.

12. Charleston in 1850 contained 42,985 inhabitants. More than half (22,973) were African American, of whom 19,532 (or nearly nine of every ten) were enslaved for life, whereas the remaining 3,441 (mostly of mixed race) were nominally free.

13. The *Charleston Mercury* applauded the grandiose scheme as "chaste, yet elaborate," a memorial that would exude the state's "appreciation of culture and refinement." Paul Starobin, *Madness Rules the Hour: Charleston, 1860 and the Mania for War* (New York: Public Affairs, 2017), 38.

14. On March 4, 1850, Calhoun, draped in a black cloak, proved too sick to deliver his forty-two-page tirade opposing conciliation with northern interests and favoring the unlimited expansion of slavery. A Virginia senator read the address for him, but within weeks the Compromise of 1850 passed the Senate anyway. Calhoun died on the last day of March.

15. Brown, *A Gullah Guide*, 44–45; Nic Butler, "A Brief History of Marion Square, Part 2," *Charleston Time Machine*, June 2, 2017, accessed July 24, 2017, https://charlestontime machine.org/2017/06/02/a-brief-history-of-marion-square-part-2.

16. Mamie Garvin Fields with Karen Fields, *Lemon Swamp and Other Places: A Carolina Memoir* (New York: Free Press, 1983), 57. Fields, a lifetime admirer of Frederick Douglass, memorized many of his speeches as a child; even in her nineties, she could still offer a succinct history lesson: "At the same time that Douglass was preaching against slavery, John C. Calhoun was preaching for it. As a US Senator, Calhoun became one of our most famous South Carolinians. He was among the early ones to speak for secession from the Union. Owning a large number of slaves, he naturally defended his 'property' rights. . . . Since we thought like Douglass, we hated all that Calhoun stood for."

17. Ibid.

18. Documented lynchings of Black men in South Carolina in 1896 include those of Calvin Kennedy (Aiken, February 29), Abe Thomson (Spartanburg, March 1), Thomas Price (Kershaw, April 19), and Dan Dicks (Aiken, July 17). South Carolina mobs perpetrated at least five such murders the previous year and would commit fifteen lynchings in 1898. "We of the South have never recognized the right of the negro to govern white men, and we never will," Tillman proclaimed. "We have never believed him to be the equal of the white man, and we will not submit to his gratifying his lust on our wives and daughters without lynching him." Michael Signer, *Demagogue: The Fight to Save Democracy from Its Worst Enemies* (New York: Palgrave MacMillan, 2009), 92. Also see the compelling biography by Stephen Kantrowitz, *Ben Tillman and the Reconstruction of White Supremacy* (Chapel Hill: University of North Carolina Press, 2000).

19. Historian Nancy MacLean makes the most cogent and dismaying case to date for the relation between Calhoun's purposes and doctrines and those of the expanding and well-funded antidemocratic forces in twenty-first-century America: "There was something alarming, even to his allies, in the monomania with which Calhoun conducted ideological warfare against the political liberalism of his day. . . . Compassion, patience, and humor all seemed as foreign to him as the notion that the people he owned had intellects and dreams of their own." She concludes: "His ideas about government broke sharply with the vision of the nation's founders and the Constitution's drafters, and even from that of his own party. He wanted one class—his own class of plantation owners—to overpower the others, despite its obvious numerical minority." Nancy MacLean, *Democracy in Chains: The Deep History of the Radical Right's Stealth Plan for America* (New York: Viking, 2017), 3.

20. Meanwhile, the Middle Passage Ceremonies and Port Markers Project, based in Jacksonville, Florida, has been working steadily, in a similar manner, to place commemorative markers at important North American ports of entry for enslaved Africans. Their map of nearly fifty documented sites is available at www.middlepassageproject.org/blogged.

21. Many descendants of these unpaid workers were sold west, joining others in the great internal forced migration of roughly a million enslaved people in the nineteenth century. As they "fanned out" to hundreds of new slave labor camps across the Black Belt, the Deep South's wealthiest 1 percent became even more rich and powerful: "By 1860, two of every three of the relatively few Americans whose wealth surpassed $100,000 lived below the Mason-Dixon Line. New York at that time had fewer millionaires than Mississippi." MacLean, *Democracy in Chains*, 2–3.

22. Edward Ball, *Slaves in the Family* (New York: Farrar, Straus and Giroux, 1998), 7.

23. Wood, *Black Majority*, xiv. On the pest house, or *lazaretto*, see Ball, *Slaves in the Family*, 89–90, 98. For the continuing use of the Ellis Island comparison/contrast in recent years,

see Peter McCandless, *Slavery, Disease, and Suffering in the Southern Lowcountry* (Cambridge: Cambridge University Press, 2011), 6; and Gregory E. O'Malley, "Slavery's Converging Ground: Charleston's Slave Trade as the Black Heart of the Lowcountry," *William and Mary Quarterly*, 3rd ser., 74, no. 2 (April 2017): 287n33.

24. Peter H. Wood, "Slave Labor Camps in Early America: Overcoming Denial and Discovering the Gulag," in *Inequality in Early America*, edited by Carla Gardina Pestana and Sharon V. Salinger (Hanover: University Press of New England, 1999), 222–38. This essay later appeared in Charles M. Payne and Adam Green, eds., *Time Longer Than Rope: A Century of African American Activism, 1850–1950* (New York: New York University Press, 2003), 17–36. For recent use of the term *slave labor camps,* see Edward E. Baptist, *The Half Has Never Been Told: Slavery and the Making of American Capitalism* (New York: Basic Books, 2014).

25. Philip D. Curtin, *The Atlantic Slave Trade: A Census* (Madison: University of Wisconsin Press, 1969). Among numerous recent examinations, four of the most probing are Stephanie E. Smallwood, *Saltwater Slavery: A Middle Passage from Africa to American Diaspora* (Cambridge, MA: Harvard University Press, 2007); Marcus Rediker, *The Slave Ship: A Human History* (New York: Viking, 2007); Sowande' M. Mustakeem, *Slavery at Sea: Terror, Sex, and Sickness in the Middle Passage* (Urbana: University of Illinois Press, 2016); and Sharla M. Fett, *Recaptured Africans: Surviving Slave Ships, Detention, and Dislocation in the Final Years of the Slave Trade* (Chapel Hill: University of North Carolina Press, 2017). A useful brief overview for teaching, with primary sources, is David Northup, *The Atlantic Slave Trade*, 2nd ed. (Boston: Houghton Mifflin, 2002).

26. Elizabeth Donnan, ed., *Documents Illustrative of the History of the Slave Trade to America* (Washington, DC: Carnegie Institution of Washington, 1930–1935).

27. To cite one example, I recently found that SlaveVoyages.com does not include a reference to the failed voyage of the *Fly,* a small brigantine of fifty tons' burden, built in Rhode Island in 1709, that left London in April 1717 and reached the mouth of the Gambia River in early May. During eleven weeks of slave trading, disease took the lives of several crew members, the supercargo, and eventually, on July 15, Captain Stephen Patrick himself. The next day, with sickness spreading among remaining crew members and with rumors of recent and pending violence facing slave ships in the area, First Mate John Smith took command and ordered the vessel's immediate departure with the human cargo then on hand. Whatever their numbers at the start of the Middle Passage, Admiralty Court records suggest that most, if not all, had disappeared by the time the leaky vessel straggled into Charleston Harbor in early September. See Peter H. Wood, "The Luck of the *Fly,*" *Sandlapper*, December 1971, 49–57.

28. See, for example, Nigel Tattersfield, *The Forgotten Trade: Comprising the Log of the Daniel and Henry of 1700 and Accounts of the Slave Trade from the Minor Ports of England, 1698–1725* (London: Jonathan Cape, 1991); Robert Harms, *The Diligent: A Voyage through the Worlds of the Slave Trade* (New York: Basic, 2002); Bruce L. Mouser, ed., *A Slaving Voyage to Africa and Jamaica: The Log of the* Sandown, *1793–1794* (Bloomington: Indiana University Press, 2002); Greg Grandin, *The Empire of Necessity: Slavery, Freedom, and Deception in the New World* (New York: Henry Holt, 2014); Anne Farrow, *The Logbooks: Connecticut's Slave Ships and Human Memory* (Middletown, CT: Wesleyan University Press, 2014); and Sean M. Kelley, *The Voyage of the Slave Ship* Hare: *A Journey into Captivity from Sierra Leone to South Carolina* (Chapel Hill: University of North Carolina Press, 2016). See also the Booker Prize–winning novel of Barry Unsworth, *Sacred Hunger* (New York: W.W. Norton, 1992); and the Brown University website, "Voyage of the Slave Ship *Sally,* 1764–1765," http://cds.library .brown.edu/projects/sally.

29. O'Malley, "Slavery's Converging Ground," 272–73.

30. *Charleston Courier,* November 22 and November 28, 1805. On buzzards, see Nic Butler, "The Rise of the Urban Vultures," *Charleston Time Machine,* July 28, 2017, accessed November 10, 2017, https://charlestontimemachine.org/?s=buzzards. "Nowhere are buzzards to be seen in such numbers as in and about the City of Charleston," commented the visitor Johann Schoepf in 1784. "Since they live only on carrion, [they] have a great part in maintaining cleanliness and keeping off unwholesome vapors from dead beasts and filth. Their sense of smell is keen, as also is their sight; hence nothing goes unremarked of them, that may serve as food, and one sees them everywhere in the streets. There are those who believe that if a buzzard lights upon a house in which an ill man lies, it is a fatal sign for they imagine the bird has wind of the corpse already."

31. Quoted in James A. McMillin, *The Final Victims: Foreign Slave Trade to North America, 1783–1810* (Columbia: University of South Carolina Press, 2004), 112–13. One sign of how slowly that slave trade historiography evolved (and of McMillin's ingenuity and determination) is the fact that his research documented tens of thousands of incoming African captives after the Revolutionary War whose arrival had been overlooked by previous scholars.

32. The books are *Washed Away Ink: The Untold Stories of Enslaved Africans,* and *12.5 Million* (Topeka: Studentreasures Publishing, 2017). For a ten-minute video about the AT LAST effort and the Ryan School initiative, see https://youtu.be/e6LISepwsVY.

33. Joseph Hawkins, *A History of a Voyage to the Coast of Africa, and Travels into the Interior of That Country* (Philadelphia: S. C. Ustick, 1797); Peter H. Wood, "Joseph Hawkins and the *Charleston*: A Story of Blindness and the Slave Trade" (paper delivered at the annual conference of the Omohundro Institute of Early American History and Culture, June 15, 2019). Sadly, the *Charleston* project remains on indefinite hold as of 2021, but a useful 3-D exploration of the French slave ship *L'Aurore* is now available at www.slavevoyages.org/voyage/ship.

34. Sam Roberts, "Ernest Finney Jr., Lawyer in Pathbreaking Civil Rights Case, Dies at 86," *New York Times,* December 9, 2017; Nikky Finney, *Rice* (Toronto: Sister Vision: Black Women and Women of Colour Press, 1995), 120. Finney, who won the National Book Award for Poetry in 2011, holds the John H. Bennett, Jr. Chair in Southern Letters and Literature at the University of South Carolina.

35. Consider "After the Reading," a recent poem by Gary Jackson, a Black Charleston resident who grew up in Kansas. (Jackson is an associate professor of English at the College of Charleston and the author of *Missing You, Metropolis,* a poetry collection that won the Cave Canem Poetry Prize in 2009.) In this telling piece the author listens to banal patter at a Lowcountry literary reception and later reflects: "I must have been in a goddamn sitcom." The conversation, Jackson recalls, spun around an unnamed "young black poet" whose strident tone had upset the literary group the previous month. "Is it really that bad?" the white ladies asked indignantly. "It can't be that bad, can it?" Certainly not here in Charleston. According to Jackson, "The woman pouring wine at the reception / exchanged a look with me— / each of us with arched brows / asking the other, / You believe this shit?" Eventually, "yet another well-meaning woman / realized they were all starting to look bad / and tried to shut things down" by turning the conversation to "the art on the walls." Still, she could not help ending with a final familiar Lowcountry assertion and question: "But it's getting better," she assured the group. "Isn't it getting better?"

Selected Bibliography

Ackerson, Robert K. *South Carolina Colonial Land Policies*. Columbia: University of South Carolina Press, 1977.

Alderman, Derek, David Butler, and Stephen Hanna. "Memory, Slavery, and Plantation Museums: The River Road Project." *Journal of Heritage Tourism* 11, no. 3 (2016): 209–18.

Alderman, Derek, and Joshua Inwood. "Landscapes of Memory and Socially Just Futures." In *The Wiley-Blackwell Companion to Cultural Geography*, edited by Nuala Johnson, R. H. Schein, and J. Winders, 186–97. New York: Wiley, 2013.

Alderman, Derek H., and E. Arnold Modlin. "On the Political Utterances of Plantation Tourists: Vocalizing the Memory of Slavery on River Road." *Journal of Heritage Tourism* 11, no. 3 (2016): 275–89.

Alryyes, Ala. "'And in a Christian Language They Sold Me': Messages Concealed in a Slave's Arabic-Language Autobiographical Narrative." In *"American Babel": Literature of the United States from Abnaki to Zuni*, edited by Marc Shell, 41–54. Cambridge, MA: Harvard University Press, 2002.

Alryyes, Ala. *A Muslim American Slave: The Life of Omar ibn Said*. Madison: University of Wisconsin Press, 2011.

Aptheker, Herbert. *American Negro Slave Revolts*. New York: Columbia University Press, 1943.

Aptheker, Herbert. "Maroons within the Present Limits of the United States." *Journal of Negro History* 24 (1939): 167–84.

Austin, Allan. *African Muslims in Antebellum America: A Sourcebook*. New York: Garland, 1984.

Austin, Allan. *African Muslims in Antebellum America: Transatlantic Stories and Spiritual Struggles*. New York: Routledge, 2011.

Autry, Robyn. "The Political Economy of Memory: The Challenge of Representing National Conflict at 'Identity-Driven' Museums." *Theory and Society* 42 (2013): 57–80.

Barr, William B. "Strawberry Ferry and Childsbury Towne: A Socio-economic Enterprise on the Western Branch of the Cooper River, Saint John's Parish, Berkeley County, South Carolina." Master's thesis, University of South Carolina, 1995.

Barringer, Paul B. *The Natural Bent: The Memoirs of Dr. Paul D. Barringer*. Chapel Hill: University of North Carolina Press, 1949.

Battle, Mary. "Confronting Slavery in Historic Charleston: Changing Tourism Narratives in the Twenty-First Century." PhD diss., Emory University, 2013.

Battle, Mary, Tyler Mobley, and Heather Gilbert. "Digital Public History in the Library: Developing the Lowcountry Digital History Initiative at the College of Charleston." In *Laying the Foundation: Digital Humanities in Academic Libraries*, edited by John White and Heather Gilbert, 35–58. West Lafayette, IN: Purdue University Press, 2016.

Beard, David. "Good Wharves and Other Conveniences: An Archaeological Study of River-ine Adaptation in the South Carolina Lowcountry." In *Carolina's Historical Landscapes: Archaeological Perspectives*, 61–70. Knoxville: University of Tennessee Press, 1997.

Benjamin Golden, Kathryn. "Through the Muck and Mire: Marronage, Representation, and Memory in the Great Dismal Swamp." PhD diss., University of California, Berkeley, 2018.

Bland, Sidney. *Preserving Charleston's Past, Shaping Its Future: The Life and Times of Susan Pringle Frost*. Columbia: University of South Carolina Press, 1999.

Blassingame, John. *The Slave Community: Plantation Life in the Antebellum South*. New York: Oxford University Press, 1972.

Blight, David, ed. *Passages to Freedom: The Underground Railroad in History and Memory*. New York: First Smithsonian Books, 2006.

Blight, David W. *Race and Reunion: The Civil War in American Memory*. Cambridge, MA: Harvard University Press, 2009.

Bluestone, Daniel. *Buildings, Landscapes, and Memory: Case Studies in Historic Preservation*. New York: W.W. Norton, 2011.

Bogger, Tommy. "Maroons and Laborers in the Great Dismal Swamp." In *Readings in Black and White: Lower Tidewater Virginia*, edited by J. H. Kobelski, 1–8. Portsmouth, VA: Portsmouth Public Library, 1982.

Botwick, Bradford. "Underwater Historic Archaeological Sites in South Carolina: A Research Plan." Master's thesis, University of South Carolina, 1989.

Bridenbaugh, Carl. *Cities in the Wilderness*. New York: Alfred A. Knopf, 1968.

Bright, Candace Forbes, Derek H. Alderman, and David L. Butler. "Tourist Plantation Owners and Slavery: A Complex Relationship." *Current Issues in Tourism* 21, no. 15 (2018): 1743–60.

Brown, Alphonso. *A Gullah Guide to Charleston: Walking Through Black History*. Charleston, SC: History Press, 2008.

Brundage, W. Fitzhugh. *The Southern Past: A Clash of Memory and Race*. Cambridge, MA: Harvard University Press, 2005.

Brundage, W. Fitzhugh, ed. *Where These Memories Grow: History, Memory and Southern Identity*. Chapel Hill: University of North Carolina Press, 2000.

Burns, Jonathan, Andrew Dudash, and Ryan Mathur. "Fort Shirley's Copper Charm: Investigating Muslim Ethnicity on Pennsylvania's Colonial Frontier." In "Immigration and Ethnicity in Pennsylvania History," special issue, *Pennsylvania Magazine of History and Biography* 140, no. 3 (October 2016): 413–16.

Burrow, Ian, William Liebeknecht, Damon Tvaryanas, and Cheryl Hendry. *Archaeological Investigations, Replacement of Woodlands Ferry and Facility Improvements, Woodland, Broad Creek and Seaford Hundreds, Sussex County, Delaware*. Trenton, NJ: Hunter Research, 2008.

Buzinde, Christine N., and Carla Almeida Santos. "Interpreting Slavery Tourism." *Annals of Tourism Research* 36, no. 3 (2009): 439–58.

Callcott, George. "Omar ibn Seid: A Slave Who Wrote an Autobiography in Arabic." *Journal of Negro History* 39, no. 1 (January 1954): 58–63.

Camp, Stephanie M. H. *Closer to Freedom: Enslaved Women & Everyday Resistance in the Plantation South*. Chapel Hill: University of North Carolina Press, 2004.

Carney, Judith A. *The African Origins of Rice Cultivation in the Americas*. Cambridge, MA: Harvard University Press, 2002.

Carter, Perry, David Butler, and Owen Dwyer. "Defetishizing the Plantation: African Americans in the Memorialized South." *Historical Geography* 39 (2011): 128–46.

Combs, Barbara H. et al. "The Symbolic Lynching of James Meredith: A Visual Analysis and Collective Counter Narrative to Racial Domination." *Sociology of Race and Ethnicity* 2, no. 3 (2016): 338–53.

Conard, Rebecca. "'Once I Built a Railroad': Viewing History from the Depot Platform." *Public Historian* 14, no. 2 (Spring 1992): 31–43.

Curiel, Jonathan. *Al' America: Travels through America's Arab and Islamic Roots*. New York: New Press, 2008.

Curtin, Philip D. *The Atlantic Slave Trade: A Census*. Madison: University of Wisconsin Press, 1969.

Davidson, Suzanne R. "African American Roots Tourism at 'Home': History, Memory, and Heritage in Holly Springs, Mississippi." Master's thesis, University of Mississippi, 2018.

Davis, Jack E. "A Struggle for Public History: Black and White Claims to Natchez's Past." *Public Historian* 22, no. 1 (2000): 52.

Diouf, Sylviane Anne. "Devils or Sorcerers, Muslims or Studs: Manding in the Americas." In *Trans-Atlantic Dimensions of Ethnicity in the African Diaspora*, edited by Paul Lovejoy and David Trotman, 139–57. London: Continuum, 2003.

Diouf, Sylviane Anne, ed. *Fighting the Slave Trade: West African Strategies*. Athens: Ohio University Press, 2003.

Diouf, Sylviane Anne. *Servants of Allah: African Muslims Enslaved in the Americas*. New York: New York University Press, 2013.

Diouf, Sylviane Anne. *Slavery's Exiles: The Story of the American Maroons*. New York: New York University Press, 2014.

Dobronravin, Nikolay. "West African Ajami in the New World (Hausa, Fulfude, Mande Languages)." In *The Arabic Script in Africa: Studies in the Use of a Writing System*, edited by Meikal Mumin and Kees Versteegh, 159–72. Leiden: Brill, 2014.

Domby, Adam. *The False Cause: Fraud, Fabrication, and White Supremacy in Confederate Memory*. Charlottesville: University of Virginia Press, 2020.

Donaldson, Susan V. "Charleston's Racial Politics of Historic Preservation: The Case of Edwin A. Harleston." In *Renaissance in Charleston: Art and Life in the Carolina Low Country, 1900–1940*, 176–97. Athens: University of Georgia Press, 2003.

Dow Turner, Lorenzo. *Africanisms in the Gullah Dialect*. Chicago: University of Chicago Press, 1949.

Dunaway, Wilma A. *The First American Frontier: Transition to Capitalism in Southern Appalachia, 1700–1860*. Chapel Hill: University of North Carolina Press, 1996.

Eichstedt, Jennifer, and Stephen Small. *Representations of Slavery: Race and Ideology in Southern Plantation Museums*. Washington, DC: Smithsonian Books, 2002.

Ellis, Clifton, and Rebecca Ginsburg, eds. *Slavery in the City: Architecture and Landscapes of Urban Slavery in North America*. Charlottesville: University of Virginia Press, 2017.

Eltis, David, and David Richardson. *Atlas of the Transatlantic Slave Trade*. New Haven, CT: Yale University Press, 2010.

Engle, Eloise, and Arnold S. Lott. *America's Maritime Heritage*. Annapolis, MD: Naval Institute Press, 1973.

Ernst, Joseph A., and H. Roy Merrens. "'Camden's Turrets Pierce the Skies!': The Urban Process in the Southern Colonies during the Eighteenth Century." *William and Mary Quarterly* 30, no. 3 (1973): 549–74.

Errante, Jim. In *Carolina's Historical Landscapes: Archaeological Perspectives*, 205–10. Knoxville: University of Tennessee Press, 1997.

Fabre, Geneviève, and Robert O'Meally, eds. *History and Memory in African American Culture.* New York: Oxford University Press, 1994.

Farrow, Anne. *The Logbooks: Connecticut's Slave Ships and Human Memory.* Middletown, CT: Wesleyan University Press, 2014.

Ferguson, Leland, and David Babson. *Survey of Plantation Sites along the East Branch of Cooper River: A Model for Predicting Archaeological Site Location.* Columbia: South Carolina Institute of Anthropology and Archaeology, 1986.

Fett, Sharla M. *Recaptured Africans: Surviving Slave Ships, Detention, and Dislocation in the Final Years of the Slave Trade.* Chapel Hill: University of North Carolina Press, 2017.

Fields, Mamie Garvin, and Karen Fields. *Lemon Swamp and Other Places: A Carolina Memoir.* New York: Free Press, 1983.

Fields-Black, Edda L. *Deep Roots: Rice Farmers in West Africa and the African Diaspora.* Bloomington: Indiana University Press, 2008.

Fouts, Raymond Parker, ed. *Registration of Slaves to Work in the Great Dismal Swamp: Gates County, North Carolina, 1847–1861.* Cocoa, FL: GenRec, 1995.

Fox-Genovese, Elizabeth. *Within the Plantation Household: Black and White Women of the Old South.* Chapel Hill: University of North Carolina Press, 1988.

Frazier, Herb, Bernard Edward Powers Jr., and Marjory Wentworth. *We Are Charleston: Tragedy and Triumph at Mother Emanuel.* Nashville: W. Publishing, 2016.

Frisch, Michael. *A Shared Authority: Essays on the Craft and Meaning of Oral and Public History.* New York: State University of New York Press, 1990.

Gable, Eric. "Maintaining Boundaries, or 'Mainstreaming' Black History in a White Museum." In *Theorizing Museums: Repressing Identity and Diversity in a Changing World,* edited by Sharon Macdonald and Gordon Fyfe, 177–202. Cambridge, MA: Blackwell, 1996.

Gallas, Kristin L., and James DeWolf Perry, eds. *Interpreting Slavery at Museums and Historic Sites.* New York: Rowman & Littlefield, 2015.

Gilmore, Edward C. "South Carolina River Ferries." *South Carolina History Illustrated* 1, no. 2 (1970): 44–48.

Glymph, Thavolia. *Out of the House of Bondage: The Transformation of the Plantation Household.* Cambridge: Cambridge University Press, 2008.

Gomez, Michael. "Africans, Culture, and Islam in the Lowcountry." In *African American Life in the Georgia Lowcountry: The Atlantic World and the Gullah Geechee,* edited by Philip Morgan, 103–30. Athens: University of Georgia Press, 2010.

Gomez, Michael. *Black Crescent: The Experience and Legacy of African Muslims in the Americas.* New York: Cambridge University Press, 2005.

Gomez, Michael. *Exchanging Our Country Marks: The Transformation of African Identities in the Colonial and Antebellum South.* Chapel Hill: University of North Carolina Press, 1998.

Gomez, Michael. "Muslims in Early America." *Journal of Southern History* 60, no. 4 (November 1994): 671–710.

Gotham, Kevin Fox. *Authentic New Orleans: Tourism, Culture, and Race in the Big Easy.* New York: NYU Press, 2007.

Grandin, Greg. *The Empire of Necessity: Slavery, Freedom, and Deception in the New World.* New York: Henry Holt, 2014.

Graves, Brian. "'Return and Get It': Developing McLeod Plantation as a Shared Space of Historical Memory." *Southern Cultures* 23, no. 2 (Summer 2017): 75–96.

Greene, Jack P., Rosemary Brana-Shute, and Randy J. Sparks, eds. *Money, Trade, and Power: The Evolution of Colonial South Carolina's Plantation Society.* Columbia: University of South Carolina Press, 2001.

Halifax, Shawn. "McLeod Plantation Historic Site: Sowing Truth and Change." *Public Historian* 40, no. 3 (August 2018): 252–77.

Hamer, David. *History in Urban Places: The Historic Districts of the United States.* Columbus: Ohio State University Press, 1998.

Harms, Robert. *The Diligent: A Voyage through the Worlds of the Slave Trade.* New York: Basic, 2002.

Harris, Leslie M. *In the Shadow of Slavery: African Americans in New York City, 1626–1863.* Chicago: University of Chicago Press, 2004.

Hartley, Michael O. "The Ashley River: A Survey of Seventeenth Century Sites." Research Manuscript Series. Columbia: South Carolina Institute of Anthropology and Archaeology, 1984.

Hartman, Saidiya V. *Scenes of Subjection: Terror, Slavery, and Self-Making in Nineteenth-Century America.* New York: Oxford University Press, 1997.

Hassane, Moulaye. "Ajami in Africa: The Use of Arabic Script in the Transcription of African Languages." In *The Meanings of Timbuktu,* edited by Shamil Jeppie and Souleymane Bachir Diagne, 109–22. Cape Town, South Africa: Human Sciences Research Council, 2008.

Hayes, Kevin. "How Thomas Jefferson Read the Qur'an." *Early American Literature* 39, no. 2 (2004): 247–61.

Helsley, Alexia Jones. *South Carolina Highway Historical Marker Guide.* Columbia: South Carolina Department of Archives and History, 1992.

Herman, Bernard L. "Slave and Servant Housing in Charleston, 1770–1820." *Historical Archaeology,* 33, no. 3 (1999): 88–101.

Heuman, Gad, ed. *Out of the House of Bondage: Runaways, Resistance and Marronage in Africa and the New World.* Totowa, NJ: Frank Cass, 1986.

Horton, James Oliver. "Presenting Slavery: The Perils of Telling America's Racial Story." *Public Historian* 21, no. 4 (Autumn 1999): 19–38.

Horton, James Oliver, and Lois E. Horton, eds. *Slavery and Public History: The Tough Stuff on American History.* New York: New Press, 2006.

Huggins, Nathan. "The Deforming Mirror of Truth: Slavery and the Master Narrative of American History." *Radical History Review* 49 (Winter 1991): 25–48.

Humery, Marie-Ève. "Fula and the Ajami Writing System in the Haalpulaar Society of Fuuta Toore (Senegal and Mauritania): A Specific 'Restricted Literacy.'" In *The Arabic Script in Africa: Studies in the Use of a Writing System,* edited by Meikal Mumin and Kees Versteegh, 173–98. Leiden: Brill, 2014.

Hunwick, John. "Toward a History of the Islamic Intellectual Tradition in West Africa Down to the Nineteenth Century." Paper presented at the International Symposium on Islamic Civilization in West Africa, Dakar, Senegal, December 1996.

Hurley, Andrew. "Narrating the Urban Waterfront: The Role of Public History in Community Revitalization." *Public Historian* 28, no. 4 (Autumn 2006): 19–50.

Jackson, Antoinette. "Changing Ideas about Heritage and Heritage Resource Management in Historically Segregated Communities." *Transforming Anthropology* 18, no. 1 (2010): 80.

Jackson, Antoinette. "Shattering Slave Life Portrayals: Uncovering Subjugated Knowledge in U.S. Plantation Sites in South Carolina and Florida." *American Anthropologist* 113, no. 3 (2011): 448–62.

Jackson, Antoinette. *Speaking for the Enslaved: Heritage Interpretation at Antebellum Plantation Sites.* Walnut Creek, CA: Left Coast, 2012.

Jakle, John. "Landscapes Redesigned for the Automobile." In *The Making of the American Landscape,* 293–310. New York: Routledge, 1994.

Johnson, F. Roy. *Tales from Old Carolina: Traditional and Historical Sketches.* Murfreesboro, NC: Johnson, 1965.

Johnson, George Lloyd Jr. *The Frontier in the Colonial South: South Carolina Backcountry, 1736–1800.* Westport, CT: Greenwood, 1997.

Jones-Rogers, Stephanie E. *They Were Her Property: White Women as Slave Owners in the American South.* New Haven, CT: Yale University Press, 2019.

Joseph, J. W., Theresa M. Hamby, and Catherine S. Long. *Historical Archaeology in Georgia.* Stone Mountain, GA: New South Associates, 2004.

Joyner, Charles. *Down by the Riverside: A South Carolina Community.* Urbana: University of Illinois Press, 1984.

Judy, Ronald A. T. *(Dis)forming the American Canon: African-Arabic Slave Narratives and the Vernacular.* Minneapolis: University of Minnesota Press, 1993.

Kahera, Akel. "God's Dominion: Omar ibn Said's Use of Arabic Literacy as Opposition to Slavery." *South Carolina Review* 46, no. 2 (2014): 126–34.

Kamran, Muska. "'A Negro Who Could Read and Write the Arabic Language': African Muslim Slaves as Intermediaries in North American Plantations and African Colonies." Master's thesis, Johns Hopkins University, 2015.

Kane, Ousmane Oumar. *Beyond Timbuktu: An Intellectual History of Muslim West Africa.* Cambridge, MA: Harvard University Press, 2016.

Kantrowitz, Stephen. *Ben Tillman and the Reconstruction of White Supremacy.* Chapel Hill: University of North Carolina Press, 2000.

Karp, Matthew. *This Vast Southern Empire: Slaveholders at the Helm of American Foreign Policy.* Cambridge, MA: Harvard University Press, 2016.

Kaufman, Ned. *Place, Race and Story: Essays on the Past and Future of Historic Preservation.* New York: Routledge, 2009.

Kaye, Anthony E. *Joining Places: Slave Neighborhoods in the Old South.* Chapel Hill: University of North Carolina Press, 2007.

Kelley, Sean M. *The Voyage of the Slave Ship* Hare: *A Journey into Captivity from Sierra Leone to South Carolina.* Chapel Hill: University of North Carolina Press, 2016.

Kovacik, Charles F., and John J. Winberry. *South Carolina: The Making of a Landscape.* Columbia: University of South Carolina Press, 1987.

Kytle, Ethan J., and Blaine Roberts. *Denmark Vesey's Garden: Slavery and Memory in the Cradle of the Confederacy.* New York: New Press, 2018.

Labaree, Benjamin W., William M. Fowler Jr., John B. Hattendorf, Jeffrey J. Safford, Edward W. Sloan, and Andrew W. German. *America and the Sea: A Maritime History.* Mystic, CT: Mystic Seaport, 1998.

Lawler, Andrew. "Muslims Were Banned from the Americas as Early as the 16th Century." Smithsonian.com. February 7, 2017.

Lea, Diane. "America's Preservation Ethos: A Tribute to Enduring Ideals." In *A Richer Heritage: Historic Preservation in the Twenty-First Century,* edited by Robert E. Stipe, 1–22. Chapel Hill: University of North Carolina Press, 2003.

Leaming, Hugo Prosper. *Hidden Americans: Maroons of Virginia and the Carolinas.* New York: Garland, 1995.

LeConte, Joseph. *The Autobiography of Joseph Le Conte,* edited by William Dallam Armes. New York: D. Appleton, 1903.

Levtzion, Nehemia. *Muslims and Chiefs in West Africa: A Study of Islam in the Middle Volta Basin in the Pre-colonial Period.* New York: Oxford University Press, 1969.

Littlefield, Daniel C. *Rice and Slaves: Ethnicity and the Slave Trade in Colonial South Carolina.* Baton Rouge: Louisiana State University Press, 1981.

Litvin, Stephen W., and Joshua David Brewer. "Charleston, South Carolina Tourism and the Presentation of Urban Slavery in an Historic Southern City." *International Journal of Hospitality and Tourism Administration* 9, no. 1 (2008): 71–84.

Loewen, James W. *Lies across America: What Our Historic Sites Get Wrong.* New York: Simon & Schuster, 1999.

Lovejoy, Paul. "Muslim Freedmen in the Atlantic World: Images of Manumission and Self-Redemption." In *Slavery on the Frontiers of Islam,* edited by Paul Lovejoy, 233–60. Princeton, NJ: Markus Wiener, 2003.

MacLean, Nancy. *Democracy in Chains: The Deep History of the Radical Right's Stealth Plan for America.* New York: Viking, 2017.

Marable, Manning. *Living Black History: How Reimagining the African-American Future Can Remake America's Racial Future.* Cambridge, MA: Basic Civitas Books, 2006.

McAlexander, Hubert H. *A Southern Tapestry: Marshall County, Mississippi, 1835–2000.* Virginia Beach, VA: Donning, 2000.

McIntosh, Jane. *The Practical Archaeologist: How We Know What We Know About the Past.* New York: Facts on File, 1999.

Midlo Hall, Gwendolyn. *Africans in Colonial Louisiana: The Development of Afro-Creole Culture in the Eighteenth Century.* Baton Rouge: Louisiana State University Press, 1992.

Miles, Tiya. *Dawn of Detroit: A Chronicle of Slavery and Freedom in the City of the Straits.* New York: New Press, 2019.

Miles, Tiya. *Tales from the Haunted South: Dark Tourism and the Civil War Legacy of Slavery and Memory.* Chapel Hill: University of North Carolina Press, 2015.

Modlin, Eddie. "Representing Slavery at Plantation-House Museums in the U.S. South: A Dynamic Spatial Process." *Historical Geography* 39 (2011): 147–73.

Moore, John Hebron. *The Emergence of the Cotton Kingdom in the Old Southwest: Mississippi, 1770–1860.* Baton Rouge: Louisiana State University Press, 1988.

Moore, Tyrel G., Jr. "Role of Ferryboat Landings in East Tennessee's Economic Development, 1790–1870." *Studies in the Social Studies* 18 (1979), 1–8.

Morgan, Philip D. *Slave Counterpoint: Black Culture in the Eighteenth-Century Chesapeake & Lowcountry.* Chapel Hill: University of North Carolina Press, 1998.

Morris, Brent. "A Concentrated Diversity: The Maroons of the Great Dismal Swamp." In *Voices from within the Veil: African Americans and the Experience of Democracy,* edited by William H. Alexander, Cassandra Newby-Alexander, and Charles H. Ford, 85–113. Newcastle upon Tyne, England: Cambridge Scholars, 2008.

Morris, Brent. "'Mingled Fear and Ferocity': A Brief Glimpse into the Maroon Communities of the Great Dismal Swamp." In *Maroons and the Marooned: Runaways and Castaways in the Americas,* edited by Richard Bodek and Joseph P. Kelly. Oxford: University of Mississippi Press, forthcoming 2020.

Mouser, Bruce L., ed. *A Slaving Voyage to Africa and Jamaica: The Log of the* Sandown, *1793–1794.* Bloomington: Indiana University Press, 2002.

Mullin, Gerald W. *Flight and Rebellion: Slave Resistance in Eighteenth-Century Virginia.* New York: Oxford University Press, 1972.

Mustakeem, Sowande' M. *Slavery at Sea: Terror, Sex, and Sickness in the Middle Passage.* Urbana: University of Illinois Press, 2016.

Nevius, Marcus P. *City of Refuge: Slavery and Petit Marronage in the Great Dismal Swamp, 1763–1856.* Athens: University of Georgia Press, 2020.

North Carolina Department of Environment and Natural Resources. "Park Purpose: State Parks System Mission Statement." Dismal Swamp State Park, November 1, 1994.

Omi, Michael, and Howard Winant. *Racial Formation in the United States: From the 1960s to the 1990s.* New York: Routledge, 1994.

Osman, Ghada, and Camille F. Forbes. "Representing the West in the Arabic Language: The Slave Narrative of Oman ibn Said." *Journal of Islamic Studies* 15, no. 3 (2004): 331–43.

Parramore, Thomas C. *Cradle of the Colony: The History of Chowan County and Edenton, North Carolina.* Edenton, NC: Chamber of Commerce, 1967.

Parramore, Thomas C., Peter C. Stewart, and Tommy L. Bogger. *Norfolk: The First Four Centuries.* Charlottesville: University Press of Virginia, 1994.

Platt, Sarah. "Urban Dialectics, Misrememberings, and Memory-Work: The Halsey Map of Charleston, South Carolina." *International Journal of Historical Archaeology* 24 (2020): 989–1014.

Potter, Amy E. "'She Goes into Character as the Lady of the House': Tour Guides, Performance, and the Southern Plantation." *Journal of Heritage Tourism* 11, no. 3 (2015): 250–61.

Price, Richard. *Maroon Societies: Rebel Slave Communities in the Americas.* Baltimore: John Hopkins University Press, 1973.

Rabinowitz, Richard. *Curating America: Journeys through Storyscapes of the American Past.* Chapel Hill: University of North Carolina Press, 2016.

Rediker, Marcus. *The Slave Ship: A Human History.* New York: Viking, 2007.

Reichmuth, Stefan. "Islamic Education and Scholarship in Sub-Saharan Africa." In *The History of Islam in Africa,* edited by Nehemia Levtzion and Randall Pouwels, 419–40. Athens: Ohio University Press, 2000.

Rockman, Diana Diz., and Nan A. Rothschild. "City Tavern, Country Tavern: An Analysis of Four Colonial Sites." *Historical Archaeology* 18, no. 2 (1984): 112–21.

Rogers, George C., Jr. *The History of Georgetown County, South Carolina.* Columbia: University of South Carolina Press, 1970.

Romano, Renee, and Leigh Raiford, eds. *The Civil Rights Movement in American Memory.* Athens: University of Georgia Press, 2006.

Rouvalis, Christina. "Commerce and Conflict on the 18th-Century Frontier." *American Archaeology* 17, no. 3 (Fall 2013): 32–37.

Rowland, Lawrence S. "Eighteenth Century Beaufort: A Study of South Carolina's Southern Parishes to 1800." PhD diss., University of South Carolina, 1978.

Rowland, Lawrence S., Alexander Moore, and George C. Rogers Jr. *The History of Beaufort County, South Carolina.* Columbia: University of South Carolina Press, 1996.

Royster, Charles. *The Fabulous History of the Dismal Swamp Company.* New York: Alfred A. Knopf, 1999.

Sayers, Daniel O. *A Desolate Place for a Defiant People: The Archaeology of Maroons, Indigenous Americans, and Enslaved Laborers in the Great Dismal Swamp.* Germantown, MD: Society for Historical Archaeology, 2014.

Sayers, Daniel O. "Scission Communities and Social Defiance: Marronage in the Diasporic Great Dismal Swamp, 1660–1860." In *The Limits of Tyranny,* edited by James A. Delle, 177–212. Knoxville: University of Tennessee Press, 2015.

Schwarz, Philip J. *Twice Condemned: Slaves and the Criminal Laws of Virginia, 1705–1865.* Clark, NJ: Lawbook Exchange, 1998.

Shackel, Paul. *Memory in Black and White: Race, Commemoration, and the Post-Bellum Landscape.* Walnut Creek, CA: AltaMira, 2003.

Shaw, Madelyn. "Slave Cloth and Clothing Slaves: Craftsmanship, Commerce, and Industry." *Journal of Early Southern Decorative Arts* 33 (2012): https://www.mesdajournal.org/.

Signer, Michael. *Demagogue: The Fight to Save Democracy from Its Worst Enemies.* New York: Palgrave MacMillan, 2009.

Skipper, Jodi. "Community Development through Reconciliation Tourism: The Behind the Big House Program in Holly Springs, Mississippi." *Community Development* 47, no. 4 (2016): 514–29.

Skipper, Jodi, and James M. Thomas. "Plantation Tours." *Contexts: Sociology for the Public* 19, no. 2 (2020): 64–67.

Small, Stephen. "Still Back of the Big House: Slave Cabins and Slavery in Southern Heritage Tourism." *Tourism Geographies* 15, no. 3 (2013): 405–23.

Smallwood, Stephanie E. *Saltwater Slavery: A Middle Passage from Africa to American Diaspora.* Cambridge, MA: Harvard University Press, 2007.

Spellberg, Denise. "Islam in America: Adventures in Neo-Orientalism." *Review of Middle East Studies* 43, no. 1 (Summer 2009): 25–35.

Spellberg, Denise. *Thomas Jefferson's Qur'an: Islam and the Founders.* New York: Vintage, 2013.

Starobin, Paul. *Madness Rules the Hour: Charleston, 1860 and the Mania for War.* New York: PublicAffairs, 2017.

Stewart-Abernathy, Leslie C. "Separate Kitchens and Intimate Archaeology: Constructing Urban Slavery on the Antebellum Cotton Frontier in Washington, Arkansas." In *Household Chores and Household Choices: Theorizing the Domestic Sphere in Historical Archaeology,* edited by Kerri S. Barile and Jamie C. Brandon, 51–74. Tuscaloosa: University of Alabama Press, 2004.

Stone, Meredith, Ian Spangler, Xavier Griffin, and Stephen P. Hanna. "Searching for the Enslaved in the 'Cradle of Democracy': Virginia's James River Plantation Websites and the Reproduction of Local Social Memories." *Southeastern Geographer* 56, no. 2 (2016): 203–22.

Tattersfield, Nigel. *The Forgotten Trade: Comprising the Log of the* Daniel and Henry *of 1700 and Accounts of the Slave Trade from the Minor Ports of England, 1698–1725.* London: Jonathan Cape, 1991.

Thompson, Alvin O. *Flight to Freedom: African Runaways and Maroons in the Americas.* Kingston, Jamaica: University of the West Indies, 2006.

Thompson, Mary V. "Religious Practice in the Slave Quarters at Mount Vernon." *Colonial Williamsburg Interpreter* 21, no. 1 (Spring 2000): 10–14.

Thorne Smith, Chesley. *Childhood in Holly Springs: A Memoir.* Lafayette, CA: Berryhill, 1996.

Tillet, Salamishah. *Sites of Slavery: Citizenship and Racial Democracy in the Post–Civil Rights Imagination.* Durham, NC: Duke University Press, 2012.

Trouillot, Michel-Rolph. *Silencing the Past: Power and the Production of History.* Boston: Beacon, 1995.

Vlach, John Michael. "'Without Recourse to Owners': The Architecture of Urban Slavery in the Antebellum South." In *Shaping Communities: Perspectives in Vernacular Architecture,* edited by Carter L. Hudgins and Elizabeth Collins Cromley, 150–60. Knoxville: University of Tennessee Press, 1997.

Walker Bailey, Cornelia. *God, Dr. Buzzard, and the Bolito Man.* New York: Doubleday, 2000.

Wallace, Mike. *Mickey Mouse History: And Other Essays on American Memory.* Philadelphia: Temple University Press, 1996.

Washington Creel, Margaret. *"A Peculiar People": Slave Religion and Community-Culture among the Gullahs*. New York: New York University Press, 1988.

Weir, L. M. W. "Ferries in Scotland between 1603 and the Advent of Steam." PhD diss., University of Edinburgh, 1985.

Weir, Robert M. *Colonial South Carolina: A History*. Columbia: University of South Carolina Press, 1997.

Wellenreuther, Hermann, Fred Siegel, Joseph A. Ernst, and H. Roy Merrens. "Urbanization in the Colonial South: A Critique." *William and Mary Quarterly* 31, no. 4 (October 1974): 653–71.

Westerdahl, Christer. "The Maritime Cultural Landscape." *International Journal of Nautical Archaeology* 21, no. 1 (1992): 5–14.

Westerdahl, Christer. "On Oral Tradition and Place Names." *International Journal of Nautical Archaeology* 9 (1980): 311–29.

Weyeneth, Robert. *Historic Preservation for a Living City: Historic Charleston Foundation*. Columbia: University of South Carolina Press, 2000.

Wilson, Gaye. "Dealings with Mellimelli, Colorful Envoy from Tunis." *Monticello Newsletter* 14, no. 2 (Winter 2003).

Wood, Peter H. *Black Majority: Negroes in Colonial South Carolina from 1670 through the Stono Rebellion*. New York: Alfred A. Knopf, 1974.

Wood, Peter H. "Slave Labor Camps in Early America: Overcoming Denial and Discovering the Gulag." In *Inequality in Early America*, edited by Carla Gardina Pestana and Sharon V. Salinger, 222–38. Hanover, NH: University Press of New England, 1999.

Wragg Chase, Judith. *Afro-American Art and Craft*. New York: Van Nostrand Reinhold, 1971.

Yuhl, Stephanie. *A Golden Haze of Memory: The Making of Historic Charleston*. Chapel Hill: University of North Carolina Press, 2005.

Zierden, Martha A., and Elizabeth J. Reitz. *Charleston: An Archaeology of Life in a Coastal Community*. Gainesville: University Press of Florida, 2016.

Contributors

AYLA AMON is curatorial assistant at the Smithsonian National Museum of African American History and Culture. Her research focuses on Islam in western Africa, enslaved Muslims in the Americas, and legacies of Islam. She is currently working on a book project chronicling the life of Omar ibn Sayyid, an enslaved Muslim man in North Carolina. Amon has degrees from the University of Chicago and George Washington University.

KATHRYN BENJAMIN GOLDEN is assistant professor in Africana studies at the University of Delaware. Her work focuses on US slavery, comparative slave resistance in the Atlantic world, public history, and collective memory.

RACHEL CLARE DONALDSON is professor of public history at the College of Charleston and author of *"I Hear America Singing": Folk Music and National Identity.*

Since 2016 ASHLEY HOLLINSHEAD has worked in public history as a cultural history interpreter, first at McLeod Plantation Historic Site in Charleston, South Carolina, and currently at Thomas Jefferson's Monticello in Charlottesville, Virginia. This chapter draws upon her master's thesis, written at the College of Charleston. The views expressed within it are her own.

EDWARD SALO is assistant professor in the History Department as well as the Heritage Studies PhD program at Arkansas State University. He was employed as a consulting historian/architectural historian for three cultural-resources-management firms, serving as head of the History Division in the last firm. In his consulting work, Salo completed historic resources surveys, management documents, and National Register of Historic Places nominations for projects across the continental United States as well as in Alaska, Cuba, Germany, Guam, Japan, Hawaii, the Mariana Islands, and Puerto Rico. During his fourteen years in consulting, Salo authored or coauthored more than 250 reports that were reviewed by professionals in their fields at the state and national level.

JODI SKIPPER is associate professor of anthropology and southern studies at the University of Mississippi. She approaches the challenge of representing pasts in the present by supporting African American cultural heritage and community education projects. Skipper was a 2017–2018 Whiting Foundation public engagement fellow, during which she developed a workshop on best practices for interpreting slavery in local communities and a companion website, behindthebighouse.org. Her research seeks to

understand how historic preservation projects might play a role in imagining more sustainable and healthier futures for US southern communities. She is also coeditor (with Michele Grigsby Coffey) of the collection *Navigating Souths: Transdisciplinary Explorations of a US Region.*

JOHN W. WHITE is founding director of the Lowcountry Digital History Initiative and dean of libraries at the College of Charleston, and he is coeditor of *Laying the Foundation: Digital Humanities in Academic Libraries.*

PETER H. WOOD is an emeritus professor of history at Duke University. He is a graduate of Harvard and Oxford who taught colonial history and much else at Duke from 1975 to 2008. His books include *Black Majority* (1974), a pioneering study of enslavement in early South Carolina, and *Strange New Land: Africans in Colonial America* (2003). He has coauthored a major US history survey text (*Created Equal*) and written three books on the Black images of the great American artist Winslow Homer. Wood has taken part in several PBS productions on the Black experience, including *Africans in America* and *Slavery in the Making of America.* Throughout his career he has been involved in public history initiatives, working with NEH, the Children's Defense Fund, the Thomas Day Education Project, the Slave Dwelling Project, and the Unpaid Labor Project (based in his hometown of St. Louis). He now lives in Boulder County, Colorado, where he conducts one-day public seminars titled "Slavery Matters," works with elementary school classes, and uses historical perspectives to address the global climate crisis at the community level.

LEAH WORTHINGTON serves as the codirector of the Lowcountry Digital History Initiative and the associate director of the Lowcountry Digital Library, two ongoing, permanent projects out of the College of Charleston libraries. Previously, Worthington worked as lead interpreter at McLeod Plantation Historic Site from 2015 to 2016.

Index